TOMB TREASURES

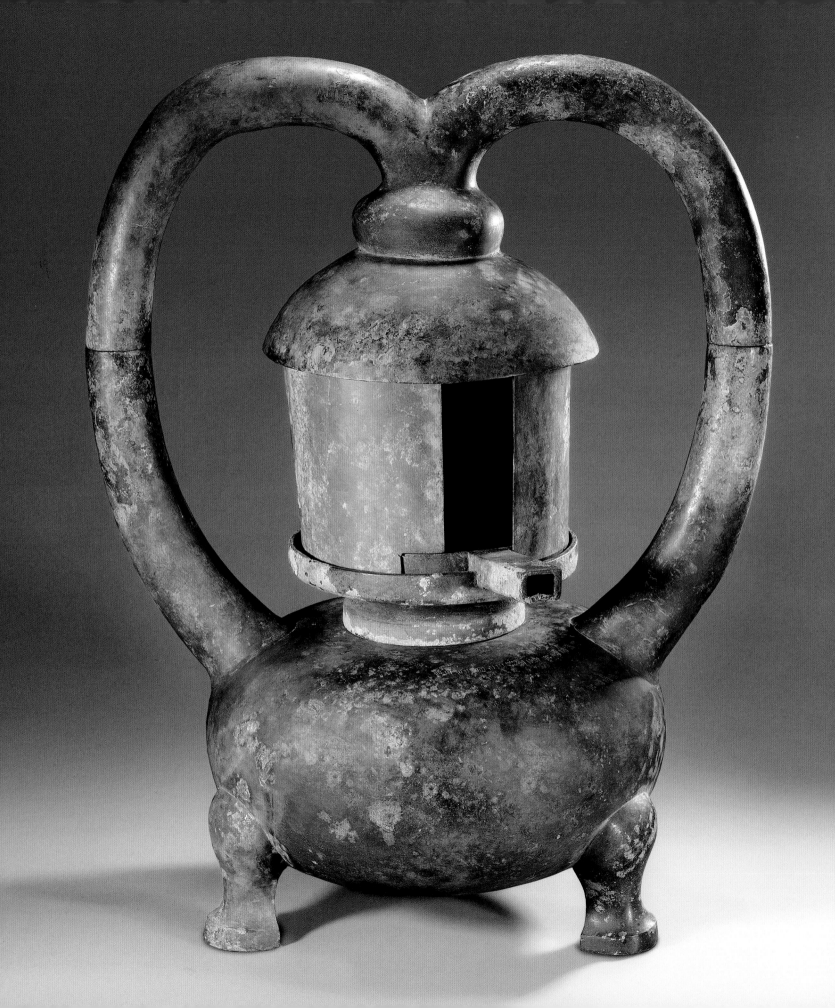

Tomb Treasures

New Discoveries from China's Han Dynasty

EDITOR

Jay Xu

COCURATORS

Jay Xu and Fan Jeremy Zhang

COORDINATING EDITORS

Jamie Chu and Claire Yi Yang

WITH TEXTS BY

Jay Xu, Li Zebin, Li Yinde, and Tianlong Jiao

ASIAN ART MUSEUM

San Francisco

∀ Asian

Published by
Asian Art Museum
Chong-Moon Lee Center
for Asian Art and Culture
200 Larkin Street
San Francisco, CA 94102
www.asianart.org

Library of Congress Cataloging-in-
Publication Data
Names: Xu, Jay, editor. | Li, Zebin. | Li, Yinde. |
 Asian Art Museum of San Francisco, orga-
 nizer, host institution.
Title: Tomb treasures: new discoveries from
 China's Han dynasty / Jay Xu, editor; Jay
 Xu and Fan Jeremy Zhang, cocurators;
 Jamie Chu and Claire Yi Yang, coordinating
 editors; with texts by Jay Xu, Li Zebin, Li
 Yinde, and Tianlong Jiao.
Description: San Francisco: Asian Art
 Museum, 2017. | Includes bibliographical
 references and index.
Identifiers: LCCN 2016038155 | ISBN
 9780939117789 (hardback)
Subjects: LCSH: Grave goods—China—
 Jiangsu Sheng—Exhibitions. | Art
 objects, Chinese—China—Jiangsu
 Sheng—Qin-Han dynasties, 221 B.C.–220
 A.D.—Exhibitions. | China—Kings and rul-
 ers—Tombs—Exhibitions. | Jiangsu Sheng
 (China)—Antiquities—Exhibitions. | BISAC:
 HISTORY / Asia / China. | ART / History /
 Ancient & Classical.
Classification: LCC DS793.K45 T66 2017 |
 DDC 931/.04—dc23
LC record available at https://lccn.loc.
 gov/2016038155

The Asian Art Museum–Chong-Moon Lee
Center for Asian Art and Culture is a public
institution whose mission is to lead a
diverse global audience in discovering the
unique material, aesthetic, and intellectual
achievements of Asian art and culture.

*Tomb Treasures: New Discoveries from
China's Han Dynasty* is organized by the
Asian Art Museum of San Francisco and
the Nanjing Museum. Presentation is made
possible with the generous support of

THE BERNARD
OSHER
FOUNDATION

E. Rhodes and Leona B. Carpenter
 Foundation
The Akiko Yamazaki and Jerry Yang
 Fund for Excellence in Exhibitions and
 Presentations
Warren Felson and Lucy Sun
Angela and Gwong-Yih Lee
Fred Levin and Nancy Livingston, The
 Shenson Foundation, in memory of Ben
 and A. Jess Shenson
Hok Pui Leung and Sally Yu Leung
Sampson C. and Faye Shen Fund

Exhibition dates: February 17–May 28, 2017

Produced by the Publications Department,
Asian Art Museum
Clare Jacobson, Head of Publications

Design and production by Amanda
 Freymann and Joan Sommers, Glue +
 Paper Workshop, LLC
Edited by Tom Fredrickson
Proofread by David Sweet
Indexed by Lydia Jones
Color separations by Professional
 Graphics Inc.
Printed and bound in China

Distributed by:
North America, Latin America, and Europe
Tuttle Publishing
364 Innovation Drive
North Clarendon, VT 05759-9436 U.S.A.
Tel: 1 (802) 773-8930; Fax: 1 (802) 773-6993
info@tuttlepublishing.com
www.tuttlepublishing.com

Asia Pacific
Berkeley Books Pte. Ltd.
61 Tai Seng Avenue #02-12
Singapore 534167
Tel: (65) 6280-1330; Fax: (65) 6280-6290
inquiries@periplus.com.sg
www.periplus.com

Front cover: Stand for musical chimes,
 cat. 4, photo courtesy Nanjing Museum
Back cover: Detail from coffin, cat. 83, photo
 courtesy Xuzhou Museum
Page ii: Lamp, cat. 51, photo courtesy
 Nanjing Museum
Page v: Pattern from Han Dynasty weapon
 handle excavated from Liu Fei's tomb
 at Dayun Mountain, drawing courtesy
 Nanjing Museum. Inscriptions taken from
 cats. 99, 100, and 67.
Page vi: *Bi* disk from bell set, cat. 3, photo
 courtesy Nanjing Museum
Page viii: Kneeling female figure, cat. 9,
 photo courtesy Xuzhou Museum
Page 196: Lamp in the shape of a deer,
 cat. 49, photo courtesy Nanjing Museum
Page 200: Detail from bell set, cat. 3, photo
 courtesy Nanjing Museum
Page 203: Mat weight in the shape of a tiger,
 cat. 47, photo courtesy Nanjing Museum

Image Credits
Pages xiv–xv, 28: TJ Romero
Pages xviii, 11L, 26, 59, 67, 72, 79, 85–87, 100,
 102, 112, 128–129, 159, 168, 176–178, 181,
 187, 189, 191, 194–195: Courtesy Xuzhou
 Museum
Pages 1–9, 11R, 56–58, 60–62, 64, 66, 68–71,
 73–74, 77–78, 82–83, 90–94, 96–97, 101,
 103–104, 106, 110–111, 113, 118–122, 124–
 126, 130, 131L, 132, 133R, 134, 136, 138–142,
 146, 149–150, 151T, 152–155, 158, 160–163,
 166–167, 169–173, 175, 179–180, 182–186,
 192–193: Courtesy Nanjing Museum
Page 14: Photographed by Wang Xiaotao,
 courtesy Yizheng Museum
Pages 16–21, 22L, 23–24, 50–55, 63, 65, 75–76,
 95, 98–99, 105, 107, 123, 127, 131R, 133L, 135,
 143, 147, 151B, 156–157, 164–165: Dayun
 Mountain Archaeological Team, courtesy
 Nanjing Museum
Page 22R: Courtesy Nanjing Museum Library
 and Information Center
Pages 29, 30L, 33L, 35–36: Photographed
 by Yan Zhongyi. Photograph © Xuzhou
 Museum
Page 30R, 33R: Photographed by Zheng
 Yunfeng. Photograph © Xuzhou Museum
Page 31: Drawn by Li Zhongyi. Diagram
 © Xuzhou Museum
Pages 38, 41L: Photographed by Tianlong
 Jiao
Page 42R: Courtesy Lu Jianfang
Pages 43–44: Courtesy Li Zebin
Pages 80–81, 84, 88–89, 108–109, 114–117,
 137, 144–145, 148, 174, 188, 190: Courtesy
 Yizheng Museum

長樂未央 Everlasting happiness without end
長生無極 Eternal life without limit
長毋相忘 Enduring remembrance without fail

—INSCRIPTIONS ON ARTWORKS IN *TOMB TREASURES*

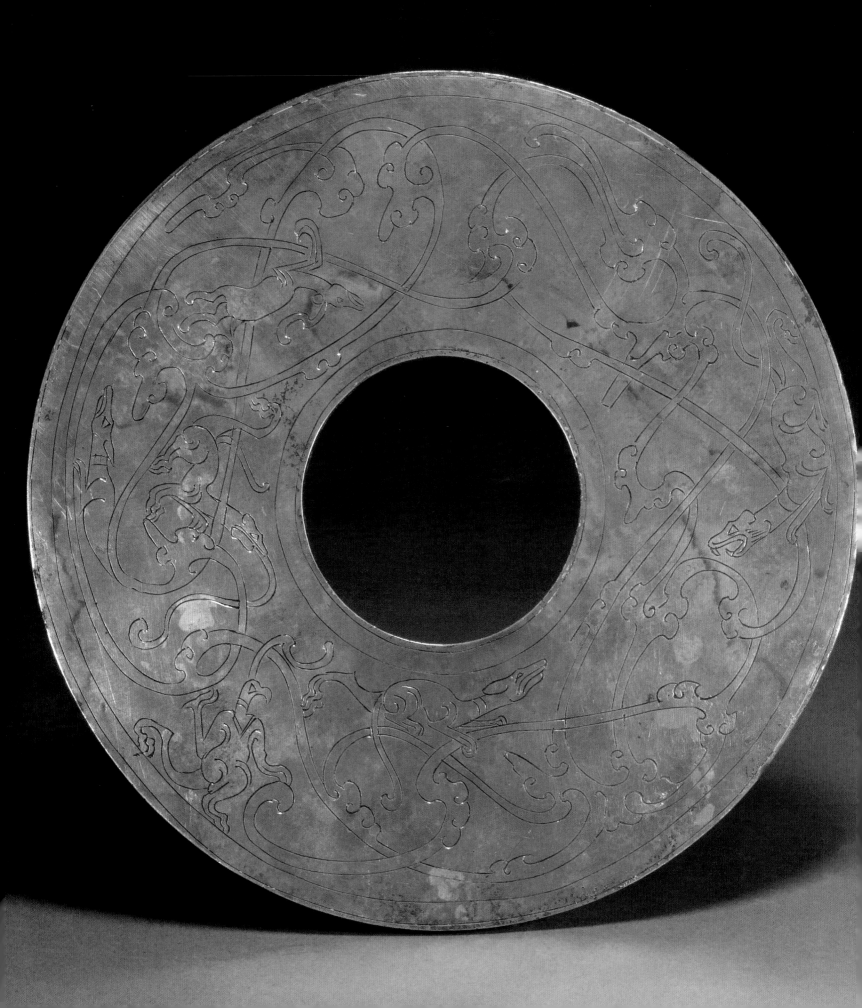

CONTENTS

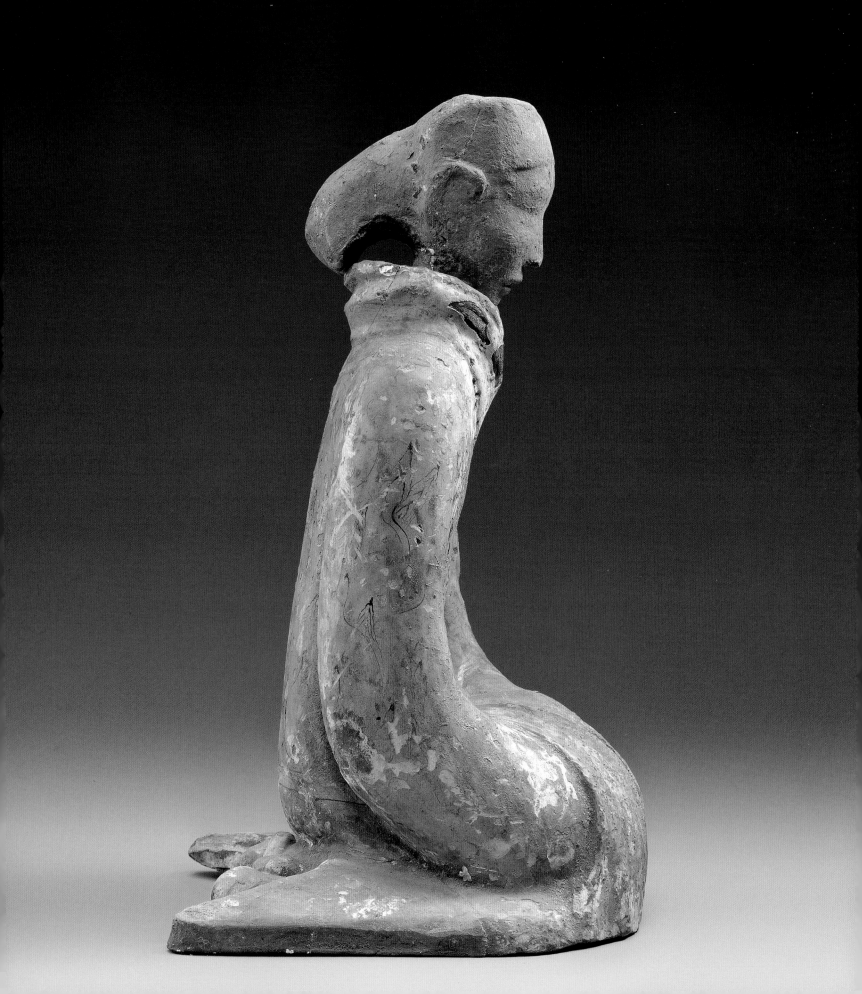

FOREWORD | JAY XU

DURING THE WESTERN HAN PERIOD (206 BCE–9 CE), death was both the end of life and the beginning of the afterlife. In Han royal tombs the deceased are laid out in splendid coffins in underground rooms, far from earthly interventions and cares. Yet the recumbent bodies seem somehow poised for action, as they are surrounded by a variety of beautiful and useful objects. A set of bells is positioned for a performance, a cauldron waits to be filled with food, a mirror looks longingly for someone to reflect, and spears stand ready to defend against the uninvited. These tombs are not simply treasure troves. They assured that the afterlife would be filled with wine, music, dancing, and even sex.

Tomb Treasures: New Discoveries from China's Han Dynasty offers 100 recently unearthed objects that give us a glimpse into the extraordinary wealth and artistic accomplishments of Han elite society. Most are from the mausoleum of King Liu Fei of the Jiangdu kingdom (169–127 BCE) at Dayun Mountain, while others come from mausoleums of the Chu Kingdom and other elite tombs in the Jiangsu region of central coastal China. These treasures were unearthed from recently discovered sites, and most are shown in this publication and its corresponding exhibition for the first time outside China.

These exquisite objects are made of gold, silver, jade, bronze, pottery, lacquer, and other refined materials. Masterworks include a full-length jade suit sewn with gold threads, an oversized coffin shrouded in jade, and a complete set of functional bronze bells. Some objects have no comparable precedents in China. Others come from as far as Persia, testifying to the network of contacts that China had established at the time.

In addition to presenting this collection, this book explores a number of ideas about life and death of Western Han royalty. An important common theme was the pursuit of longevity by all means, both in life and in death—one that still resonates in Chinese society today.

Tomb Treasures thus enables readers to appreciate ancient Chinese civilization and to gain a perspective on contemporary China. This befits the Asian Art Museum of San Francisco. The museum is at the forefront of showcasing the latest discoveries of ancient art, just as it is in presenting recent artworks. New historical research and cutting-edge contemporary art share a commonality—they constantly change our perspective and understanding of history and of the present.

I am grateful to all the people who made this book and exhibition possible. Thanks to Fan Jeremy Zhang, Senior Associate Curator of Chinese Art at the Asian Art Museum of San Francisco, for cocurating this exhibition. His enthusiasm for the project and his keen understanding of its many facets made him the perfect partner in this undertaking. I would like to restate Fan's thanks, as expressed in the acknowledgments in this volume, to staff members of the Asian Art Museum, the Nanjing Museum, the Xuzhou Museum, and the Yizheng Museum for their contributions to this effort. This collaboration depended on

the thoughtful work of these many individuals. In addition, I would like to thank Li Zebin, Li Yinde, and Tianlong Jiao for their insightful essays in this book. Their research and writing bring these tomb treasures to life. Tianlong served as Curator of Chinese Art at the Asian Art Museum from September 2014 to September 2015 before he assumed his present position at the Denver Art Museum. During that year, he carried out foundational work for this project, including developing a preliminary object list, for which I would like to extend my gratitude. Additional appreciation must also be given to Clare Jacobson, Head of Publications at the Asian Art Museum, for her invaluable work on this catalogue. Finally, I express my thanks to all the sponsors whose generous support made *Tomb Treasures* possible: The Bernard Osher Foundation; The Akiko Yamazaki and Jerry Yang Fund for Excellence in Exhibitions and Presentations; Warren Felson and Lucy Sun; Angela and Gwong-Yih Lee; Fred Levin and Nancy Livingston, The Shenson Foundation, in memory of Ben and A. Jess Shenson; Hok Pui Leung and Sally Yu Leung; and Sampson C. and Faye Shen Fund.

Jay Xu
Director, Asian Art Museum of San Francisco

FOREWORD | **GONG LIANG**

THE HAN DYNASTY (206 BCE–220 CE) saw a flourishing of great prosperity and cultural richness. Established after the short-lived Qin dynasty and commonly divided into early (Western Han) and later (Eastern Han) periods, the Han dynasty was ruled by twenty-nine emperors for over 400 years. It was peopled by the descendants of the ancient Huaxia peoples, who gradually joined together and came to be called "Han," from which the Han Chinese people derived their name. The Han dynasty represents the first "golden era" of development in Chinese history, a time when China's diverse ethnic groups experienced relative stability, social development, and harmony.

Confucian principles heavily influenced Han culture and established the foundation on which the distinct characteristics of the nation's grand rituals and customs rest. Concepts of filial piety, the importance of burial, and treating death as an extension of life resonated within the hearts of the populace and were widely followed. The large number of royal mausoleums filled with rich burial artifacts reflect not only the material culture of the time but also the disparity between commoners and royalty.

Xuzhou in Jiangsu province was the home of the Han dynasty's founder, Liu Bang. The area was subsequently divided among Liu Bang's generals and allies as rewards for their aid in establishing the dynasty: Han Xin's kingdom of Chu, the Liu clan's kingdom of Chu, and the kingdoms of Sishui, Jing, Wu, Jiangdu, and Guangling thrived during the Western Han period, and the Eastern Han period witnessed the dominance of the kingdoms of Chu, Pengcheng, Xiapi, Guangling, and more. Today Jiangsu retains city sites, villages, workshops, mining ruins, cemeteries, and other relics from its 2,000-year history.

In recent years the excavation of Jiangsu's vassal king mausoleums has garnered much attention. These include Western Han tombs at Xiaogui, Dongdong, Beidong, Nandong, Woniu, Tuolan, and Shizi Mountains, all large-scale sites carved into mountainsides. These tombs allow us to chart changes in Han society. For example, in early times, couples were buried near each other in separate tombs, while in later times they were buried together in a single tomb. Groups of tombs reveal particularities of their time and place, and individual tombs tell uniquely fascinating stories. The discovery of a silver-threaded jade suit was unearthed from the king of Pengcheng's tomb in Xuzhou's Tu Mountain, and an official gold seal of the king of Guangling was found in the tomb of Liu Shou (reigned 11 BCE–7 CE) and his wife in Hanjiang.

The Asian Art Museum of San Francisco and the Nanjing Museum both attach great importance to Asian art. Jay Xu is among those directors who possess the utmost appreciation of this art. He proposed this project, and with his leadership and more than two years of planning and collaborative efforts at both museums, *Tomb Treasures: New Discoveries from China's Han Dynasty* successfully brings rare and refined artworks from China to a US audience, which makes us deeply happy and honored.

Objects in this exhibition have been excavated from the royal tombs in China's Jiangsu province. Featured in the show are artifacts unearthed from the king of Jiangdu's mausoleum at Dayun Mountain

in Xuyi, where more than 10,000 precious artistic relics were discovered, each uniquely reflecting the economic and social development of the Han dynasty and providing insight into how people at that time sought glory even after death. Many of the works are on display outside China for the first time and possess unique scientific, historical, and artistic value. I sincerely hope the exhibition and its corresponding publication benefit the American public's understanding of life, art, and beliefs in China 2,000 years ago.

Thank you to all those who worked tirelessly on making this project happen. Because of your efforts, we have advanced cultural exchange and progress.

I wish this publication and exhibition every success!

Gong Liang
Director, Nanjing Museum
Deputy Director, Department of Culture, Jiangsu Province
Vice President, Chinese Museums Association

ACKNOWLEDGMENTS | FAN JEREMY ZHANG

IN THE SUMMER OF 2011, I first visited the excavation site of the Dayun Mountain mausoleum, located in Xuyi county near the border of Jiangsu and Anhui provinces. I was immediately stunned by the awesome scale of the burial pits and the tremendous beauty of the objects in this well-preserved mausoleum of the kingdom of Jiangdu. Four years later, I again responded to the call of the fascinating new finds at Dayun Mountain and became involved in *Tomb Treasures*, an exciting collaboration between the Asian Art Museum and the Nanjing Museum. This exhibition features remarkable archaeological finds of two kingdoms that were associated with the Rebellion of the Seven States in 154 BCE, when the imperial throne strived to consolidate its power and tighten its control over the fiefdoms across the empire. This project not only provides a rare opportunity to observe the fascinating material culture of the nobility through the lens of regional kingdoms in Jiangsu during the Western Han period, but also sheds new light on the life and afterlife of the Han dynasty nobility and their vigorous pursuits of pleasure and romance with the hope of eternal joy and immortality.

I am very grateful to the Nanjing Museum for its generous loan of these tomb treasures that make their debut in the United States. In particular, I would like to express gratitude to many of its staff members who provided their support in this multiyear project, including Gong Liang, Wang Qizhi, Wu Heng, Sheng Zhihan, Tian Mingli, Qi Jun, Chen Li, Zuo Jun, and Chen Gang. A special thank-you is due to Li Zebin, chief excavator of the Dayun Mountain mausoleum, who provided us access to and use of unpublished photos and documents from his forthcoming archaeological report. My appreciation extends to Meng Qiang, Yuan Feng, Zong Shizhen, and Yang Li from the Xuzhou Museum, as well as Liu Qing from the Yizheng Museum for their assistance.

I am very fortunate to work with a professional team at the Asian Art Museum that enables the presentation of world-class exhibitions of Asian art at an amazing pace. The successful realization of this exhibition depends heavily on the participation of all staff members of the museum. I would particularly like to acknowledge my colleagues Sharon Steckline, Kathy Gillis, and Lorraine Goodwin, who traveled with me under the hottest sun of summer 2016 to survey loans at different museums and gather educational material on tomb sites. I am indebted to He Li and Jamie Chu of the Chinese Department, who helped relieve pressure of the heavy workload. My gratitude goes to Robert Mintz, Kim Bush Tomio, Laura Allen, Shannon Stecher, Claire Yi Yang, Ruth Keffer, John Stucky, Marco Centin, Chris Busch, and the entire preparation team for their numerous contributions to this exhibition and publication. Additional appreciation extends to many other colleagues for supporting the didactic and marketing contents of the exhibition. Thanks to people outside the museum who helped in producing this book, especially to Amanda Freymann, Joan Sommers, and Tom Fredrickson. Finally, my expression of gratitude goes to Director Jay Xu of the Asian Art Museum, who entrusted me with cocurating this important exhibition.

Fan Jeremy Zhang
Senior Associate Curator of Chinese Art, Asian Art Museum of San Francisco

MAPS OF TOMBS OF THE WESTERN HAN PERIOD

Featured burial sites in Jiangsu province

Location of Jiangsu province within China

Dayun Mountain ▲

XUYI COUNTY

20 km

Daqingdun ▲

20 km

SIYANG COUNTY

Chenji yangzhuang cun
zhan zhuangzu
▲

Lianying
▲▲
Tuan Mountain

▲ Yandai Mountain

Huzhuang
▲

20 km

YIZHENG COUNTY

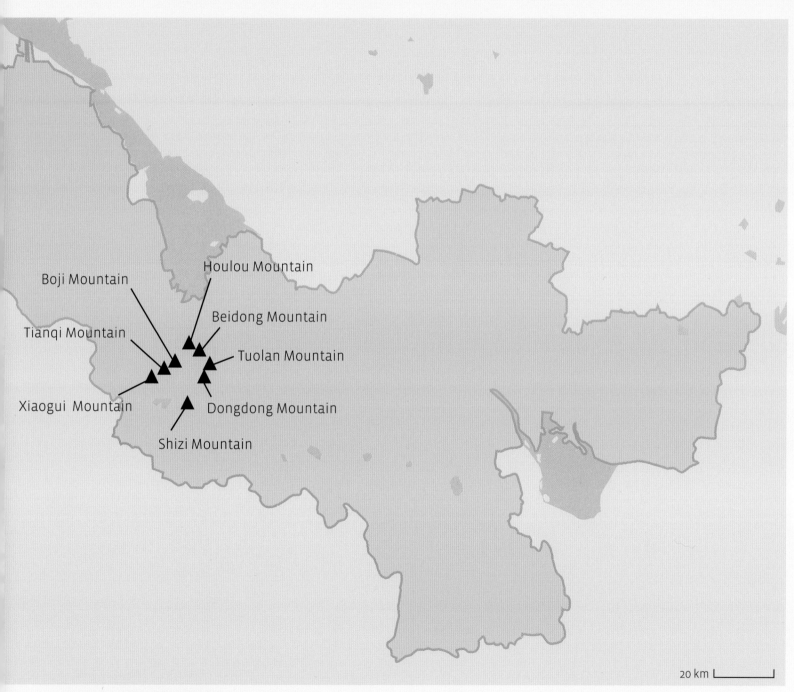

Boji Mountain

Houlou Mountain

Tianqi Mountain

Beidong Mountain

Tuolan Mountain

Xiaogui Mountain

Dongdong Mountain

Shizi Mountain

20 km

XUZHOU PREFECTURE

CHRONOLOGY OF THE WESTERN HAN PERIOD

WESTERN HAN EMPERORS

NAME	POSTHUMOUS NAME	REIGN DATES
Liu Bang	Emperor Gaozu	202–195 BCE
Liu Ying	Emperor Hui	195–188 BCE
	Empress Lü	188–180 BCE[1]
Liu Heng	Emperor Wen	180–157 BCE
Liu Qi	Emperor Jing	157–141 BCE
Liu Che	Emperor Wu	141–87 BCE
Liu Fuling	Emperor Zhao	87–74 BCE
Liu He		74 BCE (reigned for twenty-seven days)
Liu Bingyi	Emperor Xuan	74–49 BCE
Liu Shi	Emperor Yuan	49–33 BCE
Liu Ao	Emperor Cheng	33–7 BCE
Liu Xin	Emperor Ai	7–1 BCE
Liu Jizi	Emperor Ping	1–6 CE
Liu Ying[2]		

WESTERN HAN VASSAL KINGDOMS AND KINGS

NAME	POSTHUMOUS NAME	REIGN DATES	GENERATION
KINGDOM OF CHU			
Han Xin		202–201 BCE	
Liu Jiao	King Yuan	201–179 BCE	1
Liu Yingke	King Yi	179–175 BCE	2
Liu Wu		175–154 BCE	3
Liu Li	King Wen	154–150 BCE	4
Liu Dao	King An	150–128 BCE	5
Liu Zhu	King Xiang	128–116 BCE	6
Liu Chun	King Jie	116–100 BCE	7
Liu Yanshou		100–68 BCE	8
Liu Xiao	King Xiao	50–25 BCE	9
Liu Fang	King Huai	25–23 BCE	10
Liu Yan	King Si	23–3 BCE	11
Liu Yu		3 BCE–8 CE	12

NAME	POSTHUMOUS NAME	REIGN DATES	GENERATION
KINGDOM OF JING			
Liu Jia		201–196 BCE	1
KINGDOM OF WU			
Liu Pi		195–154 BCE	1
KINGDOM OF JIANGDU			
Liu Fei	King Yi	153–127 BCE	1
Liu Jian		127–121 BCE	2
KINGDOM OF GUANGLING			
Liu Xu	King Li	117–54 BCE	1
Liu Ba[3]	King Xiao	47–35 BCE	2
Liu Yi	King Gong	34–31 BCE	3
Liu Hu	King Ai	31–17 BCE	4
Liu Shou	King Jing	11 BCE–7 CE	5
Liu Hong		7–8 CE	6
KINGDOM OF SISHUI			
Liu Shang	King Si	113–104 BCE	1
Liu Anshi	King Ai	103–102 BCE	2
Liu He	King Dai	102–81 BCE	3
Liu Xuan	King Qin	80–41 BCE	4
Liu Jun	King Li	41–11 BCE	5
Liu Jing		10–8 BCE	6

[1] Two infants held the title of emperor during this period, which was dominated by the Empress Lü.

[2] Liu Ying was named heir apparent in 6 CE, during the regency of Wang Mang, who held the title of acting emperor. Liu was demoted upon the accession of Wang Mang as emperor of Xin in 9 CE.

[3] The tenure of the kingdom lapsed in 54 BCE, but it was restored in 47 BCE when Liu Ba was appointed king.

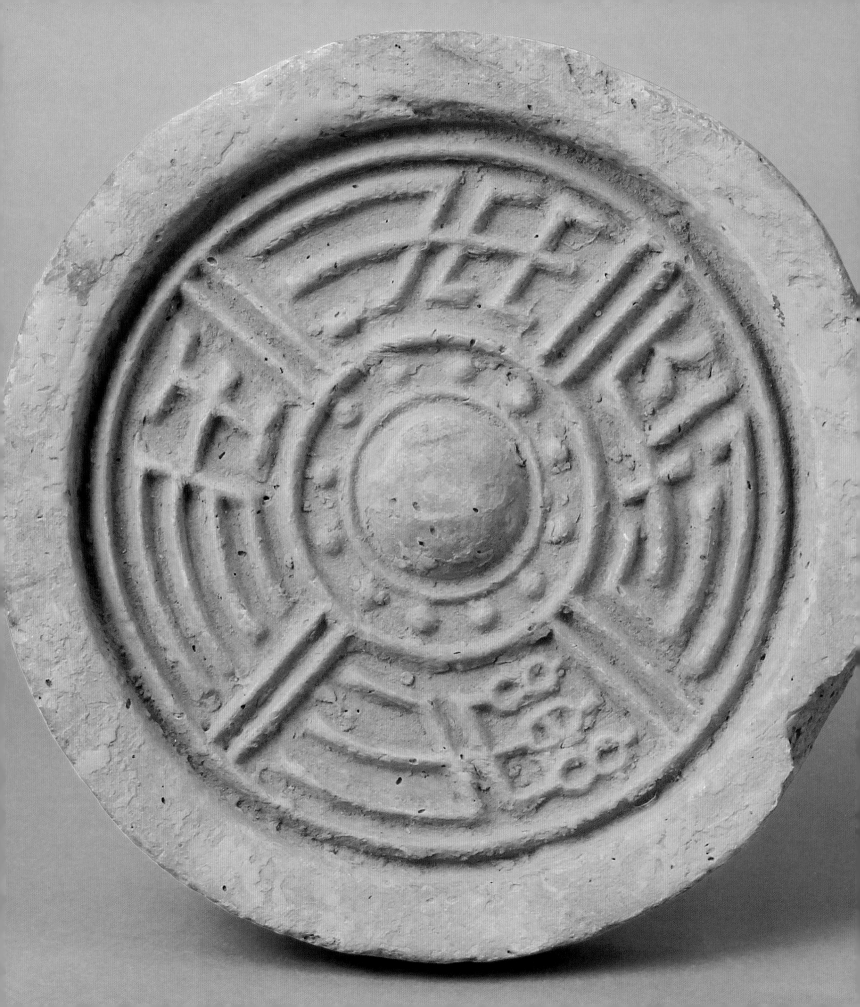

ONE | JAY XU

Everlasting Happiness without End: Life and Death for Western Han Royalty

COMMANDING A VAST UNIFIED EMPIRE for 400 years, the Han dynasty (206 BCE–220 CE) was an economic, military, and cultural superpower whose strength and splendor saw few rivals in the world then or since.[1] The political institutions developed during this period established the foundation and prototypes for later dynasties throughout the imperial period, even extending to the republics of modern times. The Han produced brilliant art and material culture, instituting fundamental values for what Chinese civilization means and exerting far-reaching influence throughout East Asia. To this day, the vast majority of Chinese call themselves Han Chinese. No other period in the history of China enjoys similar significance.

In traditional historiography, the Han dynasty is divided into two periods: the Former Han (206 BCE–9 CE) and the Latter Han (25–220 CE), separated by an interregnum of a short-lived dynasty established by a Han imperial regent. The two periods are also known as the Western Han and the Eastern Han, respectively, based on the location of their capitals: Chang'an, in northwestern China, was the capital of the former, while Luoyang, the capital of the latter, was to the east, in central China. Recent scholarship more commonly uses these two terms.

This publication presents extraordinary artifacts consumed by Han royalty during the Western Han period and focuses on the present-day Jiangsu region along China's eastern seaboard, where archaeological excavations of royal mausoleums and other elite tombs in recent decades have yielded unprecedented finds. These discoveries allow us to gain a rich understanding of the elite art and material culture of the Han and offer a glimpse into the life—and death—of the royalty that ruled that region (see the maps of Western Han tombs on pages xiv–xv).

FROM KINGDOM TO EMPIRE: HISTORICAL AND CULTURAL BACKGROUND

Sweeping transitions and striking contradictions marked the era immediately preceding the time when China first became a unified empire.[2] Called the Warring States period (approx. 480–221 BCE), this age was notable for wars of conquest and annexation among feudal states under the nominal rule of the king of the Zhou dynasty. Often bloody but rarely economically crippling, these wars actually stimulated the

Roof tile, **CAT. 99**, with the inscription
長樂未央 (*Chang le wei yang*), "Everlasting happiness without end"

movement of people and communication throughout the region. As the traditional aristocracy started to crumble, the power of petty gentries and a merchant class grew. The use of cast iron made warfare more lethal and improved agricultural productivity. The period is renowned for its brilliant intellectual achievements, characterized by the flowering of competing schools of thought that provided philosophical guidance and influenced political strategy. In this time of great uncertainty, worldly pleasures and affluence were pursued with unabashed enthusiasm, and luxury objects in metal and other mediums were produced in great numbers.

Of all the competing powers, the Qin—a peripheral state that originated in the northwestern part of China in what is now Shaanxi province—eventually triumphed in 221 BCE. (Many of the defeated states were culturally more sophisticated than the Qin, including the mighty Chu, which had ruled over a huge territory in South Central China.) Having realized his ambition of unifying the country, the new ruler called himself the First Emperor of Qin and aspired to found a dynasty that would last forever. After a mere fifteen years, however, the empire collapsed, owing to rebellions caused by, among other factors, the emperor's excessive exploitation and harsh treatment of his subjects. In 206 BCE a new ruler, Liu Bang (reigned 202–195 BCE)—a commoner from the former state of Chu—ascended to the throne after defeating the Qin and various rival rebels. The new imperial house called itself Han after the region in southern Shaanxi where Liu Bang first ruled as a vassal king, but he soon established his seat of power in Chang'an, where the Qin capital had been. The mausoleum for the First Emperor of Qin, with its famous terra-cotta warriors, is situated just twenty kilometers to the east of Chang'an.

Though short lived, the Qin dynasty nevertheless quickened the pace of fundamental change that had begun in the Warring States period. In Chinese historiography, the Qin and the Han are often treated as one common era. Among the seminal developments that followed unification in 221 BCE was the establishment of a centralized government staffed by a bureaucracy that successfully managed the large country. Private ownership of land became widespread, and the opening of new territories and advances in technology led to an agricultural boom. Economic activity in other areas thrived as well, including the production of salt, iron, and various crafts, which were often undertaken on an industrial scale. Diverse systems of writing, weights and measures, and gauges of wagon wheels that had existed in various regions were standardized, greatly facilitating transportation, administration, military action, communication, and trade within the empire.

The Qin and Han governments sustained large, robust armies that conquered territory including much of the land in the south of China and defended its northern borders against marauding nomads from the steppes. The building of the Great Wall began around the time of unification to defend this northern frontier, an objective that continued to preoccupy the Han army. To develop allies and foster trade, the Han launched diplomatic missions and military expeditions to open routes leading from the capital Chang'an westward to Central Asia. These heavily traveled routes came to be called the Silk Road in modern times, after the commodity for which China was best known.[3] In fact, a variety of products, including Central Asian horses legendary for their power and beauty and other exotic animals and plants, moved across those and other routes as China sought trade with many foreign lands.

The expansion of agriculture, industry, and trade propelled the Han empire to unprecedented prosperity and influence, rivaling those of the Roman Empire.[4] Indeed, silk was traded—via merchants in Central Asia and the Near East—as far away as Rome, where it quickly became very popular, though the

two powers probably never established direct contact. In addition to silk, elegant and superbly crafted luxury items in jade, bronze, and lacquer catered to the secular and religious needs of wealthy patrons within China and beyond. Bronzes cast by traditional means were sometimes embellished with gilding or silvering and inlays of gold, silver, and precious stones or glass—artistic innovations that had emerged in the Warring States period. Lacquerwares often featured intricate designs painted in strong, contrasting colors. Decorative themes of foreign origin were commonly incorporated into these works, a popular example being animals engaged in combat, a motif introduced from the steppes to the north of China (see CAT. 70).

The Qin–Han period saw the consolidation of intellectual developments that emerged following the Warring States period. After unification, the Qin had severely curtailed intellectual freedom to suppress resistance to the emperor's tyranny. The Han were much more lenient but eventually established Confucianism as the orthodox political philosophy of the state, combining traditional thoughts of Confucius and his disciples with more recently articulated principles regarding the nature of change. Han Confucianism maintained that the cosmos consists of three estates—heaven, earth, and man—that operate through phases of change driven by the primal forces of yin and yang. The system attached great importance to the moral behavior of man, for actions in the human world had reciprocal reactions in the other two estates—heaven, the origin and authority of all things, and earth, which nourishes them.

While Han Confucianism constituted a quasi religion, religious practices since the Warring States period had featured a plethora of natural deities and spirits as well as abstract ideals (such as heaven) derived from them. One theme common to the rich mélange of philosophical thought and regional religious practice was the interrelationship of life and death. As attested by inscriptions on ritual bronzes, *shou* (longevity) had been the most sought-after blessing in prayers as early as the eighth century BCE. Associated with the ideal of longevity is the virtue of *xiao* (filial piety) and the great importance of family. The two main palaces in the imperial court at Chang'an were named Changle (Everlasting Happiness) and Weiyang (Without End), and such wishes were enthusiastically carried forward into the afterlife, as demonstrated by royal tombs across China. Various ways to prolong life were ardently pursued and cultivated, eventually leading to a widespread cult of immortality in the Qin–Han period. Notions of immortality ranged from a deathless physical state to metamorphosis into a celestial being living in magic mountains or in the paradise of heaven among deities.

At that time, people thought it possible, if difficult, to attain eternal life, and legends offered many examples of immortals. That is why many in ancient China, including the emperor, did not see death as the end of existence and ardently pursued immortality. Death was merely an initiation into the afterlife, a belief whose basic principles had remained constant since at least the early Bronze Age in the second millennium BCE. According to these tenets, the deceased required means of subsistence similar to those of the living, such as housing and nourishment. The tomb was considered the primary, if not the only, residence of the deceased, and some spiritual force must have existed to compensate for the lack of mobility of the deceased's body. Sometime shortly before the Warring States period such spiritual forces began to be called *hun* and *po* (souls). The deceased were perceived as having power to influence worldly affairs through their blessings or malevolent actions, depending on the treatment they received from the living. The dead would also intercede in matters relating to other spiritual forces. The afterlife was understood to be structured in the same manner as the society of the living, with

corresponding social relationships and hierarchies. The world of deities and spirits also mirrored the organization of the human world. Out of these ideas developed the most enduring of China's cults: ancestor worship, which served as the basis of the Chinese approach to the spiritual world. When prayers for longevity began to appear in bronze inscriptions, they were most often addressed to ancestors and only sometimes to heaven, perhaps because the request was a more personal, familial matter.

This emphasis on longevity and the significance of ancestors naturally extended to the afterlife. In Han times, tombs—called *shouzang* (havens of longevity), with imperial tombs designated as *shouling* (mausoleums of longevity)—were constructed during a person's lifetime to help enhance his or her longevity in both worlds. The tomb's intended occupant and those who would survive him or her collaborated to furnish the tomb with all imaginable provisions. For the survivors, these efforts continued through the funeral and burial and ensuing obligations to maintain the tomb and make sacrificial offerings. They were motivated not only by their natural love and respect for the deceased but also by the desire to secure his or her blessing—and the fear that malevolent acts might be inflicted by the departed. Further, a well-appointed afterlife was commonly recognized as a mark of filial piety—a virtue of great importance in ancient Chinese society, particularly in Han times, when family ties were increasingly emphasized.

It is therefore not surprising that tombs from the Warring States period to the Han dynasty were often richly, even lavishly, furnished. Vast sums were expended on such undertakings, sometimes testing the solvency of a family or even the whole country. From time to time leading intellectuals at the Han court criticized the fashion for extravagant burials, pointing out their ruinous effects on the welfare of the living. Yet these condemnations only underscored the prevalence of the practice, not least by the imperial family and its relatives enfeoffed as royal kings.

FEUDAL KINGDOMS IN THE JIANGSU REGION

Before the Qin unification, China was ruled by a network of feudal states under token allegiance to a king. This custom was first established in the eleventh century BCE by the Zhou dynasty, which enfeoffed a large number of royal family members and allies from other clans as vassals in different parts of the land to ensure effective governance and defense of the kingdom. A long process of consolidation and annexation marked the history of this 800-year period, with the number of feudal states gradually decreasing as the power of the Zhou royal house over those states diminished. Qin was one of the last seven states. Each had enormous territories, but all fell to Qin's war machine.

Upon unification, the Qin abolished the system of feudal states and replaced it with a centralized government that oversaw regional administrative units staffed by appointed bureaucrats. This new arrangement become the foundation for the political system that endures in China to this day, but it was a drastic change that the Qin probably implemented too hastily. The Han dynasty later cited the lack of regional vassals, which served as buffers for the central government in times of crisis, as a major factor in the demise of the Qin. The Han, therefore, adopted a hybrid system of governance: the land around the capital in the western part of China was composed of regional administrative units under the direct rule of the central government and the emperor, while the vast lands to the east were divided into vassal kingdoms bestowed upon generals and allies who had helped defeat the Qin but were not members of

the imperial family. This approach helped stabilized the new dynasty, which nonetheless constantly teetered on the verge of collapse owing to the mistrust the emperor and the feudal kings felt for each other. Over the next eighty years, the Han emperors and their courts gradually reduced the power of the vassal kings. First, they eliminated every king (but one) unrelated to the emperor and installed in their stead members of the imperial family. Later, they diminished the power and land of those blood relations by stripping away their autonomy and subdividing their territories. As a result, the vassal kings might have enjoyed a great deal of wealth but exercised little political power, with their regions governed in their name by bureaucrats dispatched by the central government. Unsurprisingly, this process was marked by rebellions and bloodshed, but it ensured a long-lasting dynasty.

The founding emperor of the Han dynasty, Liu Bang, hailed from what is now Jiangsu province along China's east coast, one of the richest regions in the empire. Agriculture was highly developed there thanks to the widespread use of irrigation, iron tools, and buffalo for plowing. Resources such as sea salt and metals were abundant, and iron smelting, bronze-coin casting, and salt production became particularly lucrative business. These were practiced as private enterprises by local kings, elites, and merchants in the early Western Han period and resulted in tremendous riches. The region naturally became a privileged center of wealth and culture and was home to a number of kingdoms. Some kingdoms existed for only a short time because they rebelled against the emperor and were abolished or otherwise fell from imperial grace, while others survived throughout the Western Han period. The fates of the kingdoms of Chu (named for the state of Chu of the Warring States period) and Jiangdu (the focus of this publication) form a striking contrast.

The kingdom of Chu was established in 202 BCE by Liu Bang for his most successful general—who became the first vassal king to be eliminated just one year later. Liu Bang then enfeoffed his younger brother Liu Jiao (d. 179 BCE) as the king of Chu, attesting to the prominence of that kingdom. Despite occasional rebellions, the kingdom of Chu was ruled by twelve successive kings throughout the Western Han period.

The kingdom of Jiangdu, established in 153 BCE, had a completely different destiny. Its first king was Liu Fei (reigned 153–127 BCE), a great-grandson of Liu Bang and son of the reigning emperor. Liu Fei had distinguished himself at the age of fifteen with his valor and prowess in the imperial campaign to quell a rebellion led by an uncle of the emperor in alliance with the kings of six other kingdoms, including Chu. Liu Fei therefore earned the enfeoffment of a large and rich kingdom, Jiangdu, where he reigned for twenty-six years in prosperity and relative peace until his death. The famous thinker and statesman Dong Zhongshu (179–104 BCE), who was responsible for the establishment of orthodox Han Confucianism, served at his court as prime minister for ten years. Liu Fei's kingdom proved to be a short-lived one, however. In 121 BCE his son, who had succeeded him as the second king of Jiangdu, committed suicide after a failed revolt, and the kingdom was abolished.

Our knowledge of these kingdoms has been greatly enriched by recent archaeological discoveries. Since 1984, eighteen tombs of the kings of Chu and their consorts have been excavated, yielding a spectacular wealth of artifacts.[5] In 2009 the mausoleum for Liu Fei was discovered at Dayun Mountain. This 250,000-square-meter compound included the king's tomb; the tombs of his two queens; auxiliary tombs for consorts; pits containing horses, chariots, and armor; and the remains of architectural

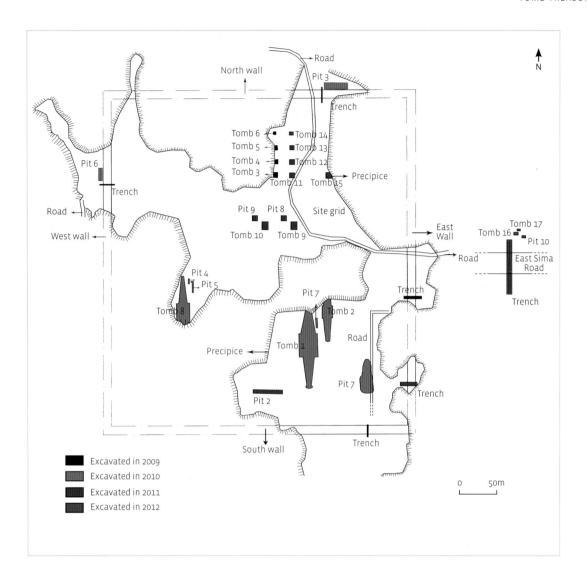

elements (FIG. 1.1). The excavation at this site continues today, and more than 10,000 objects have been
unearthed so far.[6]

UNDERGROUND PALACES ON HIGH HILLS: ROYAL MAUSOLEUMS IN JIANGSU

According to burial customs dating back to the Warring States period, tombs emulated the residences of
the living. The traditional tomb form consisted of a vertical shaft; at the bottom of this shaft stood a
rectangular burial chamber constructed of timbers and usually divided into main and auxiliary rooms.
The main chamber, containing the body of the deceased, represented the bedroom, and the auxiliary
chambers denoted other domestic functions. Beginning in the middle Western Han period (about the
time of Liu Fei's death in 127 BCE), a new tomb form emerged in elite burials: networks of caves dug
laterally into hillsides contained large-scale burial compounds more closely emulating the palatial

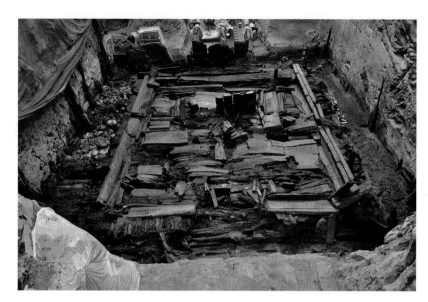

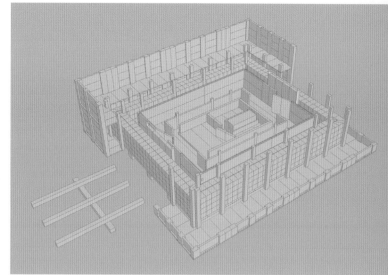

1.2 (left) Burial chamber of Liu Fei's tomb

1.3 (right) Reconstruction of Liu Fei's burial chamber

homes of the living. Sometimes entire buildings made of timbers and roofed with tiles were erected within these caves.

The tomb of Liu Fei adhered to the traditional form: a huge rectangular shaft dug into the ground and accessed by long sloping ramps (FIG. 2.6). We know from archaeological records that such access ramps were found exclusively in the tombs of high nobles in Bronze-Age China (the second half of the second millennium BCE). The adherence to tradition conveyed by Liu Fei's tomb contrasts with the tombs of the Chu kings, which exemplified the new custom of tunneling into hillsides.

The Chinese word for mausoleum, *ling*, means "earth hill," indicating the importance of height in this context. The mausoleum of Liu Fei and those of the kings of Chu were built on top of individual hills with commanding views. According to the convention of the time, a huge earthen mound was constructed on top of Liu Fei's tomb, adding further height and prominence to his burial place. Similar mounds were built on top of the hills that entombed the Chu kings.

The idea of the mausoleum as an underground home or palace was clearly expressed in the architecture of the tombs and their furnishings. Liu Fei's burial chamber consisted of a two-story outer veranda surrounding the burial chamber (FIGS. 1.2 and 1.3). The south-facing front had a large door with bronze door handles (CAT. 1). The upper level of the veranda contained more than twenty model war chariots equipped with functioning weapons, such as iron swords, halberds, knives, crossbows, and arrowheads, as well as other artifacts. The lower level was divided into several areas whose function was indicated by the objects they contained, such as a music room, a stable, a bathroom, a kitchen, and a treasury. A thick wall of timbers demarcated the outer veranda from the more private parts of the underground home: an antechamber, a middle veranda, an inner veranda, and a central burial chamber containing two nested coffins. A rich variety of goods in bronze, jade, lacquer, and other materials filled these chambers.

The structure of Liu Fei's tomb was fairly typical of royal tombs of the vertical-shaft type. By contrast, the tombs of the Chu kings expressed in a more linear manner the progression from the exterior public sphere to an interior, private realm. Take, for example, the tomb at Beidong Mountain of a king who died in 129 BCE, shortly before King Liu Fei (FIG. 3.6). One enters the tomb via an access pathway at the end of which stands a gate flanked by two guard towers, just as in a real palatial compound. Beyond the gate, storage niches or chambers are set on either side of the passage. The path continues until it reaches the main entrance of the tomb, beyond which the passageway becomes narrower and leads to an antechamber. A narrow corridor at one side of the antechamber leads discreetly to two toilets with bowls dug into the ground. Directly behind the antechamber lies the main chamber of the tomb, which contained the coffins of the king.

The tomb at Beidong Mountain includes a lower auxiliary compound that is located outside the main gate and is connected to the tomb's main pathway via a staircase. This auxiliary compound consists of four connected rooms. The first holds an armory and space for storage. The second includes a toilet, a bath, a closet, and a chamber for music and dance as indicated by the presence of figurines of dancers and musicians, a bell set, and stone chimes. The third represents a courtyard with a well for water, a kitchen, firewood storage, and a toilet. The innermost room contains another kitchen, a grain mill, and a cellar like those used as cooling chambers during summer. In this way, the royal tomb at Beidong Mountain vividly transferred a living palace into the netherworld.

FURNISHING THE AFTERLIFE: ARTIFACTS FROM THE SECULAR WORLD

In the Warring States and Qin–Han periods, functional implements belonging to and used by the deceased appeared in tombs along with *mingqi*—artifacts made specifically for burial. This publication features both types of articles, with the former accounting for the majority of objects. These practical items, interred to continue their service in the afterlife, offer a vivid portrait of the luxurious style and ritual practices of the time. Among the most basic were bronze coins, which granted the deceased a financial endowment in the afterlife. The tomb of the king of Chu at Beidong Mountain, for example, contained 52,640 bronze coins (CAT. 2) weighing 207 kilograms. In addition, a mold for casting coins was included among the burial goods, ensuring that money would never run out. Another royal tomb of Chu yielded an even more impressive number of coins: more than 170,000.

Prominent among the funerary goods were musical instruments. Music had long been an essential part of ritual life in elite society and was believed to possess the power to nourish righteous thought and action. Sets of bronze bells and stone chimes formed the centerpiece of courtly music ensembles and served as symbols of prestige and culture. The bell set from Liu Fei's tomb features nineteen bells of graduated size arranged in two tiers (CAT. 3). The bells are hung on two lacquered wooden crossbeams secured by vertical poles made of silvered and gilt bronze that rest on the backs of animal-shaped bronze stands. The crossbeams are painted with a cloud pattern, with the top beam further embellished with gilt openwork encasing three silver *bi* disks; the openwork on each end presents a dragon in profile, while the central openwork resembles rising clouds. Musicians were able to play sophisticated scales on these bells as each was capable of producing two tones depending on where it was struck. This is the most impressive Western Han bell set yet discovered.

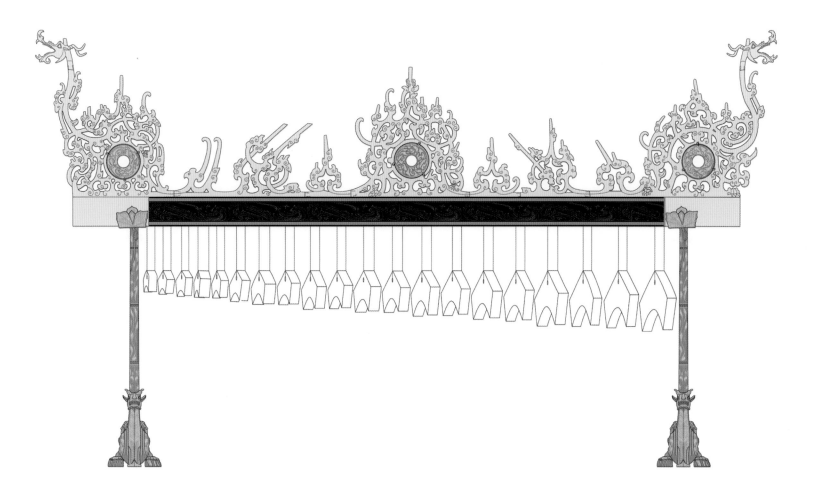

1.4 Drawing of the glass chimes from Liu Fei's tomb

An even more extraordinary find from Liu Fei's tomb are the chimes made of glass instead of the more common stone (FIG. 1.4). These are, in fact, the first Han-period glass chimes to appear in the archaeological record. Regrettably, the glass has corroded badly, but the silver-inlaid bronze stands have survived well (CAT. 4); these take the form of winged beasts that are far more fantastical than the stands for the bell set, while the decorative schemes on top of the wooden crossbeams of both instruments are similar.

Clay figurines buried in tombs—lively and graceful dancers wearing dramatic costumes with long sleeves (CATS. 5 and 6) and musicians, their instruments now lost (CAT. 7)—give us a sense of the range of entertainment presented at the royal court. Evidence of less-refined fare, in the form of comedians—perhaps dwarfs—with comical facial expressions can also be found in tombs; such entertainments were likely staged at private occasions for the king and his entourage, which certainly would have included court ladies such as the one represented by the figurine whose elaborate garments were meticulously painted in colors resembling silks (CAT. 9).

Such private pastimes were but one facet of royal life in ancient China. By the Western Han period it was understood that "the great affairs of a state are sacrifices and war."[7] Sacrifices were long-standing practices of ancestor worship that typically involved offerings of food and the performance of formal

music. The emphasis on war reflected developments that arose during the Warring States period as battles became larger in scale and weaponry and tactics more advanced and destructive. Given the conflicts that plagued the early Western Han period, it is not surprising to see a large number of weapons buried in royal tombs. These included many types that had been in use, with continuing modification, for a millennium, such as halberds (CATS. 10–12), spears (CATS. 13–14), and scabbards (CAT. 15). A more recent invention was also present: the crossbow, which was capable of shooting quarrels over a long distance. A volley of bolts shot by a group of crossbow archers to rain down on enemy troops was probably the most lethal means of attack or defense in large-scale warfare. It undoubtedly contributed to China's unification by the Qin army, which proved the best armed and organized at the time. A fine example of a crossbow trigger mechanism, decorated with a tiny bird-hunting scene in gold and silver inlay, is included here (CAT. 16).

Along with these functioning weapons, royal tombs contained ceremonial objects, such as the clay figures of foot soldiers, archers, charioteers, and cavalrymen (CATS. 18–21). The warriors in cat. 20 wear headgear that resembles the iron helmets worn by real soldiers (FIG. 1.5). Both actual and model chariots as well as fittings for horses and chariots were included among burial goods (CATS. 22–27; FIG. 1.6). Often made of gilt bronze or silver and inlaid with gems, these fittings adorned the royal transport in battle or on other important occasions. The presence in the tomb of these real and symbolic military figures and implements was obviously intended to protect the king in the afterlife.

Royal tombs were well stocked with all the utensils necessary for a luxurious afterlife. These ranged from vessels for food and drink made of bronze, silver, lacquer, jade, and ceramic (CATS. 28–43) to various household items such as furniture (CATS. 44–45; FIG. 1.7), weights for securing seating mats (in Han times people sat on mats placed directly on the ground or on low daises; CATS. 8, 46–48), and incense burners and lamps (CATS. 49–53). Lamp types included those with open stands (some, such as CAT. 49, displaying the notable skill of Chinese artisans); those supporting multiple candles (CAT. 50); and more advanced types featuring ingenious details. One lamp found in the tomb of Liu Fei includes a cylindrical midsection composed of two semicircular shields into which a candle was placed (CAT. 51). The shields were designed to slide freely and thus control the direction light was projected. The lid of the lamp is connected to two curved tubes designed to direct the flow of smoke and soot to the base below, which was probably filled with water and served as an absorbing reservoir—a clever invention that highlights the cleanliness prized by the Han.

More intimate items ensured the comfort, hygiene, and pleasure of the deceased. A nearly complete set of bathing implements was interred in Liu Fei's tomb, including a bath stone used for scrubbing skin, basins, and pouring vessels (CATS. 54–59). Ceramic urinals (CAT. 60) were also standard items, testifying to the meticulous attention paid to daily needs in the afterlife. Perhaps the most intimate tomb objects were bronze phalluses (CATS. 61–62). Hollow and highly polished within and without and designed with holes so they could be strapped to the body, such phalluses were clearly meant to be utilized, likely to enhance a male user's potency and possibly for use between women.

Tombs were generously provisioned with clothing accessories such as belt hooks and belt buckles (CATS. 63–70). One particularly noteworthy example is a tiny silver belt hook excavated from the tomb of a female consort in Liu Fei's mausoleum (CAT. 67). It consists of two pieces—one convex and one concave and each bearing the auspicious four-character inscription "Forget me not"—that fit together perfectly

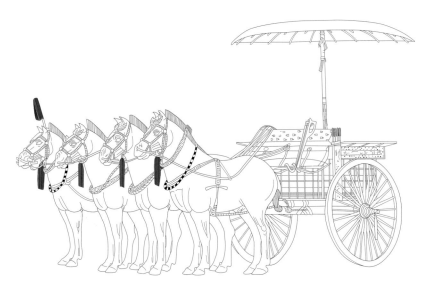

1.5 Reconstruction of iron
headgear from Chu royal tomb at
Shizi Mountain

1.6 Drawing of a royal chariot

1.7 Reconstruction of a lacquer
table with dragon-shaped gilt
bronze feet

and literally become one. Similar inscriptions appear on bronze mirrors of the time, sometimes together with the popular axiom "Everlasting happiness without end" (CATS. 71–73).

In contrast to the traditional belt hooks, belt buckles functioned like their modern equivalents, a design imported from nomadic regions. This connection is explicit in the decorative themes on these accessories, which are typical of the steppes north of China. One shows a bear and a large cat ferociously attacking a horse (CAT. 70). Another gold ornament prominently features ram horns, a popular motif in nomadic tradition (CAT. 76). The influence of foreign cultures can also be seen in a silver basin (CAT. 75) with tear-shaped lobes worked in high relief. This design can be traced to Western Asia, where it was seen on gold and silver libation bowls of the Achaemenid court no later than the sixth century BCE.[8] The connections with other parts of Asia evident in these works testify to the busy traffic across trade routes and suggest that artifacts of exotic origin were a widespread fascination among the Han elite. By contrast, Liu Fei was extraordinary for his interest in antiquities. Several objects from his tomb clearly date from earlier periods (CATS. 76–79). Perhaps he was an antique collector.

Mingqi, artifacts made specifically for burial, were usually created in clay and sometimes in wood. They range from imitations of utilitarian implements (CATS. 31 and 43) and musical instruments to models of humans (CATS. 5–9, 18–21), animals, and physical environments of the royal courts. (In this sense, the tomb itself was a *mingqi*.) Such models offer us an in-depth look at the interests, concerns, and aesthetic values of the time as well as many aspects of life that would otherwise have been lost to us.

These funerary copies embody several interesting contradictions. By replicating in clay and wood objects usually fashioned from more expensive materials, such as bronze and lacquer, *mingqi* made it possible for people of lesser means to achieve (symbolically, at least) a more luxurious afterlife than they otherwise would. Indeed, such utensils are present in many modest tombs. Yet their prevalence in the tombs of the rich and powerful suggests *mingqi* had other uses and meanings. Certainly, as totems replacing actual implements and the sacrifice of humans or animals, they evinced a pragmatic attitude toward the afterlife—a life lived through symbols as well as actual implements. More importantly perhaps, the notion of creating such symbolic objects allowed for the unlimited transfer of worldly goods into the afterlife, thus ensuring the well-being of the deceased.

The development of *mingqi* charted a gradual shift from real to symbolic funerary goods in burial customs. Pottery *mingqi* utensils had appeared long before the Warring States period, but they existed alongside their utilitarian originals. From the Warring States period through the middle Western Han period, luxury objects, such as those seen in this publication, dominated in the tombs of high nobles. After the middle Western Han period, however, use of ceramic *mingqi* eclipsed the presence of functional objects. In the late Western Han and throughout the Eastern Han, burial goods came to consist mostly of pottery implements and models, with architectural replicas becoming particularly elaborate toward the end of the period.

Human figurines first appeared in tombs sometime before the Warring States period, and they were common in Han tombs. Many were colorfully painted to take on a lifelike appearance (CATS. 5–9, 18–21) and provided the deceased with an entire staff to sustain a luxurious lifestyle. In this way, the development of *mingqi* corresponded with changes in tomb construction during the same period: both attempted to replicate for the afterlife the comforts of this world. Tombs in north China, including those

of the Qin dynasty, usually contained pottery figurines, while tombs of the kingdom of Chu in the south were furnished with wooden figures. These human figurines were usually small, in keeping with the limited scale of the tombs—but not always: the First Emperor of Qin had immense armies of life-size statues of infantry, cavalry, and chariot troops buried in his mausoleum. No other tomb is known to have contained so impressive a legion.

FURNISHING THE AFTERLIFE: THE SUPERNATURAL WORLD

The supernatural world of the ancient Chinese was dominated by a plethora of complex forces and creatures, both benign and malevolent. Evidence drawn from excavated tombs points to two primary concerns in the Warring States and Qin–Han periods: protection of tombs from harm by evil forces, mundane or spiritual, and the blessing of both the living and the deceased by cosmic beings and deities for welfare and longevity. These harmful and protective powers were not necessarily distinct; indeed, they were often the same or related.

It was only natural, therefore, that objects that had offered security during life would be carried into the afterlife. Belief in the protective power of supernatural beasts is attested by their rich variety and frequent presence in tombs, such as the winged beast in CAT. 4. The ferocity they exhibit was thought to ward off wicked spirits. Some worldly creatures were also perceived to possess supernatural powers, such as deer and tigers (CAT. 80). Real dear antlers were often used on a type of monstrous figure made of lacquered wood popular in the kingdom of Chu during the Warring States period. Their placement near the deceased suggests such totems were thought to protect the tomb and its occupant—a power likely attributed to the antlers. Deer were also associated with light, as in a pair of masterfully crafted bronze lamps with gold and silver inlays (CAT. 49). The pair of menacing tigers from Liu Fei's tomb look ready to pounce on any intruders (CAT. 47). In Han times, the tiger emerged as one of the four creatures guarding the cardinal directions—a turtle for the north, a bird for the south, a dragon for the east, a tiger for the west—as depicted on the lacquer fan in CAT. 17.

Playing *liubo* (game of sixes) was also thought to offer protection from malicious entities. The rules are long lost, but we know that two players used a set of six long sticks in this game. In Han times, immortals were depicted playing *liubo*, making its magical significance clear, and textual sources reveal that the game could function as a means of divination, perhaps by deciphering the interplay of the cosmic forces of yin and yang. *Liubo* playing boards have been found in some Warring States–period tombs and many tombs of the Qin–Han period (FIG. 1.8). These playing boards feature the so-called TLV pattern after its resemblance to those letters. The pattern, marking routes and positions on the board, was evidently endowed with cosmological import. From the middle Western Han period on, the pattern joined images of deities, auspicious animals, and prayers for good fortune and longevity in the rich decorations on the backs of bronze mirrors (CATS. 71–73). With their ability to manipulate and reflect light, mirrors were probably understood to represent magical powers and became popular as luxury objects and protective talismans that ensured immortality or longevity, both in this world and the next.

Another cosmologically significant pattern can be found on the divination board in CAT. 81. Rare among surviving Han artifacts, the board is inscribed with heavenly stems and earthly branches

(*tiangan* and *dizhi*, elements of the Chinese zodiac), five elements (*wuxing*), twelve months (*shi'er yue*), four cardinal directions (*si fang*), and twenty-eight constellations (*xingsu*)—all key components of Chinese cosmology and astrology. While we don't know exactly how this board was used, it clearly was intended to help the diviner foretell the future, secure good fortune, and prevent bad luck.

The material that afforded utmost protection was jade, which had long been perceived as having the power to prevent the body from decaying and thus guaranteed eternal life. Jade attained its most extravagant manifestation during the Western Han period. The body of a king or queen would be placed in a custom-tailored suit made of hundreds of pieces of jade sewn with gold threads (CAT. 82); then the jade-shrouded corpse would be placed in a lacquered wood coffin lined with jade (CAT. 83). Numerous other jade artifacts—tablets, pillows, circular disks, pendants, and figures in the shape of dragons, fish, and cicadas (thought to have the power to renew life; CATS. 84–96)—contributed to the auspicious environment in which the king would embark on his journey into the afterlife.

CONCLUSION

Tomb artifacts from the Western Han period are remarkable for their diversity, comprising worldly luxuries and practical implements as well as symbolic representations of earthly objects and imaginative images of supernatural creatures. Some of these articles were carried over from the world of the living, where they had served simple domestic needs or offered cosmic protection. Others were a means to transfer status and power from this world to the next, thus ensuring the deceased's longevity in the afterworld. The combined presence of such artifacts in tombs illuminates ancient Chinese beliefs. The

increasing resemblance between the habitats of the living and the tombs of the deceased underscores the supreme importance of longevity to the people of the Han dynasty, both in life and in death. Even today this theme continues to resonate in China. In admiring the power and beauty of these artifacts, we enhance our appreciation of their historical and cultural context, iconographical import, and religious purpose.

1 For more on Han dynasty history, see Twitchet and Fairbank 1986, Lewis 2007, and Nylan and Loewe 2010.

2 For a survey of that period, see Loewe and Shaughnessy 1999.

3 For a discussion of the Silk Road, see Hansen 2012.

4 For studies of Han-Roman comparison, see Mutschler and Mittag 2008.

5 For more on archaeological finds of royal mausoleums of the kingdom of Chu, see the essay by Li Yinde in the present catalogue. Information about the finds from those mausoleums cited in the present essay is based on National Museum of China and Xuzhou Museum 2005.

6 For a survey of archaeological finds at Dayun Mountain, see the essay by Li Zebin in the present catalogue and Nanjing Museum 2013.

7 Legge 2000, p. 382.

8 Gunter and Jett 1992, pp. 66–67.

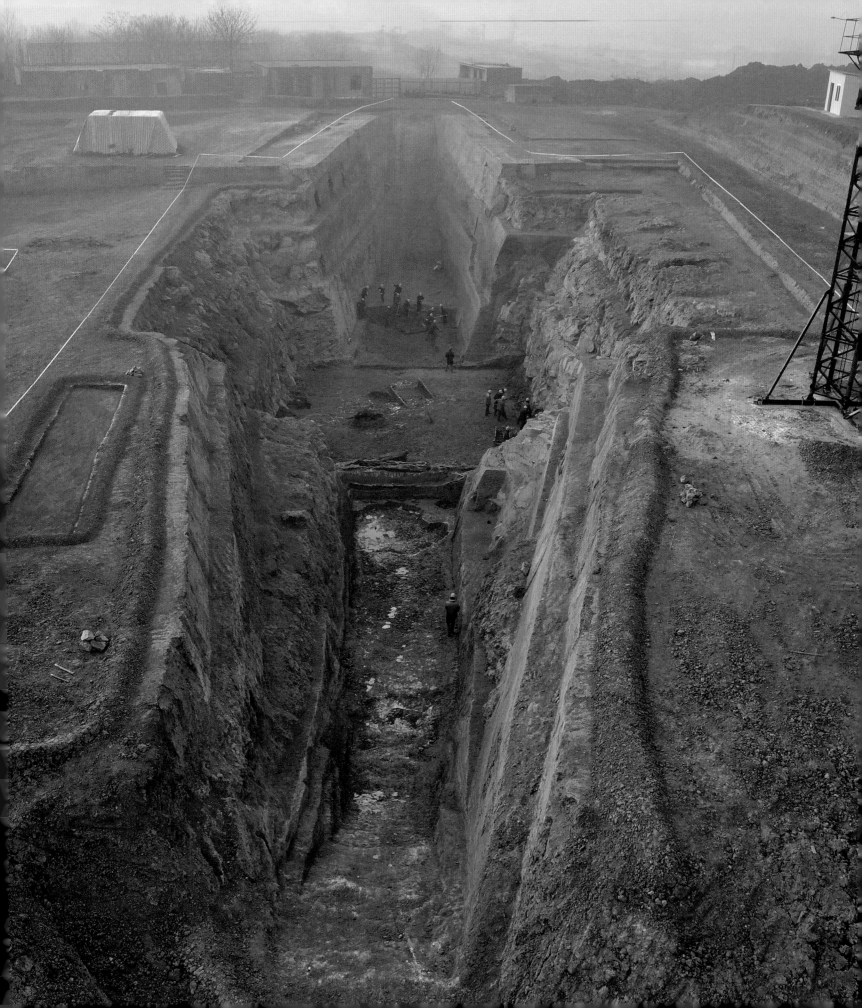

Mausoleum of the King of Jiangdu at Dayun Mountain

IN 154 BCE A GROUP OF VASSAL KINGS—including Liu Pi, the king of Wu, and Liu Wu, the king of Chu—launched what became known as the Rebellion of the Seven States against Emperor Jing of the Han dynasty (reigned 157–141 BCE). Liu Fei (169–127 BCE), the emperor's fifteen-year-old son, asked to lead an army against the rebels, a wish his father granted.[1] The young general quickly achieved success and conquered the king of Runan, a small vassal state. Soon thereafter he was enfeoffed the former state of Wu, with its three commanderies and fifty-three cities, now called the kingdom of Jiangdu. Taking the title of king, Liu Fei (reigned 153–127 BCE) established his capital at Guangling, now the site of Yangzhou in Jiangsu province. After the heroic exploits of his youth, Liu Fei enjoyed the trappings of a vassal king, yet his ambitions remained unfulfilled. After his death at the age of forty-two, Liu Fei was buried—along with his royal consorts and concubines—in tombs that took a lifetime to construct.

In 2009 the mausoleum of Liu Fei was discovered at Dayun Mountain, Xuyi county, Jiangsu province (FIG. 2.1). Subsequent excavations have greatly enhanced our knowledge of this king.

THE SETTING OF DAYUN MOUNTAIN

The king's mausoleum was built on Dayun Mountain, a squat dormant volcano with an elevation of seventy-four meters (FIG. 2.1). It lies to the north of Dongyang, a historic town set in the foothills of the mountain (FIG. 2.2). Inhabited since the Qin dynasty (221–206 BCE), Dongyang reached its greatest height during the Han dynasty, when it served as an economic and cultural center. Under the reign of Liu Fei, its population reached 250,000 inhabitants. Unlike other vassal kings, Liu Fei did not situate his mausoleum near his capital—Guangling, some eighty kilometers to the southeast—but sought out the relatively distant Dayun Mountain. This decision was certainly tied to the size, population, wealth, and strategic position of Dongyang, yet human factors might also have played a role. It is possible that Liu Fei may have had some degree of contact with a woman named Chen Jiao (d. late second century BCE) who lived in Dongyang. She was the daughter of the Marquis of Tangyi (Chen Wu; d. 129 BCE) and later became the first empress of Emperor Wu of Han (Liu Che; reigned 141–87 BCE). The house of Chen had tombs among

View of the mausoleum of Liu Fei, king of Jiangdu, at Dayun Mountain

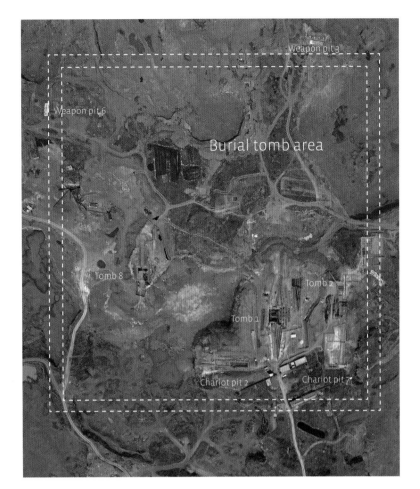

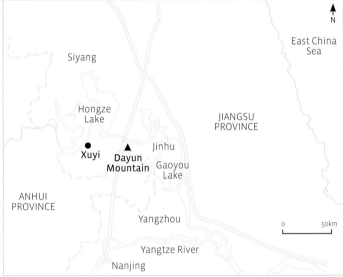

the Western Han royal burial sites at Xiaoyun Mountain, which abuts Dayun Mountain (FIG. 1.1). The nature of this relationship and its influence on Liu Fei may never be known for certain.

The king's mausoleum lies atop Dayun Mountain. Measuring 500 meters on each side, its total area amounts to 250,000 square meters—or about the size of thirty-five soccer fields, equivalent to a large county during the Western Han period. The walls surrounding the mausoleum precinct are made of rammed earth and average ten meters in width but flare out to as much as twenty-three meters near the gates of the mausoleum, with layered stones on both the inside and the outside the walls (FIG. 2.3). Recessed drains of stone are set below the walls (FIG. 2.4). A road more than sixty meters in width—wider than a modern eight-lane highway—leads to the mausoleum.

ORGANIZATION OF THE MAUSOLEUM

The interior of the mausoleum consists of the tombs of Liu Fei and his two consorts (FIG. 2.5), dozens of graves for concubines, and pits for chariots and weapons—very much like a realistic version of the king's

2.1 (left) Aerial view of the mausoleum of Liu Fei at Dayun Mountain

2.2 (right) Map showing the location of Dayun Mountain

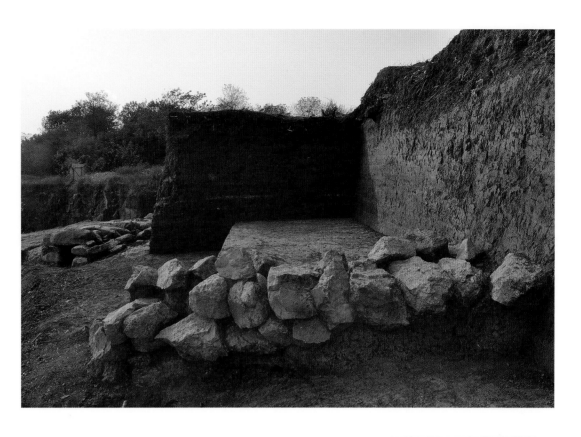

2.3 Walls of Liu Fei's mausoleum
precinct

2.4 Recessed drain located under
the walls of Liu Fei's mausoleum

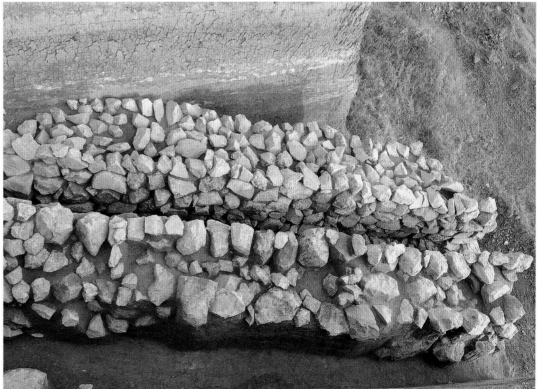

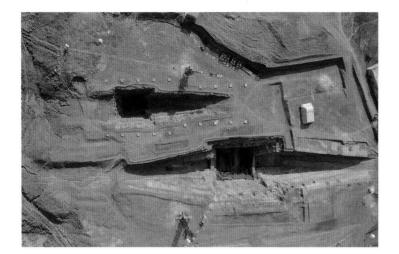

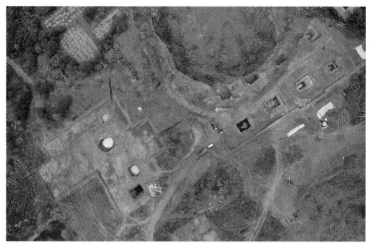

palace transposed underground. The mausoleum faces south, with the tombs of the king and his consorts being the largest and taking the most prominent positions near the front.

The king's mausoleum followed the sumptuary regulations of the Han dynasty, which dictated that a king's tomb had two ramps or passageways oriented on a north–south axis. (An emperor's tomb had four ramps, resulting in a cruciform shape, while a marquis's tomb had one ramp to the south.)[2] With its burial chamber, Liu Fei's tomb has a total length of 127 meters. It takes the traditional form of a vertical pit twenty meters in depth dug into the mountaintop. After the king and his cohort were interred in the tomb, layer after layer of clay and earth was packed and rammed in order to seal it, and then a large mound of earth, 150 meters on each side, was placed on top of the tomb.

Immense planks of timber were employed in the king's burial chamber. In accordance with the Han-dynasty burial system for vassal kings, the outermost area was an "outer storage chamber" (*waicangguo*);[3] followed by the *huangchang ticou,* a reinforcing wall made of beams cut from the inner core of the tree; outer, middle, and inner coffin chambers made of rare nanmu wood; and two inner coffins of the highest-grade catalpa with jade inlays. Within the inner coffins Liu Fei's body was interred in a "jade suit with gold threads"—the highest grade of funerary dress in the Han sumptuary code.[4]

On either side of the tomb are pits containing earthenware horses and carriages for the king's transportation needs in the afterlife as well as chariots symbolizing his military power. The graves of the concubines are neatly arranged in five rows according to rank toward the back of the mausoleum (FIG. 2.6): the higher the concubine's status, the closer her grave was to the king—and the larger its scale and the richer the funerary objects within. Each of the king's concubines, regardless of rank, had her own site within the mausoleum precinct.

Outside the king's mausoleum, numerous burial sites for various ministers dot the hill along the road leading from the site in accordance with each minister's rank (FIG. 2.7). Because there are so many tombs, not all have been unearthed. One tomb that has been unearthed is that of Zhang Yi, a high-ranking minister, together with his wife.

2.5 (left) Joint burial sites of Liu Fei and his consorts at Dayun Mountain

2.6 (right) Graves of concubines buried with Liu Fei at Dayun Mountain

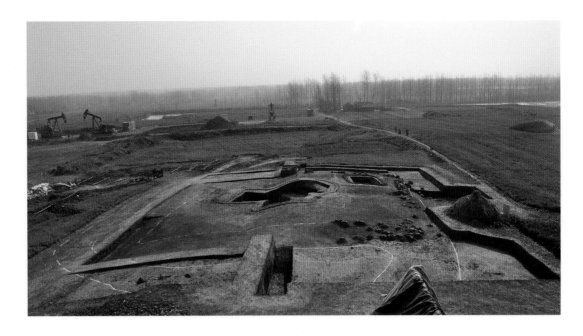

2.7 View of Tombs 6 and 17 at Dayun Mountain

TREASURES UNCOVERED

More than 10,000 ancient artifacts have been uncovered in Liu Fei's mausoleum. These exquisite objects chart various aspects of life during the Western Han period, some of them attaining a staggering level of artistry. Following the Han dynasty belief that a man should retain in the afterlife the comforts and status he enjoyed while living, Liu Fei had his tomb stocked with items he would find useful or enjoyable.

Music at the king's court is represented by a bronze bell set (CAT. 3) consisting of fourteen bells hung from a beam and five handbells. These instruments were an important part of ancient musical ensembles—the classic "sounds of gold and vibrations of jade" (*jinsheng yuzhen*).[5] Moreover, the bells hang from special frames adorned with mythical creatures, patterned designs of twin dragons, and disks with holes (*bi*) (FIG. 2.8). The disks, made of silver, have extremely fine engravings of floating clouds with birds and beasts. The bronze components of these frames were gilded and inlaid with silver—a magnificent match of performance and artistry. Even more stunning are the chimes found in the tomb (FIG. 1.4), which are made not of stone or jade, as was customary, but of ancient Chinese glass (*liuli*). The piece epitomizes the use of composite materials in ancient Chinese musical instruments. Not only do the chimes resemble beautiful jades, they also produce an ethereal timbre—a feast for both eyes and ears. After research and restoration, the chimes can be played today, more than 2,000 years after they were made (FIG. 2.9).

A set of mat weights (CAT. 8) found in Liu Fei's mausoleum vividly depicts people listening to music—a common sight at his court.

The king's mausoleum contained everything required for a royal feast. The utensils and dinnerware found there are exceedingly luxurious, often plated or inlaid with gold or made of pure silver. Among them are two sets of silver boxes and pots that were elaborately decorated in a Persian style, allowing people to experience different aesthetic tastes from Central Asia. The decorative artistry of the

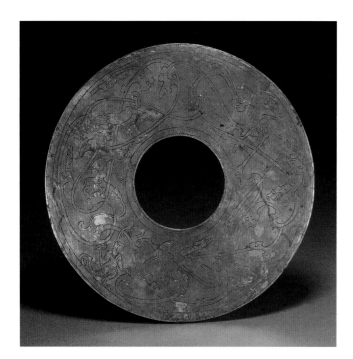

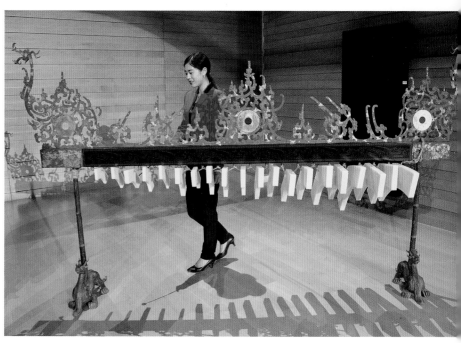

2.8 (left) A silver *bi* disk from a bronze bell set (CAT. 3)

2.9 (right) Staff member of the Nanjing Museum performing with replicas of Han-dynasty *bianqing* chimes

lacquerware, particularly in practical, lightweight utensils, is exceptional (FIG. 2.10). One can imagine two men sitting across from each other, enjoying food from the hot pot (CAT. 32), which is divided into five parts for different dishes. A similar vessel called a *ding* (CAT. 28) was also used as a hot pot in ancient times.

Men in ancient China enjoyed drinking alcohol with dinner, and the vessels associated with this practice are exquisite. Cups, for example, were made of jade or lacquer, with lacquered cups inlaid with gold and precious stones (FIG. 2.11). The *xing* container found in Liu Fei's tomb (CAT. 33) was designed to carry wine for the king when he traveled and has a capacity of fifteen liters; its handle with dragon patterns makes it convenient to carry. A wine-dipping vessel (CAT. 34) displays consummate craftsmanship, especially in its gold plating, but even more notable is the fact that people had mastered the technique of using a vacuum to siphon liquids 2,000 years ago.

In addition to practical dining and drinking items, Liu Fei's tomb contained a set of bronze vessels made specifically for burial (CAT. 43). Although they are only one-fifth the size of everyday vessels, these funerary objects display high-quality craftsmanship and production techniques.

When the king was alive, he lived in a luxurious palace with exquisite decorations and furniture. The furnishings in Liu Fei's mausoleum give us some indication of what his daily life was like. CAT. 49 is a deer lamp (*ludeng*)—a sculptural masterpiece. Ancient Chinese people saw the deer as a symbol of good luck. The deer forming the base is very realistic and elegant. CAT. 51 is a cleverly designed lamp (*gangdeng*) that collects smoke from the flames through pipes and neutralizes it in water within its base. By allowing the reader to be closer to the flame without harm or annoyance, the lamp provided safe light for nighttime reading.

Tigers were considered protector deities, and their presence in a household ensured good fortune. A pair of bronze weights in the shape of tigers (CAT. 80), inlaid with gold and silver, crouch as if ready to

attack, their heads lifted and mouths open, presenting an awe-inspiring sight. A set of mat weights (CAT. 47) are very lifelike, portraying one tiger lying in wait to leap on its prey and another devouring it. The ancient craftsmen's minute observation of wild animals is admirable.

People in the Han dynasty took great care with their appearance, and both men and women enjoyed applying makeup and taking baths; there were even specific holidays for ablutions.[6] The silver bath basin from Liu Fei's tomb (CAT. 55) is enormous and was used together with gourd-shaped pouring vessels (CAT. 58). Inscriptions on the vessel indicate that Liu Fei himself used it in his palace. His tomb also contained a bath stone (CAT. 54), a scrubbing aid similar to pumice that is still used by Chinese people today. Four different grades of bathing stones were available, ranging from rough to fine. Additionally, a large variety of cosmetics—some kept in special vanity cases (FIG. 2.12; CAT. 98), some made portable so they could be applied on the go—was unearthed from the tomb, as were bronze mirrors used on a variety of occasions (CATS. 71–73).

Though the costumes of the Han dynasty have not survived in the mausoleum, we can glean something of them from accessories unearthed there. Among the golden ornaments for hair and hats and buckles made from gold and jade, one of the most stunning finds is a crystal belt hook (CAT. 65). It is hard to believe this exquisite object was crafted from a natural material without the aid of machines or computers.

Military affairs were a main occupation of the king, so his mausoleum included special pits for armor and battle chariots. The arms interred with him were enormous in number and comprehensive in variety, everything from swords to spears and halberds. According to historical records, Liu Fei was very strong and sturdy, which meant he would have been able to handle the heavy halberd (CAT. 12) buried with him. One item especially worthy of mention is a bronze spearhead with a rare decorative pattern

2.10 (left) Drawings of a lacquered plate inlaid with gold and silver

2.11 (right) Drawings of a lacquered ear cup inlaid with precious stones

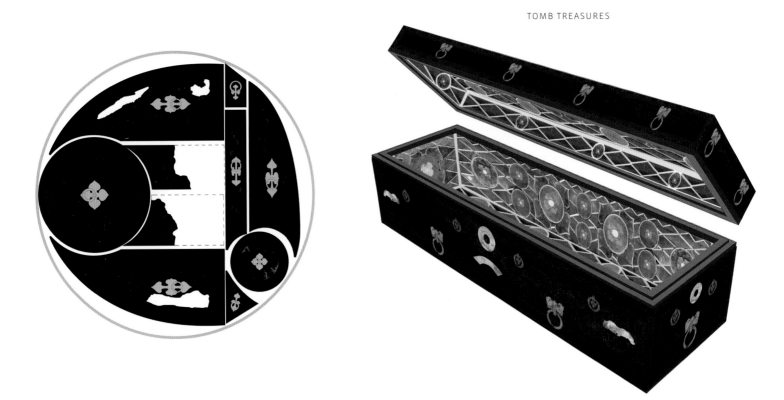

2.12 (left) Drawing of a vanity case composed of eleven small boxes

2.13 (right) Drawing of a restored jade coffin

(CAT. 13). This kind of decoration was popular in the regions of Wu and Yue during the Spring and Autumn period (771–approx. 475 BCE), but it had become rare by the Han dynasty.

Liu Fei collected relics from earlier dynasties, and he received the posthumous name Yi Wang, which means "the king who loved things of the past." One such item was a dagger-axe (*ge*) made of jasper dating from the Shang dynasty (approx. 1600–1050 BCE; CAT. 76); it was already an antique by Liu Fei's time, and people of the Han dynasty no longer understood how it was used. A large bronze basin (*xuan*) designed to show one's reflection in the water (CAT. 78) is judged to be from the Spring and Autumn period and was cast with delicate patterns of mythical creatures. A military bell from the kingdom of Yue in the Warring States period (approx. 480–221 BCE; CAT. 79) is unusual for its size. In addition to cast patterns of dragons and snakes, it features the "bird and insect" calligraphic script of the Yue, unrecognizable by Liu Fei's time.

Polygamy was widespread among royalty and nobility during the Han dynasty, and many men had concubines. Among the curios unearthed in the burial chambers of Liu Fei's concubines was a silver belt hook (CAT. 67). This small accessory features the engraved words "Enduring remembrance without fail" or "Forget me not" (*Chang wu xiang wang*), a message of faithfulness and constancy. The occupant of this tomb, a concubine of the third rank, was called Chunyu Yinger; *Yinger* is a pet name that means "baby" and reflects the affection between Liu Fei and his concubine. A bronze phallus (CAT. 61) was discovered among the everyday objects in the king's tomb, indicating that sexual aids were popular more than 2,000 years ago.

In order to realize the dream of eternal life, people in the Han dynasty believed in dressing in precious jade. A form-fitting jade suit (CAT. 82) is made up of thousands of pieces of jade threaded together with gold. The delicate handiwork, the immense expense of the jade, and the huge number of

gold threads reflect the outstanding craftsmanship of the artisans. A king's jade coffin is even more spectacular (FIG. 2.13): its interior is inlaid with round jade *bi* disks as well as jade pieces of various shapes to form a persimmon pattern symbolizing auspiciousness. The gaps between the jade pieces are decorated with gold or silver pieces. On the exterior of the coffin, images of moving clouds, mythical animals, and immortals were painted in vermillion lacquer. Coffins such as this represent the ultimate in ancient Chinese mortuary practice.

CONCLUSION

The works discussed here are treasures not only because they are fashioned from gold or silver or jewels or jade. More significant is the insight into ancient life these objects give us. These amazing artifacts allow us to learn more about the ways and wisdom of ancient cultures, a heritage that remains an asset to all humankind.

Translated by Daniel Szehin Ho

1 Liu Fei was the elder brother of Liu Che, who would later become one of the most illustrious emperors in Chinese history, Emperor Wu of Han.

2 According to layout and number of ramps, the tombs of ancient Chinese nobles can be categorized as follows: *ya*-shaped tombs, with four ramps, are of the highest rank, reserved for emperors; *zhong*-shaped tombs have two ramps; and *jia*-shaped tombs have one ramp, designated for vassal lords and nobles. These names are derived from resemblance between the cross-section of the tomb layout and the characters *ya* (亚), *zhong* (中), and *jia* (甲). The number of burial tombs in each mausoleum indicates the rank and status of the deceased.

3 "The Biography of Huo Guang" in *History of the Former Han Dynasty* states: "Guang departed this life . . . and was granted . . . one catalpa coffin [*zigong*], one ceremonial burial chamber [*bianfang*], one *huangchang ticou*, and fifteen fir outer storage chambers." In the same text, Su Lin commented on this last element of the burial system: "Piling up cypress and magnolia outside the coffin, it is thus termed *huangchang*. The wood all pointing inward, it is therefore called *ticou*." Ban Gu 1983.

4 According to the ritual stipulations in *Continuation on History of the Han Dynasty: Etiquette*, the jade suit with gold threads was reserved for emperors, while a "jade suit with silver threads" was permitted for kings, and a "jade suit with copper threads" was allowed for other high-ranking nobility and princesses. Archaeological excavations show that various vassal kings of the Western Han flouted this rule and were buried in jade suits with gold threads. Sima Biao 1980.

5 Mencius 1983.

6 The most common rest days for Han-dynasty officials were called "washing breaks" (*xiumu* or *ximu*).

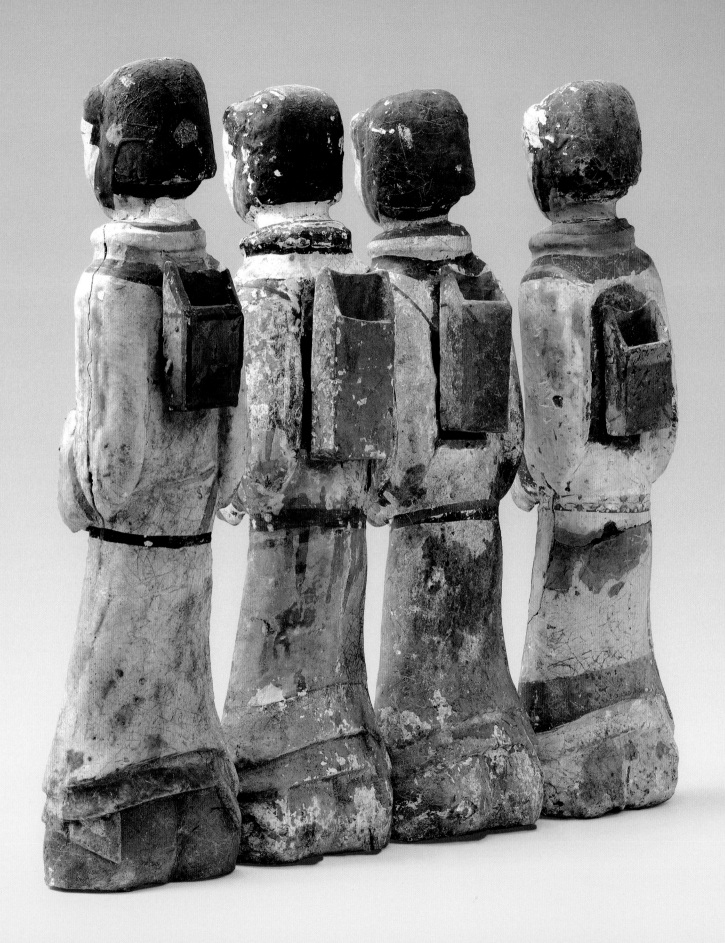

Mausoleums of the Kings of Chu at Xuzhou

EACH ROYAL TOMB FROM THE KINGDOM OF CHU dating to the Western Han period is enormous, and taken together, they form a monumental architectural group. The tombs and the all-encompassing nature of the funerary objects found within them allow us to understand the architectural techniques and artistic accomplishments of the period, as well as to appreciate, more than 2,000 years later, the wealth of the kings of Chu and the luxury of their surroundings.

THE KINGDOM OF CHU DURING THE WESTERN HAN PERIOD

Xuzhou is a renowned city in the cultural history of China. During the Xia (approx. 2100–1600 BCE) and Shang (approx. 1600–1050 BCE) dynasties, the Xuzhou area was known as the kingdom of Peng. During the Spring and Autumn period (771–approx. 475 BCE) it was called Pengcheng, and during the Qin dynasty (221–206 BCE) it became established as Peng prefecture. Between the Qin and Han dynasties, King Huai II of Chu (Xiong Xin; d. 206 BCE) designated Pengcheng as his kingdom's capital, as did the Hegemon King of Western Chu, Xiang Yu (232–202 BCE), who declared his dominion over nine counties, with Pengcheng as their capital.

Xuzhou is also the birthplace of the founder of the Han dynasty, Liu Bang (reigned 202–195 BCE). His brother Liu Jiao joined him in rebelling against the Qin dynasty and was a key adviser, often "conveying important developments in state affairs and formulating strategy."[1] In 201 BCE, Liu Bang bestowed the kingdom of Chu upon Liu Jiao, who, with the title of king, ruled the three commanderies of Dong Hai, Pengcheng, and Xue and their thirty-six counties until 179 BCE, with Pengcheng serving as the capital. Chu was second only to the fiefdoms of Qi and Wu in size. Before Emperor Wen (Liu Heng; reigned 180–157 BCE) became imperial leader of the Han dynasty, he humbly suggested that Liu Jiao should become emperor. Thus, during the early Han period the kingdom of Chu had a close relationship with Chang'an, the capital of the Han dynasty, and enjoyed a privileged position in matters of governance. Liu Jiao's sons were treated like imperial princes, with his five favorite sons granted the title of duke.

Set of archer figurines (CAT. 19) from the tomb of the king of Chu at Beidong Mountain

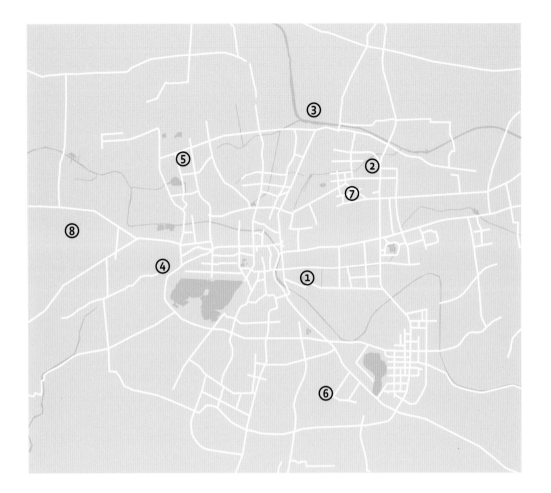

3.1 Locations of the Chu royal tombs in Xuzhou

1. Shizi Mountain and Yanggui Mountain
2. Tuolan Mountain
3. Beidong Mountain and Huan Mountain
4. Woniu Mountain
5. Gui Mountain
6. Nandong Mountain
7. Dongdong Mountain
8. Chuwang Mountain

In 154 BCE the king of Chu, Liu Wu (reigned 175–154 BCE), launched the Rebellion of the Seven States.[2] When their armies were defeated by the emperor's forces, the kings were forced to commit suicide and their states vanquished. Soon after, Liu Jiao's son Liu Li, the Marquis of Pinglu, was crowned king of Chu (reigned 154–150 BCE). Eight more kings ruled Chu until Wang Mang's interregnum (9–23 CE); in all, twelve successive kings ruled the kingdom of Chu during the Western Han period (see chronology, pp. xvi–xvii).

THE DISCOVERY OF THE CHU ROYAL TOMBS

In order to prevent collusion among the vassals of prior kings, the Han dynasty decreed that no king or duke was permitted to leave his fiefdom without permission—even in death. Thus, in theory, there should be twelve tomb sites for the Chu kings and their consorts in Xuzhou. Unlike other vassal rulers, whose tombs consisted of large coffins set in deep pits, the kings of Chu carved their tombs into the limestone strata of the bluffs surrounding Xuzhou. These cliff-side tombs took the form of large horizontal caves whose shape and structure have been fully preserved thanks to the hard rock.

So far, eight tomb sites and eighteen royal graves for twenty-four people from the kingdom of Chu have been discovered and excavated. These sites are scattered in a loose circular pattern in the mountains surrounding the ancient capital of in Xuzhou (FIG. 3.1):[3]

1. The tomb of a Chu king—probably the second king of Chu, Liu Yingke (reigned 179–175 BCE)—at Shizi Mountain, and the tombs of two royal consorts at Yanggui Mountain.
2. The tombs of a Chu king—probably the third king of Chu, Liu Wu (reigned 175–154 BCE)—and tombs for two royal consorts at Tuolan Mountain.
3. The tomb of a Chu king—probably the fourth king of Chu, Liu Li (reigned 154–150 BCE)—at Beidong Mountain, and the tombs of two royal consorts at Huan Mountain.
4. The tombs of a Chu king—probably the fifth king of Chu, Liu Dao (reigned 150–128 BCE)—and two royal consorts at Woniu Mountain.
5. The tombs of the sixth king of Chu, Liu Zhu (reigned 128–116 BCE), and two royal consorts at Gui Mountain.
6. The tombs of a Chu king—probably the seventh king of Chu, Liu Chun (reigned 116–100 BCE)—and two royal consorts at Nandong Mountain.
7. The tombs of a Chu king—probably the eighth king of Chu, Liu Yanshou (reigned 100–68 BCE)—and two royal consorts at Dongdong Mountain.
8. The tombs of a Chu king—probably the ninth king of Chu, Liu Xiao (reigned 50–25 BCE)—and two royal consorts at Chuwang Mountain.

Of these royal graves, all but the tomb at Chuwang Mountain are carved into the limestone cliff with a sloping tunnel ending in a box-shaped burial chamber similar in appearance to the form of the character *jia* (甲). In this period the royal tombs of neighboring states—such as Liang, Lu, and Zhongshan[4]—were also set in large horizontal caves, but this approach appeared first in the kingdom of Chu, and more tombs in this style have been discovered from Chu than any other kingdom.

While there is virtually no evidence of names marking the tombs, a silver seal with the name "Liu Zhu"—the sixth king of Chu—on one side and a tortoise on top was excavated from the tomb at Gui Mountain (FIG. 3.2). Using this clue to establish a chronology and synthesizing information about the structures of the tombs and the development of their funerary objects with the lineages of the kings of Chu in *History of the Former Han Dynasty*, scholars have identified the occupants of the other royal tombs in Xuzhou.

3.2 Tortoise seal bearing the name of Liu Zhu, king of Chu, discovered at Gui Mountain

PALATIAL TOMBS

Each royal tomb from the kingdom of Chu is located within its own cemetery perched within its own mountain range, although the boundaries of these cemeteries have yet to be discovered. The architectural structure of each tomb is located above ground, while accompanying burial chambers and graves are below ground. Within these burial chambers are pits for, among other items, earthenware soldiers, warhorses, and chariots; earthenware jars (for storing grains); kitchens; bathing utensils; ironware; and money. In addition to the pits for earthenware soldiers and warhorses, niches in tomb passageways contained statues of cavalry figures, archers, and ministers who stand guard over the king (FIGS. 3.3–3.5).

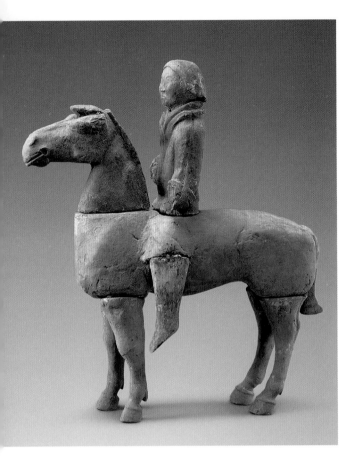

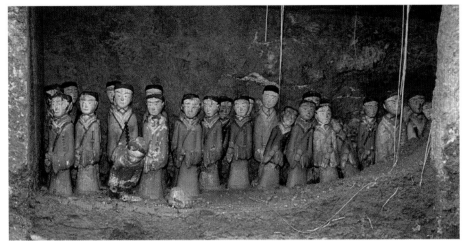

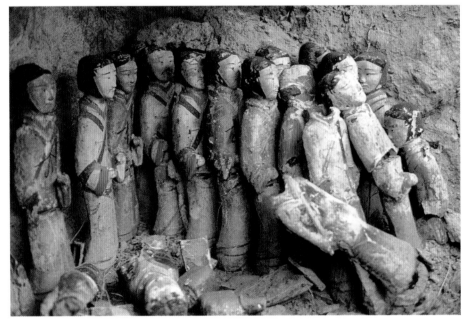

Within the tomb passages, parallel rows of large natural stones are wedged against the dirt to form simple tunnels.[5] The practice of creating such tunnels arranged in groups of more than ten emerged during the reign of Emperor Jing of Han (Liu Qi; reigned 157–141 BCE). Many of the tombs feature complex drainage systems, and from the time of Emperor Wu (reigned 141–87 BCE) the walls of the burial chambers were painted with red lacquer and vermillion. After the reign of Emperor Wu, most tombs consisted of an architectural edifice made of separate wooden structures with tile roofs.

The tombs included rooms and layouts that mimicked the grand palaces of the kings of Chu above ground. The tomb at Beidong Mountain (FIG. 3.6) is most representative, with a burial mound, tomb passages, a main burial chamber, and a group of attached burial chambers. A gate was carved from the walls of the passageway with seven niches and access to two auxiliary rooms. The main burial chamber

3.3 (left) Earthenware cavalry figure excavated from the Chu royal tomb at Shizi Mountain, Xuzhou Museum.

3.4 (top right) Painted court attendant figures discovered in niche 1 in the eastern tunnel of the Chu royal tomb at Beidong Mountain

3.5 (bottom right) Painted earthenware figures discovered in niche 2 in the eastern tunnel of the Chu royal tomb at Beidong Mountain

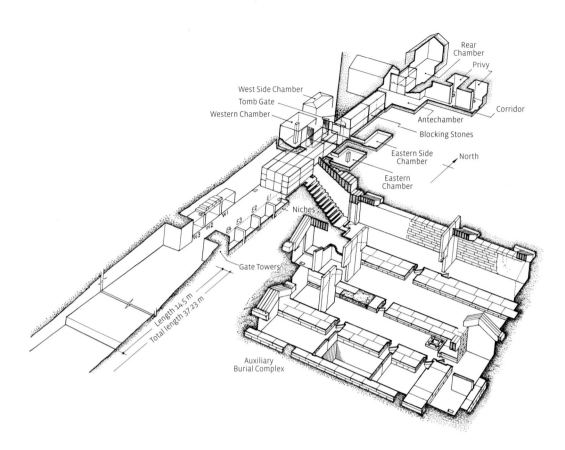

3.6 Rendering of the Chu royal tomb at Beidong Mountain

has side rooms, an antechamber, a rear chamber, a passageway, and two flanking rooms. The attached burial chamber is 2.98 meters lower than the main burial chamber and was created by carving out a rectangular-shaped tomb from the cliff rock and then layering long pieces of rock upon each other like bricks. It contains an arsenal, a treasury, a chamber for entertainment, a washroom, a patio, a kitchen, a mill, storage rooms, a woodshed, and a lavatory. These large-scale cave-tunnel tombs featured a variety of roof types—flat roofs, slope roofs, hip roofs, pagoda roofs, four-cornered upturned roofs, gabled roofs, wagon-vaulted roofs, groin-vaulted roofs, domed roofs, and barrel-vaulted roofs—all of which reflect the high level of architectural accomplishment in the Western Han period.[6] From the time of Emperor Wu (141 BCE), builders used central pillars to spectacular and imposing effect—as if propping up the sky—in Chu royal tombs.

PERSONAL ADORNMENTS AND DAILY LIFE

Just as the tombs echoed the palatial residences of the kings, so the objects supplying the tombs reflected the luxurious taste of royals. For example, the belts worn by the kings of Chu to hold their opulent robes in place were far from ordinary. They no longer wore belt hooks in the more traditional style of the Central Plains, preferring instead buckles like those worn by the Xiongnu aristocracy of the northern grasslands, though these styles were soon Sinicized. A gold belt buckle excavated from Tianqi Mountain (CAT. 70) features a fierce beast and a bear ravenously tearing into the twisting hindquarters of a horselike animal

and a border decorated with a pattern of bird beaks. These decorative motifs are distinct from the belt buckles excavated in the northern steppes, and it is very likely that this particular item was crafted in the interior of China. While they retained the structure of belt buckles developed and worn by other ethnic groups, the gilt-and-jade belt buckles excavated from the tomb at Dayun Mountain (CAT. 68) and the gold belt buckle of a royal concubine (CAT. 69) demonstrate that decorative imagery had come to feature dragons, tortoises, and other distinctly Chinese subjects during the rule of Emperor Wu.[7]

Royal bedding was "woven from silk" or consisted of "golden beds and ivory mats"[8]—these have, alas, deteriorated beyond recognition. Since sleeping mats tended to slip in use, their corners were held down by bronze weights such as those in the shape of leopards (CAT. 48) inscribed with characters such as *shang wo* (master of chambers; 尚卧) to indicate that they were specifically used by the kings of Chu.[9] To ensure they were sufficiently heavy, the weights were filled with "nineteen catty, thirteen taels and one *zhu*"[10] of lead (about twelve kilograms). Mat weights in the form of a stone leopard and a jade bear excavated from the Chu royal tomb at Northern Grotto illustrate the traditional line of verse: "Weights of white jade to hold the mat."[11] Without exception, each of the aforementioned beasts wears a collar around its neck, reflecting the practice among Han regents of domesticating wild animals such as leopards and tigers.

Seating also required mats. Beyond comfort, one of the most important qualities of seating during the Han dynasty was that each piece only accommodate one person, especially for a monarch: if power was not to be shared, then neither was one's seat. All sorts of human and animal figurines were used as weights for these mats, such as people listening to music (CAT. 8) and tigers of bronze inlaid with gold and silver (CATS. 46–47). Since these depictions of fierce animals are filled with vibrant colors, it is possible that they were intended to repel dark spirits. Some weights feature hooks on the bottom that secured the weights to the weave of the mat and prevented them from shifting. The surfaces of some weights are decorated with inlaid agate or turquoise, while others feature designs in the material from which it is crafted—gold, silver, or bronze.

BANQUETS, MUSIC, AND DANCE

The kings of Chu led lives filled with extravagance. The drinking vessels they used for imbibing wine were all of carved jade from Hotan, Xinjiang. In *Records of the Grand Historian,* Sima Qian said, "When the Eternal Palace was completed, Kao-tsu [Liu Bang] summoned the nobles and officials to a great reception, setting forth wine for them in the front hall of the palace."[12] The type of cup Liu Bang used at this event was established in 1995, when an exquisitely crafted cup (*yuzhi;* FIG. 3.7) was discovered in a cache of jade drinking implements excavated from the royal tomb at Shizi Mountain.[13] This discovery confirmed that the kings of Chu and the emperor all used the same type of top-grade wine vessel—the jade cup.

Drinking was a luxury enjoyed by the kings of Chu. It was not only an occasion for savoring the taste of wine but also for displaying knowledge of etiquette and self-cultivation. When Liu Jiao held a banquet, he would always offer sweet wine to the official Mu Sheng, who did not drink. When Liu Wu took the throne, he offered Mu Sheng wine at first but over time forgot to do so. Mu Sheng said to his fellow officials Shen Gong and Bai Sheng, "We can retire! Not serving [us] sweet wine makes clear that we have already lost the king's favor. Neglecting to serve sweet wine is not an insignificant matter of

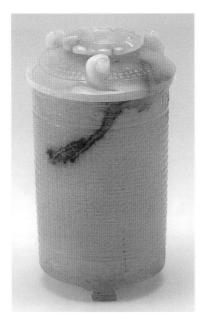

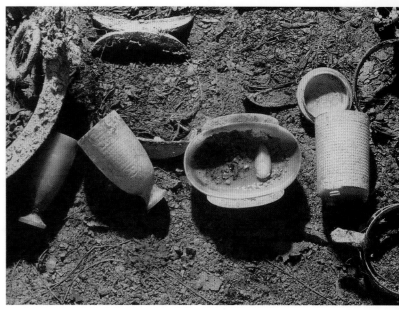

3.7 (left) Jade cup (*yuzhi*) excavated from the Chu royal tomb at Shizi Mountain

3.8 (right) Jade vessels in situ in the Chu royal tomb at Shizi Mountain

ceremony, it is an oversight, and those who are overlooked will not remain for long. If we don't leave, the king will put us in shackles and punish us in public." Remembering the benevolence of the former king, Shen Gong and Bai Sheng remained, while Mu Sheng, feigning illness, asked for permission to return to the kingdom of Lu soon thereafter. Sure enough, Shen Gong and Bai Sheng were put in shackles, made to wear the ocher clothing of prisoners, and humiliated by performing hard labor in the middle of a busy market. Not long after that, the rebellion Liu Wu plotted failed, and he committed suicide.[14]

The kings of Chu enjoyed other pleasures as well. Performers filled the palace with music from zithers, chimes, and bells (CAT. 3) as talented beauties performed elegant, back-twisting dances. Fu Yi's[15] "Rhapsody on Dance" describes a scene of dancers: "gossamer gowns blow in the breeze, / Long sleeves tangle and twine together."[16] Many figurines of musicians and dancers have been unearthed from the royal Chu tombs. The musicians—all kneeling—strike chimes, strum stringed instruments, and blow upon reed pipes and organs (CAT. 7). The posture of a dancer wearing a robe with coiled lapels (CAT. 6) is bold and unrestrained. If we could only travel back 2,000 years in time and hear the music that lasted through the night and see the dancing that lasted until dawn in the palaces of the kings of Chu.

THE WASHROOM AND BATH

By the time of the Han dynasty, the use of lavatories was widespread. Han tombs in every region included mortuary models of bathrooms that were integrated with animal pens—essentially pigpens with a latrine built on stilts over one corner. A squat toilet would empty directly into the pigpen, and the hogs would feed on the excrement. Even royal palaces made use of such arrangements. *History of the Former Han Dynasty* records that when Liu Dan, the king of Yan, attempted a coup d'état against his younger brother, Emperor Zhao (Liu Fuling; reigned 87–74 BCE), "The pigs broke out of the privy in a herd and smashed the stove of the royal butler [kitchen]."[17] Despite this widespread custom, the toilets of the Chu

kings were *not* attached to pigpens. Befitting their elevated status and self-regard within the empire, the kings of Chu had the most advanced, hygienic, and fashionable restroom facilities in all of the far-flung prefectures of the state.

The tomb at Beidong Mountain includes a dedicated corridor leading to two latrines, each in a separate room, evidently one for each sex. The corridor and bathrooms were painted with the same cinnabar pigment as the walls of the antechamber and rear chamber, suggesting that at the time bathrooms were not thought to be any different from other rooms in the palace.[18] These facilities were often thoughtfully designed. The auxiliary chamber of the tomb at Beidong Mountain features a room dedicated to entertainment whose bathroom is divided down the middle by hollow bricks, with a toilet in the inner portion of the room and a bronze water receptacle meant for washing in the outer portion.

The bathroom in the tomb at Tuolan Mountain is even more comfortable and ingenious (CAT. 97): a squat rectangular toilet sits in the center of a platform that is raised 1.5 centimeters off the ground. Rectangular stepping-stones sit along the sides of a rectangular drainage hole. Behind the toilet stands a sturdy slab of stone that can be leaned against, and a rail on the right allows the user to lower or raise him- or herself into or out of a squatting position. All of the stone components in the latrine have been ground with meticulous care. As these examples prove, the Han dynasty enjoyed toilets that would be considered luxurious in many parts of the world today.

Bathing was an important part of daily life for regents and aristocrats in the Han dynasty. *Observances of the Han Bureaucracy* tells of officials in the imperial court who "worked five days and rested one day to bathe, and this day was also called 'bathing day.'"[19] Just as toilets are often located in bathrooms today, the kings of Chu had their latrines and bathrooms placed in adjacent spaces. In the corner of the bathroom, a rectangle was carved from stone for collecting water, and where the reservoir meets the wall, a slab of stone was carved to guard against splashing. Excavations at Shizi Mountain and Dongdong Mountain make clear that the kings of Chu used vessels decorated in gold or silver to adjust the water temperature while bathing. Among the sets of such implements are a silver mirror, pot, and plate found at Shizi Mountain; a gold-decorated washbasin, a plate belonging to the queen, and another gold-decorated dish discovered at Dongdong Mountain; and two dishes decorated with a pattern of lotus petals and a silver washbasin from Dayun Mountain. Although these shallow round washbasins might seem prone to being knocked over, they were, in fact, placed on sturdy three-footed stools that ensured their stability.[20]

A vassal king or royal consort would be served by court attendants or maids during a bath. Oval or circular pieces of pumice (CAT. 54) were used by the kings to clean themselves. A mortar and pestle found alongside bathing implements in an auxiliary pit at Shizi Mountain suggests that such implements were used to grind medicinal ores or plants to add to the bathwater to promote wellness. According to contemporary inscriptions, court attendants were responsible for managing bathing utensils, while the mortar and pestle were the responsibility of the pharmacy.

COFFINS AND SUITS OF JADE

Jade was worshipped during the Han dynasty. It was thought to possess the five virtues: benevolence, righteousness, propriety, wisdom, and fidelity. The ancient Chinese believed that jade would protect a

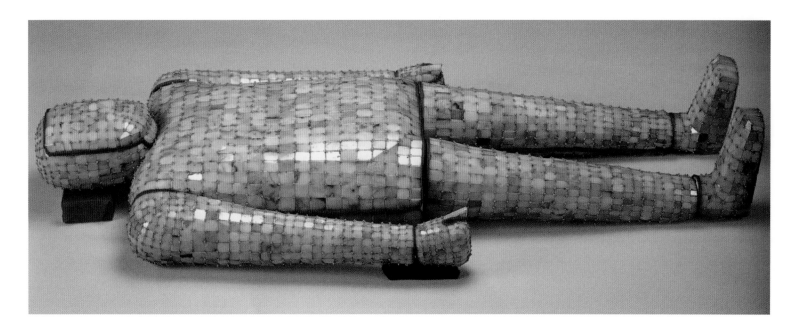

3.9 Gold-threaded jade suit of Liu Yingke from the Chu royal tomb at Shizi Mountain

body from decay, so every effort was made to bury a person with as many such objects as possible. Eschewing the traditional burial robes dating from the Shang and Zhou dynasties (approx. 1600–256 BCE), the kings of Chu were buried in jade suits sewn with gold thread. Such suits or pieces of them have been excavated from the royal tombs at Shizi Mountain, Beidong Mountain, Woniu Mountain, and Dongdong Mountain, clearly indicating that four kings of Chu were buried in jade attire. The most magnificent of these is Liu Yingke's suit, the earliest and most exquisitely crafted of the Chu jade cloaks, and the one with the most pieces of the highest-quality jade (FIG. 3.9). A piece worn by Liu Li was sewn to resemble a suit of armor, the jade tiles overlapping like fish scales. This practice likely corresponds with the description of "burials [that] now include pearls put in the mouths of corpses, [and] jade suits that cover their bodies like fish scales" that appears in *The Annals of Lü Buwei*.[21]

In death, the kings rested their heads on pillows of jade, as well. The ends of Liu Yingke's pillow are inlaid with tiger heads (FIG. 3.10). The ears and noses of deceased kings were stuffed with small columns of jade to prevent their vital essences from escaping. It is likely that jade articles were also placed in their mouths, hands, and anuses for the same reason, but looting of the tombs has made this difficult to ascertain.

Most of the kings of Chu were interred in jade coffins whose surfaces were painted in lacquer and inlaid with jade planks and circular *bi* disks with a hole in the center. A coffin that was perhaps Liu Yingke's is made from jade planks in a variety of shapes, including diamond-shaped pieces (CAT. 83). Inlaid into the surface of the lacquered wood and attached with jade rivets and gold nails, they form a dazzling geometric pattern. Few vassal lords of the Western Han period were laid to rest in such elaborate coffins. Apart from those buried at Xuzhou, only Liu Sheng, king of Zhongshan, and his royal consort, Lady Dou Wan, and the king and royal consort of Jiangdu discovered at Dayun Mountain were buried in such splendor. While jade planks were present inside their coffins, the outer surfaces were inlaid with relatively few jade *bi* disks, semicircular jade ornaments (*huang*), and dragons. These regents of the Han

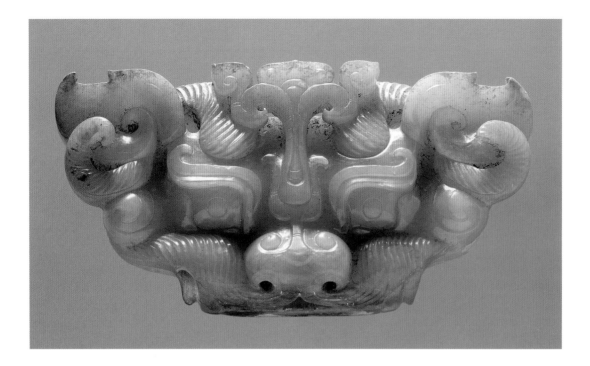

dynasty were honored with only the most sumptuous and highest-quality coffins. Perhaps the knowledge that they would be received into the afterlife wearing jade suits and resting in jade-covered coffins within their well-stocked underground palaces allowed these kings to be secure in their belief in immortality.

3.10 Jade tiger pillow from the Chu royal tomb at Shizi Mountain

CONCLUSION

The kings of Chu carved enormous burial chambers into mountainsides, and the glut of precious objects they brought with them in their tombs are material manifestations of their worldly wealth and power, which they fully expected to endure as they passed from one realm and into the next. These objects—the endless piles of lustrous jade implements and the countless coins, along with the many broken and decayed articles—embody the majesty of the lives, customs, and aspirations of the kings of Chu.

Translated by A. C. Baecker

1 Ban Gu 1962.

2 The king of Chu, Liu Wu, joined forces with the kings of Wu (Liu Pi), Zhao (Liu Sui), Jinan (Liu Biguang), Zichuan (Liu Xian), Jiaoxi (Liu Ang), and Jiaodong (Liu Xiongqu) along with other kings and vassals bearing the royal clan name of Liu. They waged war in the name of "removing the bad influence surrounding the emperor" (*qing jun ce*).

3 Xuzhou Museum and Nanjing University, Department of History, Archaeology Major 2003; Qiu Yongsheng and Xu Xu 1992; Nanjing Museum and the Cultural Bureau of Tongshan County 1985; Nanjing Museum 1985; Xuzhou Museum 1997; Xuzhou Museum 1984; Excavation Team of the Chu Royal Tomb at Shizi Mountain 1998; and Geng Jianjun and Liu Chao 2013.

4 Henan Provincial Institute of Cultural Relics and Archaeology 1996; Henan Province Shangqiu City Cultural Relics Management Committee et al. 2001; Shandong Museum 1972; Institute of Archaeology at the Chinese Academy of Social Sciences and Henan Provincial Cultural Relic Management Office 1980.

5 The end of the tunnel is open to the air and is called a tomb passage. The portion of the tunnel extending to the main chamber is enclosed and is called a corridor. In the tomb at Shizi Mountain the entrance to the corridor is blocked by a rock upon which text is carved in vermillion.

6 Liu Dunzhen 1980.

7 Nanjing Museum and the Cultural Bureau of Tongshan County 1985 and Nanjing Museum 1985.

8 See Zou Yang's (fl. 150 BCE) "Jiu fu" (Rhapsody on Ale) in Ge Hong 2009. See also Guo Xian's (fl. 9–35) *Hanwu dongning ji, juan er* (A record of the Han Emperor Wu's penetration into the mysteries of separate realms, vol. 2) in Smith 1992, p. 611.

9 During the Han dynasty, an emperor was served by an administration led by "six masters"—the master of books, the master of food, the master of clothing, etc. (In reality, there were more than six.) The master of chambers was devoted to managing affairs related to the emperor's sleep.

10 Inscription on the top of the leopard mat weight, providing the actual weight inside the object.

11 Qu Yuan 2002.

12 Sima Qian 1961.

13 The emperors imbibed according ceremonial regulations. These rules were meant to reveal whether or not the emperor was truly humble and respectful of the wise.

14 Ban Gu 1962.

15 Fu Yi lived during the Eastern Han period. *Luo* (gossamer) is a light type of silk that floats in the wind. During the Han dynasty, the sleeves of gowns were very long and wide, like those worn by dancers in ancient times and whose motion created a dazzling spectacle during dance.

16 Fu Yi 1996.

17 Ban Gu 1974, p. 62.

18 The color red was worshipped during the Han dynasty, and the sight of red in the palace inspired feelings of solemnity and mystery. During the Qin and Han dynasties cinnabar was called *dan* (red). In *Records of the Grand Historian,* Sima Qian mentions Qing, the widow of Ba, who lived during the Qin dynasty and mined cinnabar, generating considerable wealth for several generations of her descendants; see Sima Qian 1959. The primary ingredient in cinnabar is mercuric sulfide, which has antibacterial and anticorrosive properties.

19 Sun Xingyan et al. 1990.

20 Yangzhou Museum 2004.

21 Knoblock and Riegel 2000.

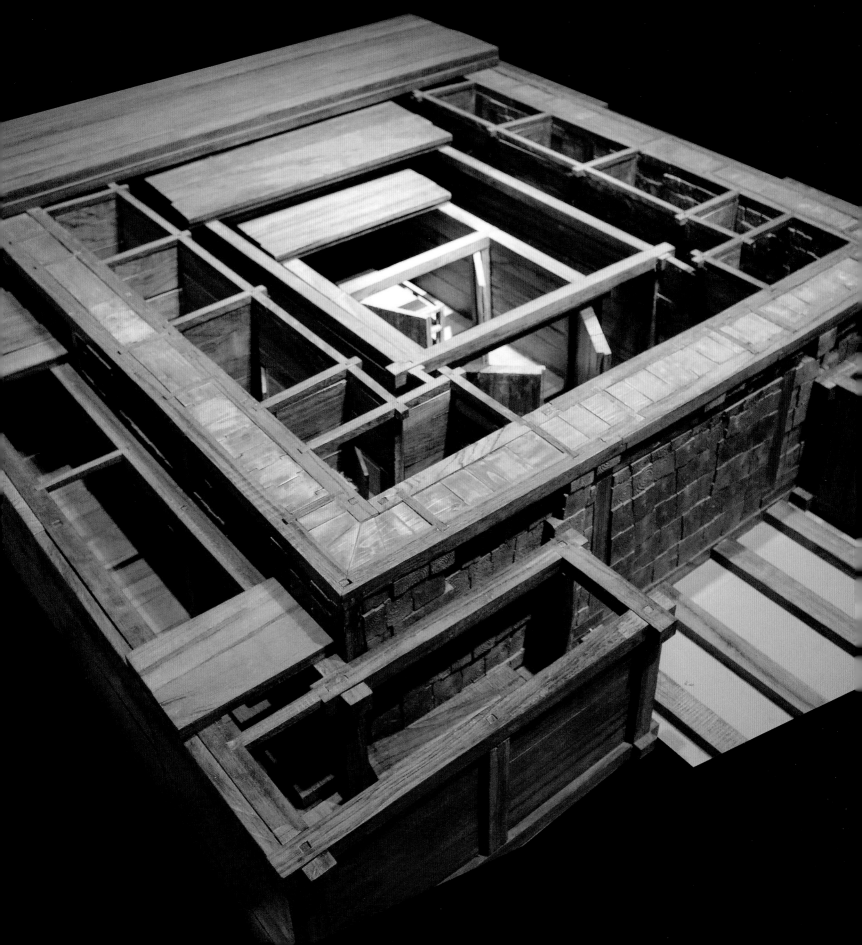

Mausoleums of the Kings of Wu, Sishui, and Guangling

Model of Guangling royal Tomb 1 at Shenju Mountain, displayed at the Nanjing Museum

THE REGION OF CHINA KNOWN TODAY AS JIANGSU PROVINCE was the home of Emperor Gaozu (Liu Bang; reigned 202–195 BCE), the founding ruler of the Han dynasty. As such, Jiangsu was an ancestral land to the imperial family. After the establishment of the empire, this territory was divided into a number of kingdoms—including Chu, Jiangdu, Wu, Guangling, and Sishui—ruled by the Liu family. The fate of these kingdoms was closely tied to their relationship with the emperors and the court, particularly during the early, strife-filled decades of the dynasty. Some of these kingdoms, such as Wu and Jiangdu, rebelled against the emperor or lost the favor of the court and, as a result, quickly fell. A number of others, however, such as Chu, Sishui, and Guangling, survived to the end of the dynasty. Their rise and fall were related to the political struggles between the emperors and the ambitious kings who ruled these lands, a system established to guarantee the absolute power of the emperors while maintaining the stability of the empire. Despite the turmoil, this ancestral land was one of the richest regions in the empire, partly because of its proximity to abundant resources, particularly sea salt and copper.

Over the past century, extensive archaeological excavations have discovered a large number of Western Han royal mausoleums and elite tombs in Jiangsu, exposing a rich amount of information about the life and afterlife of the royalty and their officials. According to common mortuary practice at the time, all were buried in grand style, bringing enormous treasures with them into the afterlife. The structures of these mausoleums and tombs reflect the enormous wealth and prestige of these rulers, and the objects interred in their underworld homes exemplify the extravagant ways they had lived—or wished to live in the next life. These tombs and their contents represent the finest craftsmanship of the Han dynasty. The burial objects are made of gold, silver, jade, bronze, pottery, lacquer, and other refined materials, and some have no comparable precedents in the archaeological finds of China. They not only symbolize royal power and wealth, they also demonstrate just how culturally inspired and artistically creative the Han dynasty was.

THE MAUSOLEUM OF THE KINGDOM OF WU

Of all the states in Jiangsu, the kingdom of Wu was the shortest lived. It was established in 195 BCE after Emperor Gaozu made Prince Liu Pi the king. Wu was one of the largest early Han kingdoms, comprising territory that included what is now middle and southern Jiangsu, Shanghai, northern Zhejiang, and eastern Anhui; its capital was located in what we now know as Yangzhou. Liu Pi was able to build up a very powerful and wealthy kingdom through his control of sea-salt resources and the illegal casting of coins. His son was accidently killed in the Han capital, Chang'an, by Crown Prince Qi (later Emperor Jing; reigned 157–141 BCE). This was the beginning of Liu Pi's conflicts with the court. In 154 BCE he led the Rebellion of the Seven States, an uprising subsequently crushed by the emperor's army. After Liu Pi was killed, his kingdom ceased and was reestablished as the kingdom of Jiangdu in 153 BCE.

It has been difficult for archaeologists to identify tombs and other sites associated with the kingdom of Wu given its short history. Evidence suggests that the royal mausoleum complex of the Wu was likely located in the region of Miao (Temple) Mountain and Tuan (Circular) Mountain in what is now Yizheng county, Jiangsu province. In 1990 four large tombs at Tuan Mountain were excavated.[1] These tombs, all interring females, were ranged from the top to the bottom of the mountain. Based on the available information at that time, the archaeologist Zhang Min speculated that these four tombs accompanied that of Liu Fei, king of Jiangdu, which was believed to be located at Miao Mountain. However, as Li Zebin's essay in this publication shows (pp. 17–25), Liu Fei's mausoleum was actually at Dayun Mountain in what is now Xuyi county and not at Miao Mountain.

While the mausoleum on Miao Mountain has not yet been excavated, contextual evidence suggests that it was likely the burial place for Liu Pi of Wu or his queen (FIG. 4.1). Miao Mountain has an altitude of 46.9 meters; to its summit has been added an artificial earth mound about 55 meters long, 40 meters wide, and 2 meters high. Using Ground Penetrating Radar (GPR) coring techniques, archaeologists detected a rectangular pit under this earth mound about 32 meters long, 18 meters wide, and 11 meters deep. This pit is surrounded by a complicated series of wooden compartments, very likely the inner and outer chambers of the mausoleum. This all suggests a king's or queen's mausoleum. If this hypothesis proves true, the four large tombs on the slope of the adjacent Tuan Mountain should be the accompanying tombs of Liu Pi, likely for his consorts. All were interred with many bronzes, glazed ceramics, wooden statues, lacquerwares, and jades.

Rescue excavations undertaken since 1990 have found more tombs at Tuan Mountain. Tomb 5 was damaged by a local brick factory before the archaeological rescue efforts started. Evidence demonstrates it was a large tomb with three wooden compartments in the burial chamber. A pair of jade fish (CAT. 96) was found on top of the inner coffin in this tomb in 1994. Made of greenish nephrite, these fish are almost identical in size and decoration: head, eyes, fins, and tail were carved with simple concave lines, and the surface was fully polished. Fish had been a favorite subject for jades since the Shang dynasty (approx. 1600–1050 BCE), yet the popularity of this motif declined during the Han dynasty, making this pair particularly precious. While most were strung as pendants, this pair has no holes, meaning it is unlikely they were used in this fashion. The patina and the excessive polishing of the surface suggest they saw heavy use before being buried. It is possible they served as makeup implements, as the Han people believed that jades had the power to make people beautiful as well as immortal. A jade fish was

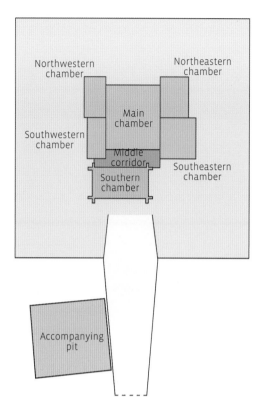

4.1 (left) Sign at the Wu royal tomb at Miao Mountain

4.2 (right) Plan of the Sishui royal tomb at Daqingdun

also discovered at the kings' mausoleum (tomb no. 1) at Dayun Mountain inside a lacquer box with a bronze mirror, further suggesting its use in relation to cosmetics. Jade fish were used for other purposes during the Western Han period, as well. A pair found in the hands of the deceased in a late Western Han period tomb in north Xi'an suggest they were used as funerary objects.

THE TOMBS OF THE KINGDOM OF SISHUI

Little was known about the kingdom of Sishui before the archaeological excavation of its mausoleums in 2002. Historical texts such as *Records of the Grand Historian* and *History of the Former Han Dynasty* record that the Sishui kingdom lasted from 113 BCE to 8 CE. Six kings ruled the minor kingdom over five generations; the first was Liu Shang, the last, Liu Jing. Historical texts record almost nothing about the Sishui except this genealogy. Its compact territory comprised parts of what is now Siyang county, Jiangsu province.

The excavation of the Sishui mausoleum complex in 2002–03 has provided rich information about the material culture, technology, and burial practices of the kingdom.[2] The complex is about 700 meters long and 500 meters wide. Within this area, more than forty burial mounds are clustered in five groups, each with a large mausoleum at the center. These five large tombs, each about 5,000 square meters, are believed to be the kings' mausoleums. They are situated on a north–south axis, connecting the burial site to the capital of the kingdom to the south.

The main tomb in one of these clusters is known as the Daqingdun mausoleum (FIG. 4.2). It consists of a pit about 18.5 meters square and a ramp more than 10 meters long and 4.2 meters wide. The pit was a burial chamber with five compartments constructed from large wooden timbers and planks; in the middle of one of these compartments were two coffins, indicating this was a joint husband-and-wife tomb. Inscribed on top of one of the outer coffins are such words as "king's residence" (*wang zhai*) and "king of Sishui's tomb" (*sishui wang zhong*), yet it is not clear which king was buried in this mausoleum. Some scholars believe it was the fourth king, Liu Xuan, or the fifth, Liu Jun. A silver seal bearing the name of Liu Sui was discovered at one of the pits where looters stored goods, but no king had this name. Archaeologist Li Yinde has questioned whether this was even the tomb of a king, since in no mausoleums of the Western Han period excavated so far have a king and his wife been buried together.[3] Nevertheless, given its size and location in the cluster, it is more than likely a mausoleum for a king and his queen.

Although this mausoleum was looted many times, archaeologists still found more than 660 objects, including lacquers, bronzes, iron items, ceramics, and jades. Among the most notable discoveries are 549 lacquer and wooden objects, including a stunning procession of wooden figurines: standing and sitting human figures, cavalry soldiers, horses, musicians, dogs, a boat, a tiger, drums, and even chariots. This find demonstrates that the burial practices of the Sishui kingdom were deeply rooted in the ancestral traditions of the kingdom of Chu during the Warring States period (approx. 480–221 BCE). This excavation also uncovered bronze objects that are among the best yet found from the Western Han period. Especially noteworthy are a crossbow trigger mechanism (CAT. 16) and a bronze bath basin (CAT. 56).

The crossbow appeared in the fifth century BCE, and it soon revolutionized warfare. It was the most efficient long-range weapon from the late Warring States period to the Han dynasty, and it was said a crossbow could fire a bolt a half a mile. As a result, the weapon was widely used by the forces of all states and saw continual improvement over time. The trigger mechanism in this publication is exceptional in that it was elaborately inlaid with gold and silver. On the bottom of the arrow socket, two silver-inlaid birds fly as a long gold-inlaid arrow seems to be shooting toward them. The trigger and the "tooth," or sighting device, are also full of mysterious creatures and clouds inlaid in gold and silver. Such an elaborately decorated weapon is very rare, indicating that it was likely a favorite of this Sishui king.

Bronze basins were widely used for bathing during the Western Han period, and many of them were made in the imperial workshops at the capital, Chang'an. Some were given to kings or other royalty by the emperor or empress as gifts or rewards. A bronze basin excavated from the Daqingdun mausoleum bears the inscription "*chang le,*" indicating it was initially used at the emperor's Changle Palace and later given to a Sishui king. Vessels of a similar size were also found at the mausoleums of the Chu kingdom (see Li Yinde's essay, pp. 27–37), and some of those were fully gilded, indicating their status as precious items.

THE TOMBS OF THE KINGDOM OF GUANGLING

History of the Former Han Dynasty records that the kingdom of Guangling was established in 117 BCE by Emperor Wu (reigned 141–87 BCE) and that its first king was Liu Xu, son of the emperor. Liu Xu ruled the kingdom for sixty-three years (117–54 BCE). Harboring ambitions to become emperor himself, he committed suicide when his plots were discovered. The kingdom was occupied for seven years, but in 47 BCE

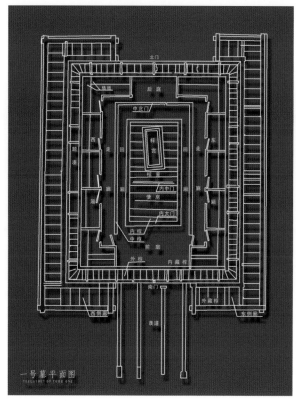

4.3 (left) Detail of the *huangchang ticou* chamber at Guangling royal Tomb 1 at Shenju Mountain

4.4 (right) Plan of Guangling royal Tomb 1 at Shenju Mountain

Liu Xu's son Liu Ba was installed as the king by Emperor Yuan (reigned 49–33 BCE). After four more short-lived kings, the Guangling kingdom was eventually destroyed in 9 CE by Wang Mang, the founder of the Xin dynasty (9–23 CE).

The excavation of two mausoleums in Gaoyou county in 1979–80 uncovered rich material related to the afterlife of the Guangling kings.[4] These mausoleums are located on Shenju Mountain, very close to the site of the Guangling capital, in what is now Yangzhou. Written records found inside the tombs leave no doubt that they are the mausoleums of Liu Xu and his queen.

Both mausoleums feature a complicated *huangchang ticou* chamber, in which the inner and outer coffin compartments were surrounded by a wall of well-cut timbers—an amenity only the king and his queen enjoyed in the Western Han period (FIG. 4.3). The chamber of mausoleum 1 was further elaborated by two wooden corridors inside and outside the wall of the *huangchang ticou* (FIG. 4.4). These corridors are 13 meters long, 11 meters wide, and 4 meters high, with two doors facing north and south, respectively. More than 850 planks were used to build this wall. The coffin chamber was also divided into two compartments, with the two nested coffins in the rear compartment. The inner and outer corridors were further divided into small rooms, the name of each clearly labeled on the door: "central court" (*zhongfu*), "food officials" (*shiguan*), and so on. Each room was filled with a different type of funerary objects, such as wooden figurines, wooden animals, lacquerware, ceramics, and bronze coins. Unfortunately, this tomb has been looted, so the original number and types of objects interred here are not known. Scholars believe this is Liu Xu's mausoleum.

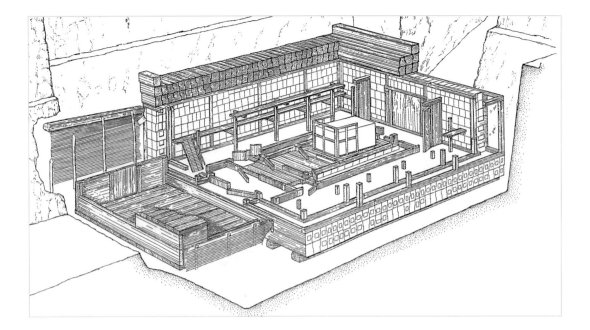

Tomb 2 has a similar chamber structure (FIG. 4.5). Each of the timbers in the *huangchang ticou* wall was marked with numbers and locations, suggesting that the construction process was well organized. Some of the planks were initially employed for other purposes as indicated by their inscriptions; one, for instance, was used to build a boat. Given the amount of wood required for building such an enormous underground palace, it is not surprising that the kingdom made use of whatever resources were available. Mausoleum 2 has two inner coffins and three outer coffins. Fragments inside the inner coffin suggest that the deceased was buried in a jade shroud sewn with gold threads. Twelve life-size wooden chariots and horses were found in one of the tomb's outer compartments, indicating the extravagant lifestyle of the deceased. Several objects provide conclusive evidence about the identity of the deceased: four characters—"private court of Guangling" (*guangling si fu*)—on a clay seal clearly indicate this is a mausoleum of the Guangling kingdom. A wooden tablet in the outer chamber has a line of writing in ink that says, "The *wuxi* day of the eighth month in the sixty-second year" (*liushier nian ba yue wuxu*). Since Liu Xu was the only king of Guangling to rule that long, this inscription is strong evidence that the mausoleum is that of his queen.

4.5 Structural diagram of Guangling royal Tomb 2 at Shenju Mountain

THE TOMBS OF OTHER ROYAL FAMILY MEMBERS OR OFFICIALS

In addition to the mausoleums of the Wu, Sishui, and Guangling kingdoms discussed above, a number of other Western Han tombs have been excavated within their territories. Some of the larger ones were possibly for members of the royal family or officials as indicated by the elaborate furnishing of the tombs. These finds have provided new material to help us understand the social lives and material culture of these kingdoms unrecorded in any historical texts. Twelve objects included in this publication were excavated from four cemeteries—Yandai Mountain, Lianying, Zhanzhuang, and Huzhuang—in what is now Yizheng county, Jiangsu province. Each cemetery has clusters of tombs, indicating they

belonged to specific clans or families. The size and structures of the tombs in which these objects were found indicate they were elite tombs. However, it is difficult to determine their associations with specific states as the region was ruled successively by the three different kingdoms in the early and middle Western Han period. Both the Wu and Jiangdu kingdoms lasted only a few decades, and the archaeological data from these tombs are typically not enough to identify which kingdom they belonged to unless the tombs contain burial objects with written evidence to date them.

In 1985 the Nanjing Museum excavated a large Western Han tomb at Yandai Mountain, revealing more than 400 objects, including 126 wooden human figurines and 10 wooden horses.[5] It was a large tomb—about 9 meters long, 5 meters wide, and 8 meters deep—intended for a couple. Although it was looted before excavation, the basic structure remained intact. The tomb pit was covered with rammed earth and a layer of mud about a meter thick. A T-shaped wooden chamber was covered with big wooden planks and timbers; some of the planks are 4.5 meters long. The chamber is divided into five compartments, with the largest further divided into four rooms with two coffins in the middle. An auxiliary room was filled with wooden horses, wooden dogs, and bronze and ceramic vessels. About 388 objects, including most of the wooden human figurines, were found in the main compartment, but the rest of the tomb was badly looted. Based on the size, structure, quality, and quantity of the funerary objects, it is believed the deceased couple interred in this tomb were likely members of the Jiangdu or Guangling royal family.

The wooden figurines and horse statues are among the most important objects found in this tomb. Most Western Han royals and elite were interred with ceramic statues or figurines. The tradition of furnishing tombs with wooden figurines was a continuation of the burial practices of the state of Chu dating from the Warring States period. Many of the human figurines found at Yandai Mountain are meticulously carved to represent their gender and identity as servants, entertainers, or procession guards. A horse and rider (CAT. 21) are especially good examples. The body, head, tail, and feet of the horse were carved separately and then attached with wooden pegs. The rider was carved from a single piece of wood; his upper body, face, and hairstyle are well depicted, while the legs are roughly carved and the feet are missing.

A number of tombs at Yandai Mountain have been excavated since 1985, many of them conducted as rescue projects. As such, detailed information about the tombs is yet to be published. One piece found in 2002 is a glazed ceramic *hu* kettle (CAT. 40), an exceptional example of its kind. Such vessels, usually originating in southern China during the Western Han period, were fired at temperatures up to 1,200°C. The glaze, which ranges from green to yellow, was usually applied to the upper part of the vessel only. The high firing temperature turned the unglazed portion yellowish red or brownish purple, giving the vessel two contrasting colors. This particular kettle features a glazed lid decorated with double-lined circles, and the rim and neck were carved with wavelike motifs. The most intriguing decorations are the exotic birds on the shoulder, all meticulously incised into the clay before the application of the glaze. The birds were depicted looking back over their exaggeratedly long bodies and tails, a rather abstract and mystical representation. The handles are decorated with motifs of the heads of ferocious mythical creatures. Glazed stoneware of this type was highly valued by the upper classes of the Han dynasty, as it is found in many large tombs and mausoleums. Some were used as wine vessels, others as food containers. There are also examples imitating bronzes to serve as ritual vessels.

In 1999 Yizheng County Museum conducted a rescue excavation of a damaged tomb at the Yandai Mountain cemetery. One of the objects uncovered at that time was the jade mount of a scabbard decorated with a dragon design (CAT. 15). For the elite class during the Western Han period, it was common practice to use jade in their scabbards, often with feline motifs. However, this piece is exceptional in that it features two cats playing. The larger cat is well carved in relief, and part of its body is executed in openwork. It twists gracefully while looking back toward the smaller cat, a vivid and joyful composition.

Lianying, another important elite cemetery, is only about one kilometer away from the Tuan Mountain-–Miao Mountain mausoleum complex discussed above. Since 1994 nine high-ranking tombs have been excavated there, mostly under the circumstance of rescue archaeology. Although detailed reports of these excavations are yet to be published, a number of articles have provided relevant information about objects featured in this publication. Tomb 10 at the Lianying cemetery was excavated in 2006. As the tomb was severely damaged, only about 100 objects were recovered, most of them bronze weapons and iron arrowheads. The large wooden planks inside the tomb chamber indicate this was an elite tomb, and its contents suggest the occupant was involved in major military campaigns.[6] The surviving objects were found in the western corner of the chamber, including an exceptional lacquer divination board (*shipan;* CAT. 81). During the Western Han period, this kind of board was consulted in relation to important military campaigns and political actions. Only a few such boards from the Western Han period have been excavated, and this one is among the earliest and most complex. The square wooden board is completely covered with dark brown lacquer, and the top is marked by rectilinear lines in red lacquer. Each area marked out by the red lines is identified by Chinese characters to indicate the heavenly stems (*tiangan*), the earthly branches (*dizhi*), the five elements (*wuxing*), the twelve months (*shi'er yue*), the four cardinal directions (*si fang*), and the twenty-eight constellations (*xingsu*). The characters were written in red on black lacquer and together constitute a complicated Chinese cosmology. It has three layers: the inner layer has the heavenly stems associated with the five phases: earth (*tu*) in the middle, corresponding with heavenly stems *wu* and *ji;* wood (*mu*) represents the east, which is associated with the heavenly stems *jia* and *yi;* fire (*huo*) represents the south, associated with the heavenly stems *bing* and *ding;* the west is represented by metal (*jin*), associated with the heavenly stems *geng* and *xin;* and the north is water (*shui*), associated with *ren* and *kui.* The twelve earthly branches and the two months are found in the middle layer. The outer layer features the twenty-eight lunar mansions, seven on each side. The heavenly stems and the twelve months are arranged in a clockwise orientation, while the earthly branches and the lunar mansions run counterclockwise. This sequence is identical to that of a fabric cosmic map found at the Mawangdui tomb, indicating both were used for divination. The fact that this board was found in a tomb with many weapons indicates it was likely used by the deceased for divining military campaigns.

Many thousands of lacquer objects have been excavated in Yizheng and the adjacent Yangzhou area, indicating this was likely an important production center of lacquerwares during the Western Han period. In fact, some of the lacquer objects have workshop names such as "*dongyang*," which likely refers to the site of modern-day Dongyang in Xuyi county.[7] Lacquer was obviously highly valued by the elite, as many of the large tombs excavated to date were well stocked with lacquer objects. Many of these were daily utensils, such as the pouring vessel (CAT. 59) found at one of the tombs at the Lianying cemetery.

This vessel is completely covered in black, brown, and red lacquer and decorated within and without by a series of fluid clouds in dark brown and red, giving it a mysterious appearance.

The tomb at Lianying also held an object in the shape of a penis (CAT. 62). It was cast in bronze, is hollow, and features a ring at its base. Similar objects have been found in Liu Fei's mausoleum at Dayun Mountain (CAT. 61) and other tombs, suggesting they were popular in the Western Han period. They are believed to have been used by females as sex toys.[8] But the fact they are all hollow suggests that they may have been used by men, too. Most of these phalluses were, like this one, found in the tombs of males, indicating the deceased had made use of them in life. Historical texts record that during the Western Han period kings usually had hundreds of consorts and other female servants, so it is perhaps not surprising that there was a need for this kind of aid.

Of all the Western Han lacquer objects excavated from the tombs in Yizheng county, none has puzzled archaeologists more than the rectangular lacquer object (CAT. 17) discovered on top of a coffin in a large tomb at Zhanzhuang, Chengi, in 1994. It was first believed to be a shield, but after repair and much research, scholars now believe it was a ceremonial fan used in processions and other important occasions. Historical texts called this kind of fan a *sha*. Its top is rounded, and there was likely a handle attached to the bottom, now missing. On the front, elaborate designs and fantastical creatures are painted in yellow and black lacquer over a red lacquer background. At the top of the board two birdlike humans face each other, one kneeling with open arms, the other bending over. In the middle of the board two flying birds reminiscent of peacocks face one another as a swan flies in the background. Under these birds are two fearsome beasts: one has the head of a tiger with horns, the body of a leopard, and dragon claws; the other looks like a tiger. Beneath these creatures two bird-men ride a tiger and a dragon before a cloud background that makes it seem as if they are flying. Across the bottom stand a turtle, a snake, and a dragon with wings. The tiger, dragon, peacock, and turtle symbolize the four cardinal directions. Around these mysterious images zigzag lines in black lacquer. The imagery on the back is equally complex, featuring bird-men, flying peacocks, dragons, rabbits, deer, cows, and a turtle on a background of red lacquer. Clouds and other cryptic motifs fill the space between the images, and the entire composition is framed by a circle of triangles painted in red and brown lacquer.[9]

CONCLUSION

The royalty of the Western Han period was a unique class. Members of the royal family received extravagant privileges and lived as lords on their enfeoffed lands. Those who ruled lands in their ancestral homeland of Jiangsu had access to critical resources such as sea salt and copper, and their kingdoms were among the richest of the dynasty. Some rulers were content to indulge themselves in extravagant lifestyles, surrounding themselves with luxurious goods, entertainment, and women. Others were not satisfied being mere kings and chose to challenge the emperor; some launched unsuccessful rebellions and eventually lost their kingdoms. The fights between these ambitious kings and the emperor constituted some of the most critical episodes in the early Western Han period. Yet their stories amount to little more than a few lines written by early historians, many of whom tailored their narratives to serve particular political ends. What really happened in these kingdoms remained virtually unknown before the arrival of modern archaeology.

Over the past century, a great number of royal mausoleums and tombs have been excavated by archaeologists. While many had been looted, archaeologists have been able to uncover an enormous amount of data that has given us a much better understanding of the lives and afterlives of these people. As royalty, they all were interred in elaborately furnished underground palaces. They brought with them all kinds of goods in the hope that they might enjoy the afterlife in the style to which they had become accustomed: armies, servants, chariots, precious objects, necessary utensils, foods, even sex toys. These materials have opened up a window that allows us to examine the technology, culture, beliefs, and many other aspects of life in the Han dynasty that have gone unrecorded in historical texts.

1 Zhang Min et al. 1992.

2 Lu Jianfang et al. 2003.

3 Li Yinde 2013.

4 Nanjing Museum 1990.

5 Nanjing Museum 1987.

6 Liu Qin 2007.

7 Li Zebin 2002.

8 Chen Hai 2004.

9 Huang Ruxuan 2015.

Excavation at Dayun Mountain

IN EARLY 2009 THE DEATHS OF FOUR TOMB ROBBERS IN JIANGSU PROVINCE brought the attention of the local government to a little-known site. The place was named "dragon pond" (*longtang*), and it sat in a stone quarry on Dayun Mountain, sixteen miles west of Xuyi county, near the border of Anhui province. Archaeologists soon determined the site was a Han-dynasty cemetery, and they started a salvage excavation in September 2009. They discovered that the cemetery was a well-preserved royal mausoleum of a vassal kingdom of the Western Han period (206 BCE–9 CE). Over the next two years, they excavated three large tombs, thirteen attendant tombs, two weaponry pits, and two chariot pits, unearthing more than 10,000 artifacts. Based on the inscriptions of burial objects, archaeologists now speculate that the tomb occupants were Liu Fei, the king of Jiangdu; two of his queens; and a dozen of his consorts. In 2011 this find was selected as one of the ten most important archaeological discoveries in China, and the mausoleum site has now been established as a museum.

The following pages show a selection of photographs taken during the 2010–11 excavation of Tomb 1 at Dayun Mountain, the tomb of Liu Fei. Accompanied by the two large tombs of his queens, this tomb is located at the southeast corner of a sixty-two-acre walled mausoleum complex about 73.6 meters above sea level. Because it had been looted several times since the Eastern Han period (25–220 CE), nothing is left in the central chamber except for a wood frame and block structure. Due to the collapse of the floors of the top level, the lower level of the tomb's corridors and side chambers were hidden away from previous tomb robbers, leaving burial objects inside mostly untouched. The excavation photos show how objects were tightly packed together in different storage compartments, including those for kitchen vessels, banquet containers, toiletry items, weaponry, interior furniture, and coins. The majority of artworks in this publication were unearthed from this tomb. While these photos show that many of the objects were found damaged, the Nanjing Museum has recently managed to restore some of the most important works so that we may see them in their original condition.

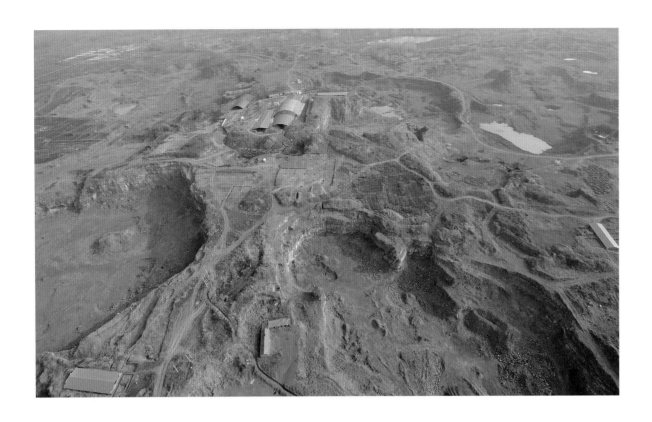

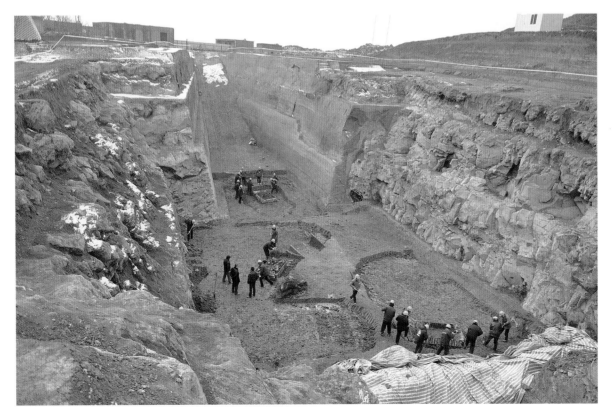

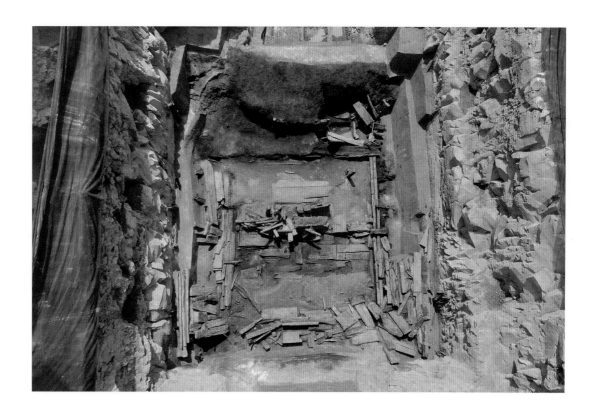

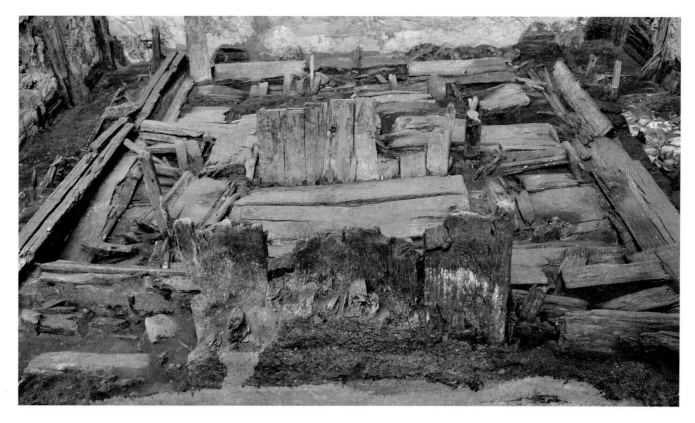

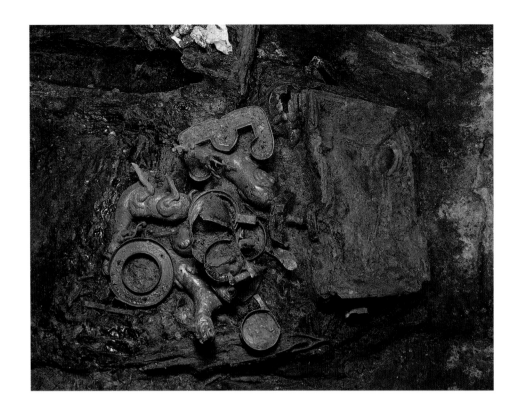

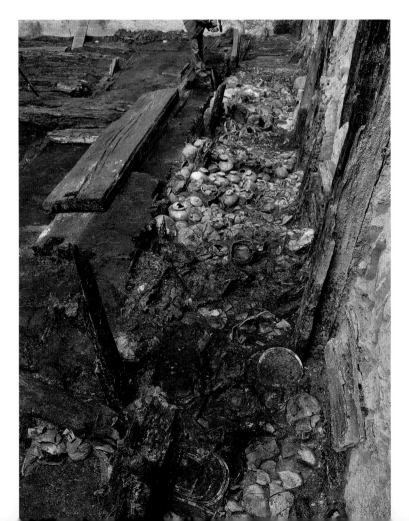

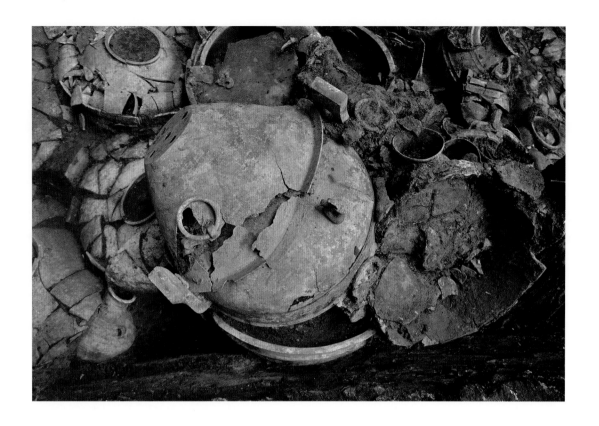

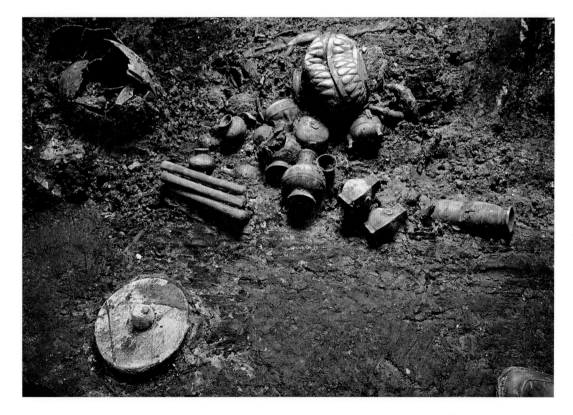

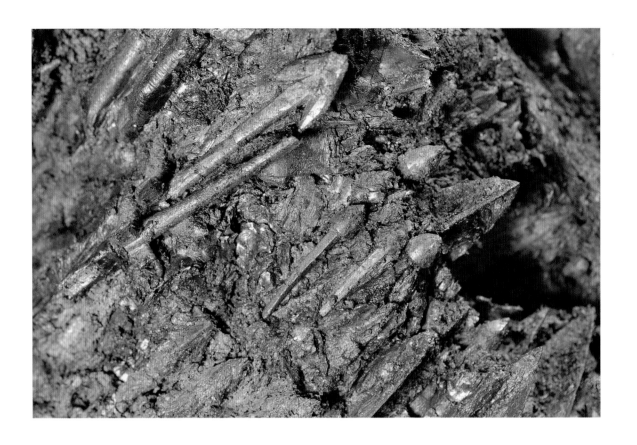

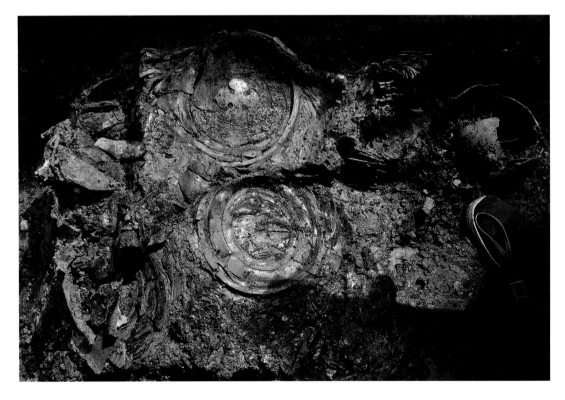

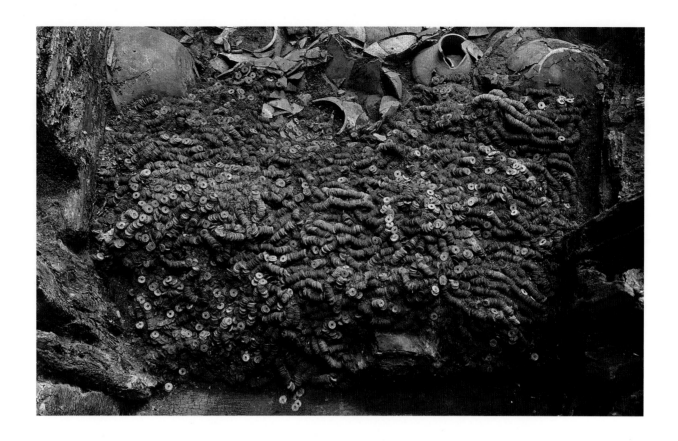

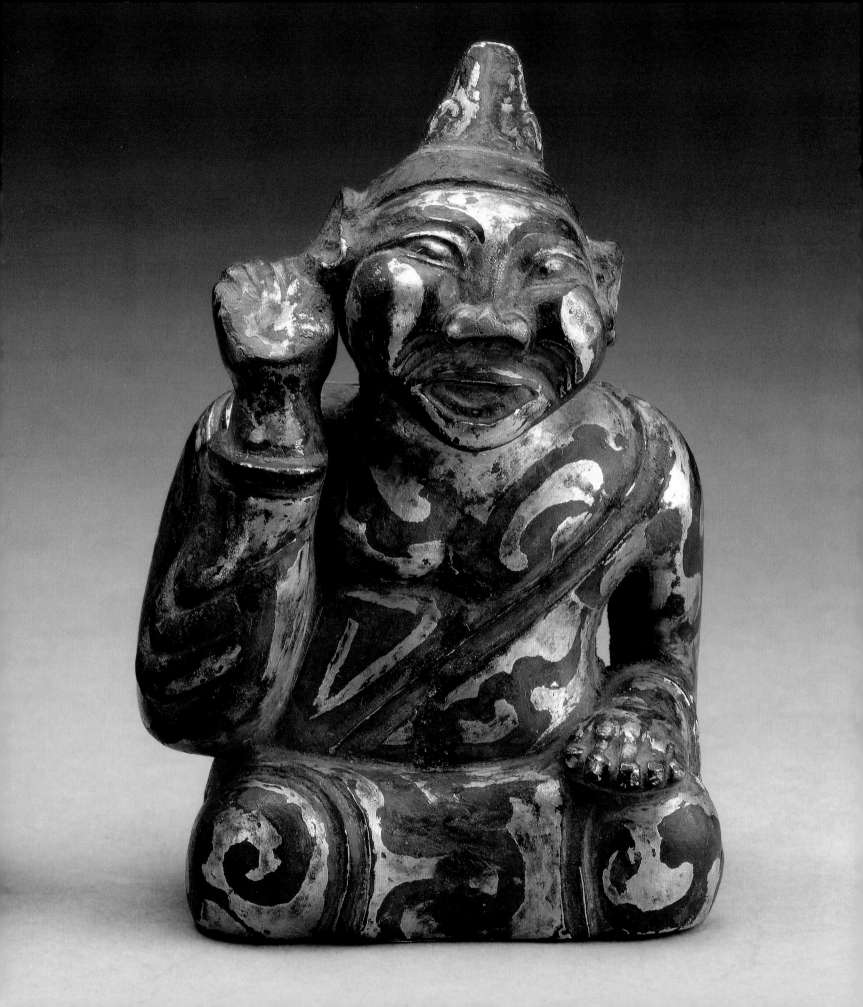

Catalogue of Works

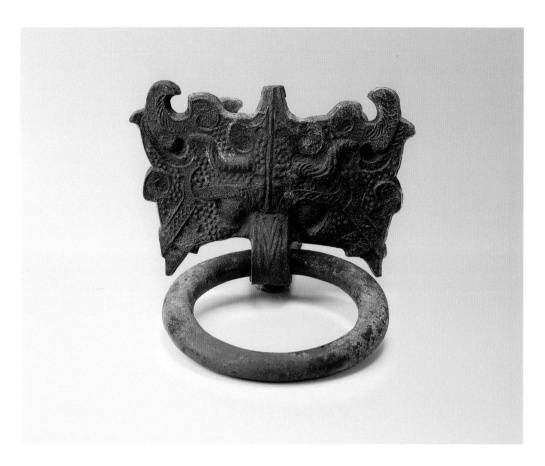

1

銅鋪首 盱眙大雲山1號墓
1號坑出土 西漢早期

**Pair of door handles
(*pushou*)**

Unearthed from Tomb 1, Pit 1,
Dayun Mountain, Xuyi, Jiangsu
Western Han period (206 BCE–9 CE),
2nd century BCE
Bronze
H: 24 cm, L: 14.5 cm, W: 18.5 cm
H: 23.8 cm, L: 14.5 cm, W: 16.5 cm
Nanjing Museum

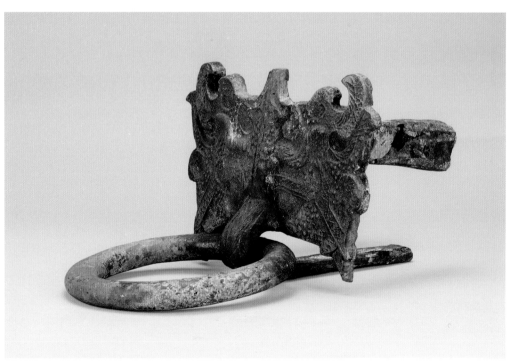

2

"半兩" 銅錢 徐州北洞山
楚王墓出土 西漢早期

Banliang coins

Unearthed from the Tomb of the King of
Chu, Beidong Mountain, Xuzhou, Jiangsu
Western Han period (206 BCE–9 CE),
2nd century BCE
Bronze
Diam: 2.5–4 cm
Xuzhou Museum

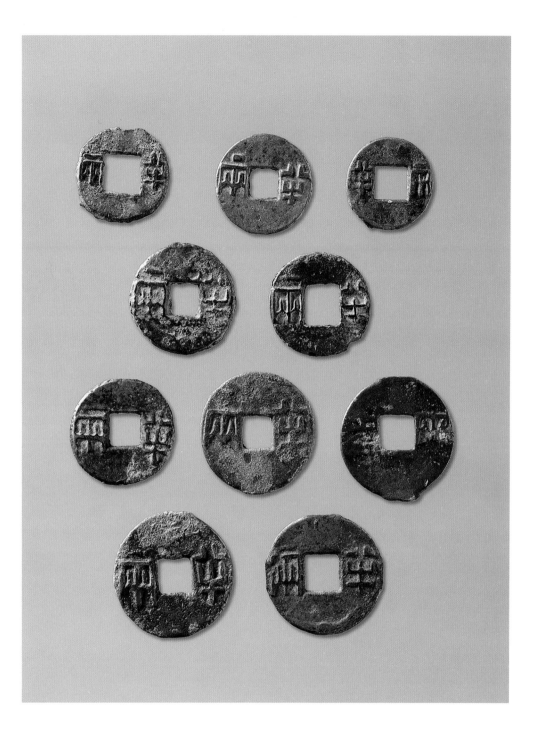

3

青銅編鐘 盱眙大雲山1號墓出土
西漢早期

Bell set

Unearthed from Tomb 1,
Dayun Mountain, Xuyi, Jiangsu
Western Han period (206 BCE–9 CE),
2nd century BCE
Bells: bronze; stands: lacquer and silver
H: 218 cm, L: 345 cm, W: 50.5 cm
Nanjing Museum

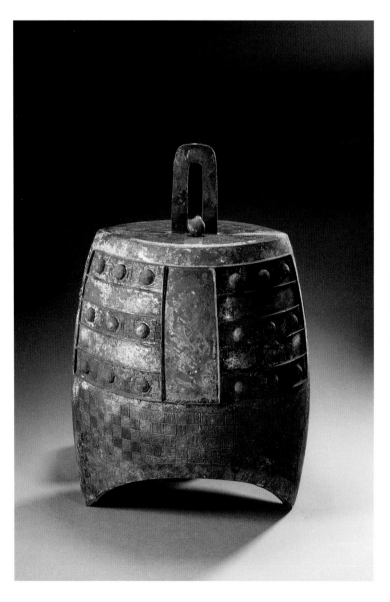

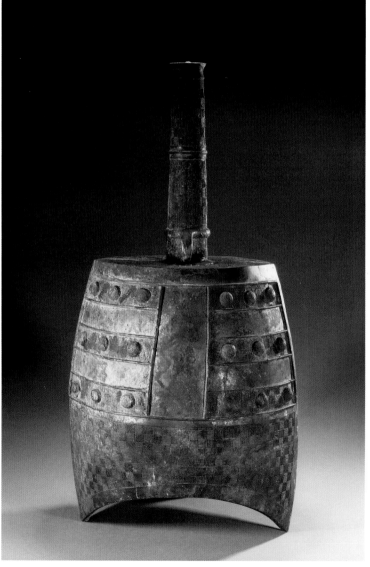

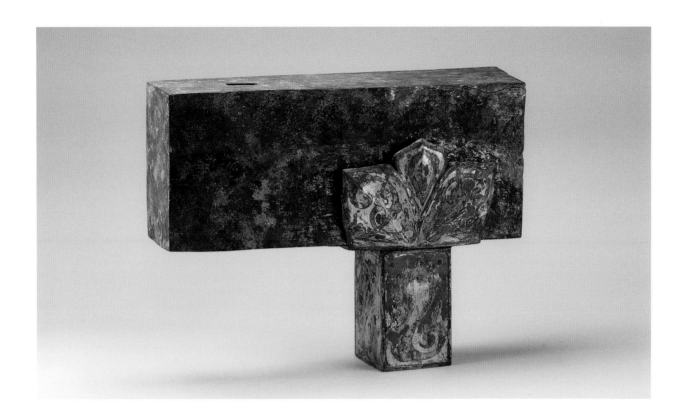

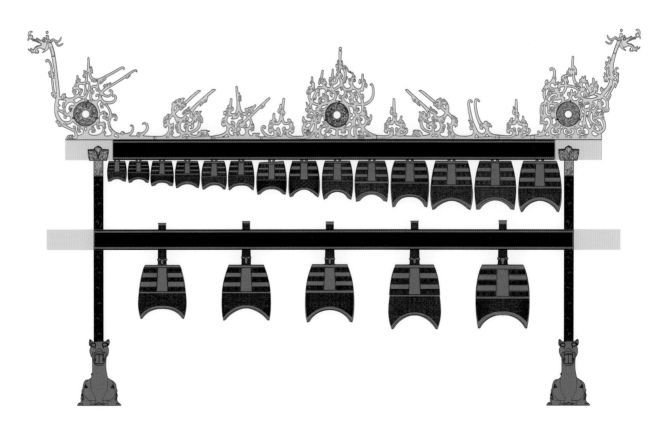

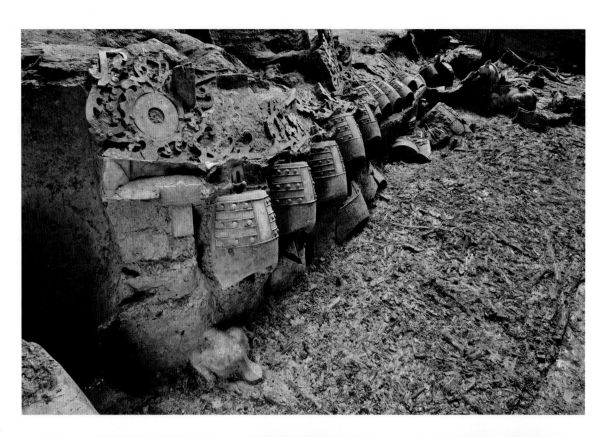

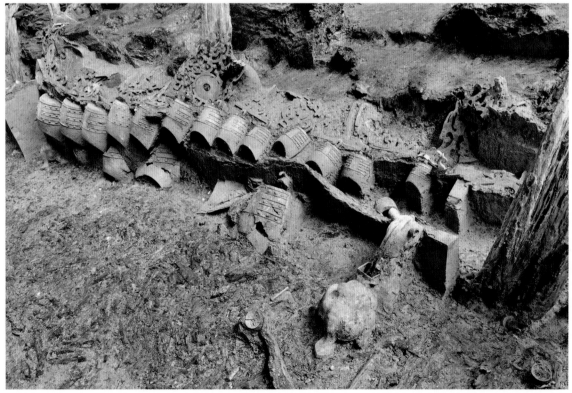

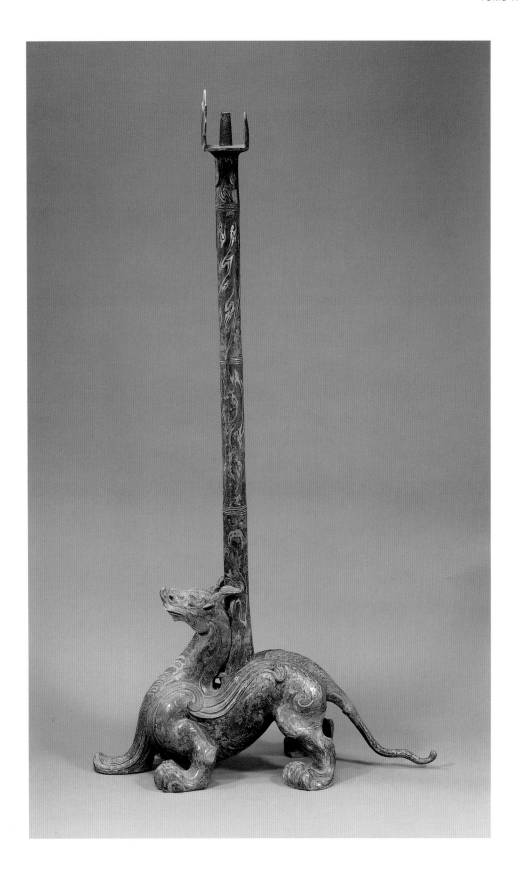

4

编磬器座 盱眙大雲山1號墓出土
西漢早期

Stand for musical chimes

Unearthed from Tomb 1,
Dayun Mountain, Xuyi, Jiangsu
Western Han period (206 BCE–9 CE),
2nd century BCE
Bronze with inlays of silver
H: 104 cm, L: 56 cm, W: 26 cm
Nanjing Museum

Two of these artworks are exhibited.

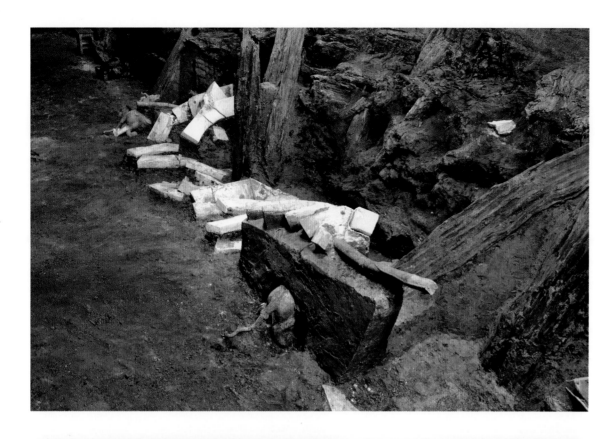

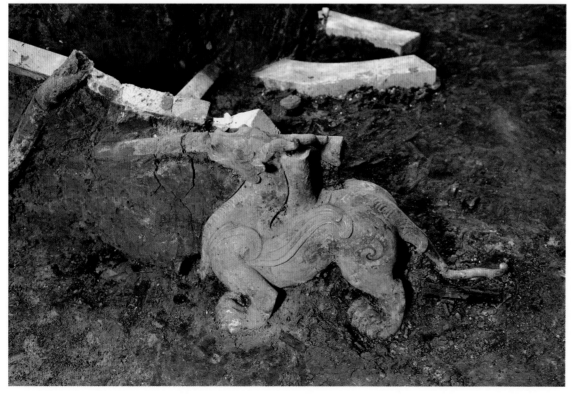

5

陶舞女俑 徐州出土 漢朝

Pair of female dancer figurines

Unearthed in Xuzhou, Jiangsu
Han dynasty (206 BCE–220 CE)
Earthenware
H: 46 cm, L: 35 cm, W: 23 cm
H: 46 cm, L: 34 cm, W: 26 cm
Nanjing Museum

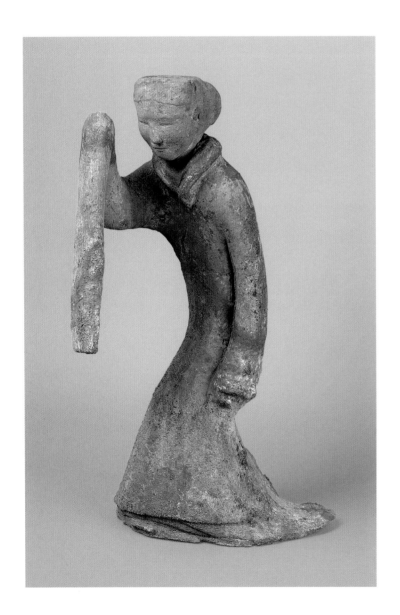
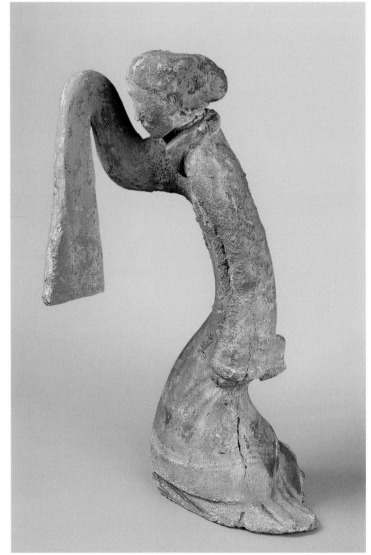

6

陶舞俑 徐州馱藍山楚王墓出土
西漢早期

Dancer figurine

Unearthed from the Tomb of the King of
Chu, Tuolan Mountain, Xuzhou, Jiangsu
Western Han period (206 BCE–9 CE),
2nd century BCE
Earthenware
H: 49 cm, L: 23 cm, W: 48 cm
Xuzhou Museum

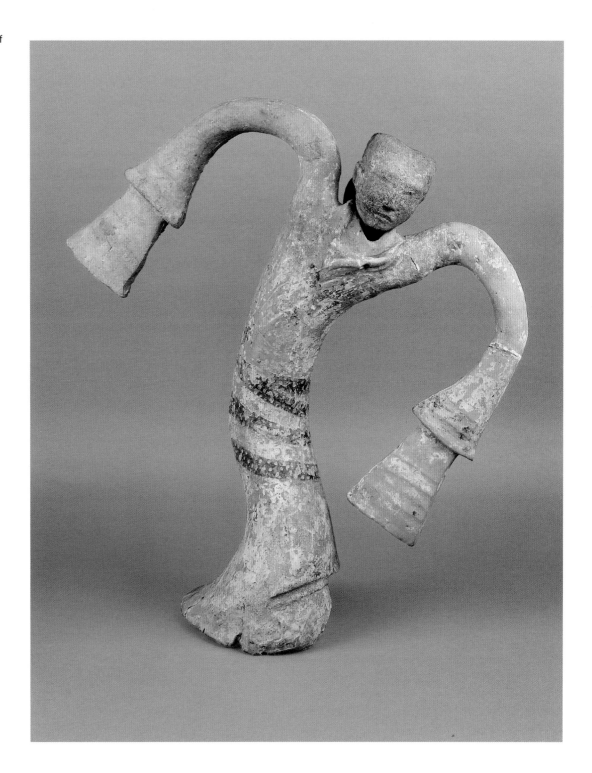

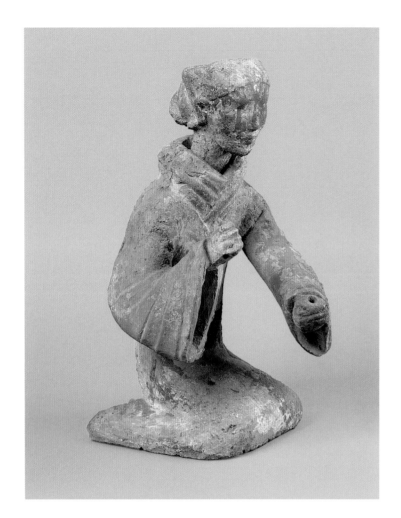
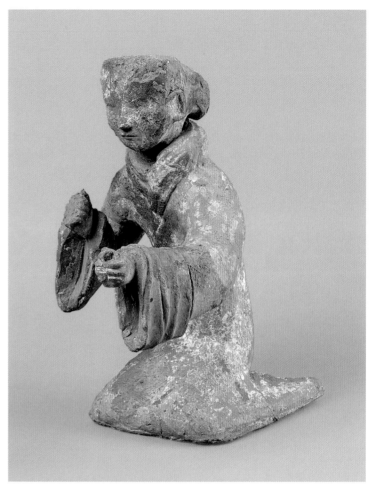

7

陶女樂俑 徐州出土 漢朝

Pair of female musician figurines

Unearthed in Xuzhou, Jiangsu
Han dynasty (206 BCE–220 CE)
Earthenware
H: 33 cm, L: 24 cm, W: 20 cm
H: 31 cm, L: 27 cm, W: 23 cm
Nanjing Museum

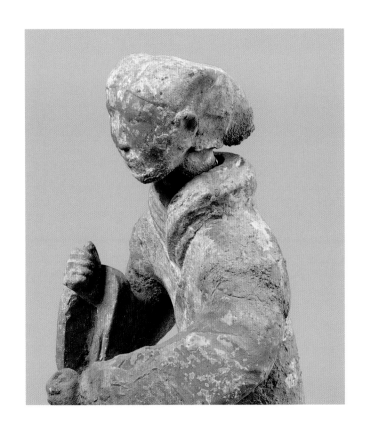
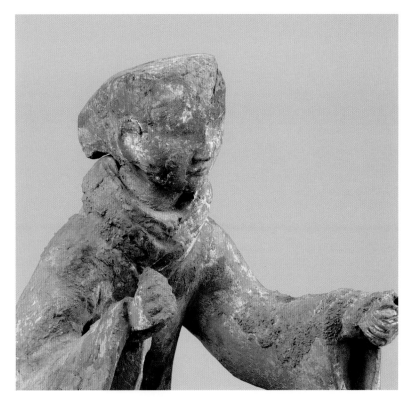

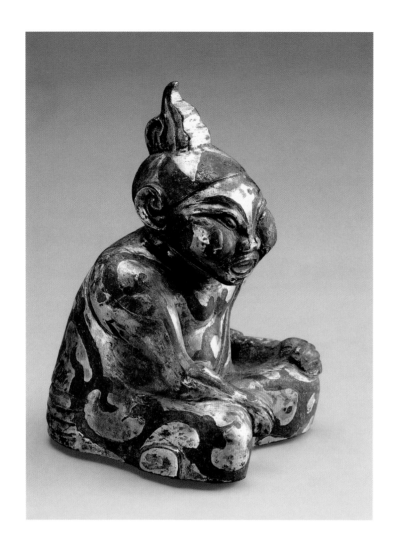

8

錯金銀說唱俑銅鎮 盱眙大雲山
1號墓出土 西漢早期

Set of mat weights in the shape of figures listening to music

Unearthed from Tomb 1,
Dayun Mountain, Xuyi, Jiangsu
Western Han period (206 BCE–9 CE),
2nd century BCE
Bronze inlaid with gold and silver
H: 7.8 cm, L: 4.8 cm, W: 5.1 cm each
Nanjing Museum

Two of these artworks are exhibited.

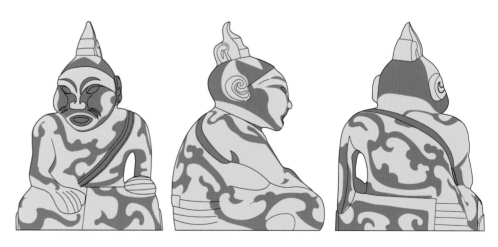

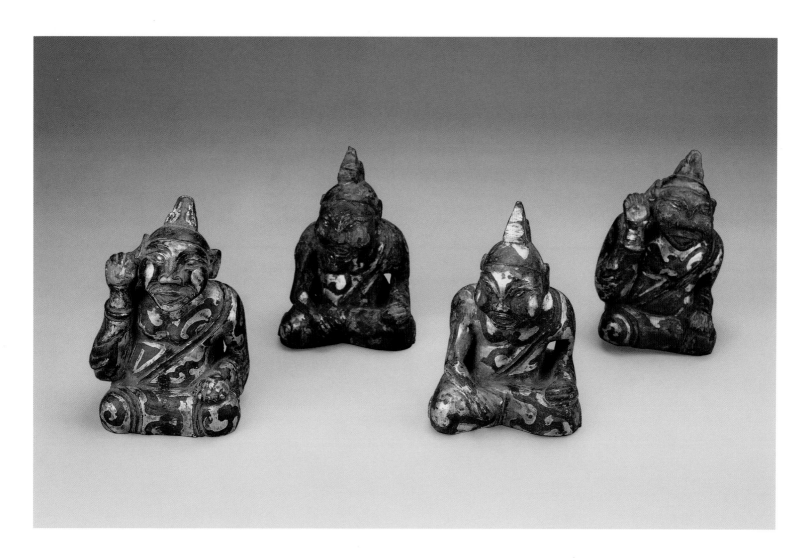

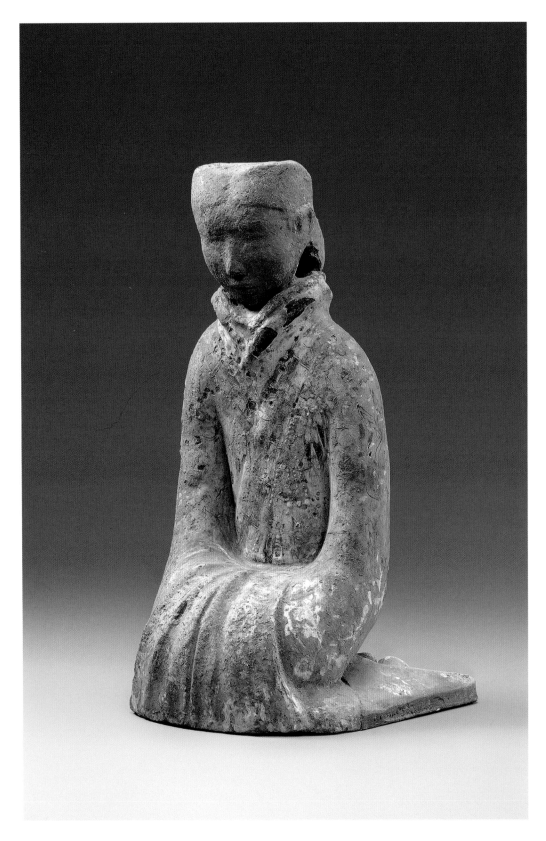

9

踑坐女陶俑 徐州北洞山
楚王墓出土 西漢早期

Kneeling female figurine

Unearthed from the Tomb of the King of
Chu, Beidong Mountain, Xuzhou, Jiangsu
Western Han period (206 BCE–9 CE),
2nd century BCE
Earthenware
H: 31 cm, L: 18 cm, W: 17.5 cm
Xuzhou Museum

10

鎏金青銅戈 盱眙大雲山1號墓
1號坑出土 西漢早期

Dagger-axe (*ge*)

Unearthed from Tomb 1, Pit 1,
Dayun Mountain, Xuyi, Jiangsu
Western Han period (206 BCE–9 CE),
2nd century BCE
Gilt bronze
H: 11.4 cm, L: 0.3 cm, W: 20 cm
Nanjing Museum

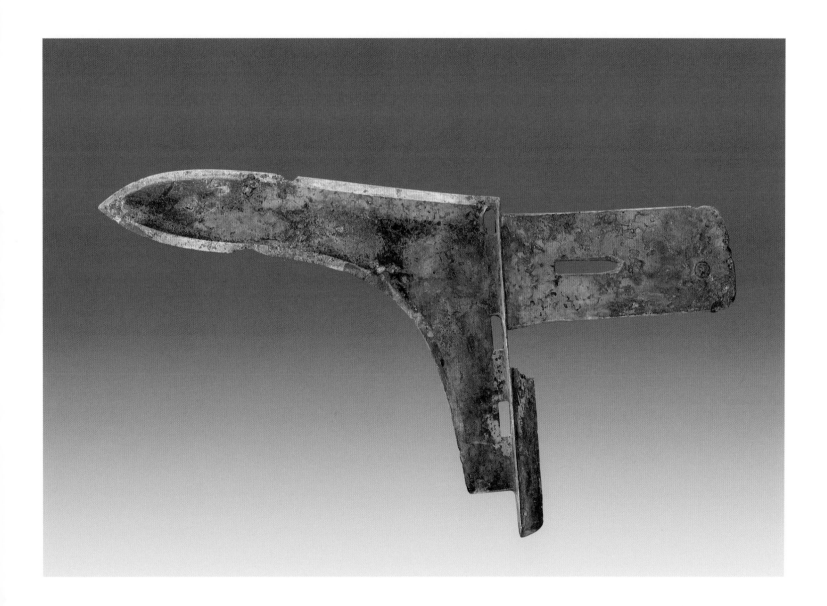

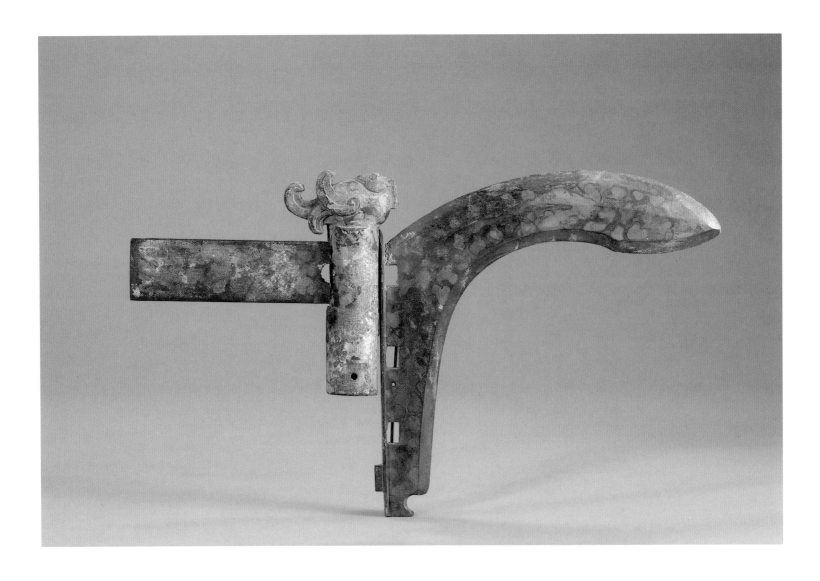

11

青銅戈 盱眙大雲山
1號墓1號坑出土 西漢早期

Dagger-axe (*ge*)

Unearthed from Tomb 1, Pit 1,
Dayun Mountain, Xuyi, Jiangsu
Western Han period (206 BCE–9 CE),
2nd century BCE
Bronze
L: 20.1 cm, W: 13 cm
Nanjing Museum

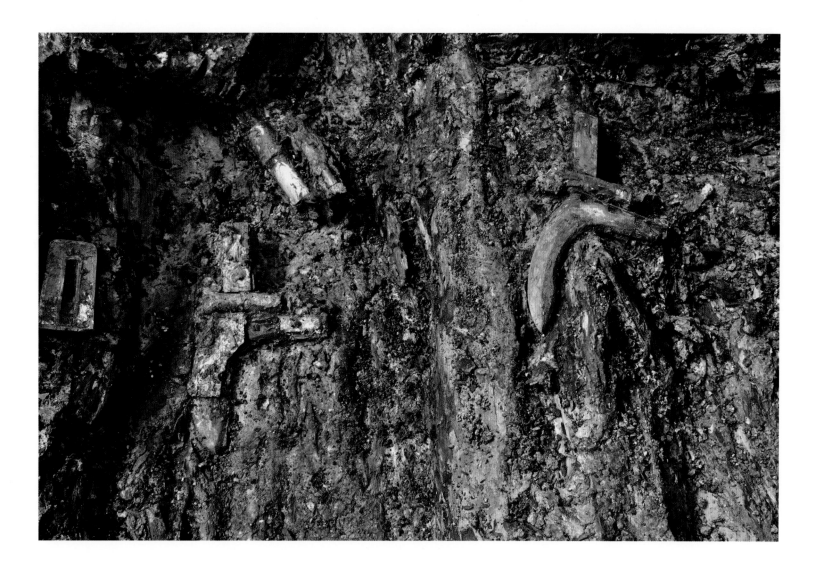

12

銅雞鳴戟和柲帽 盱眙大雲山
1號墓出土 西漢早期

Halberd (*ji*) and shaft cover (*bimao*)

Unearthed from Tomb 1,
Dayun Mountain, Xuyi, Jiangsu
Western Han period (206 BCE–9 CE),
2nd century BCE
Halberd: bronze; shaft cover: gilt bronze
with inlays of silver
L: 50.8 cm, W: 38.6 cm
Nanjing Museum

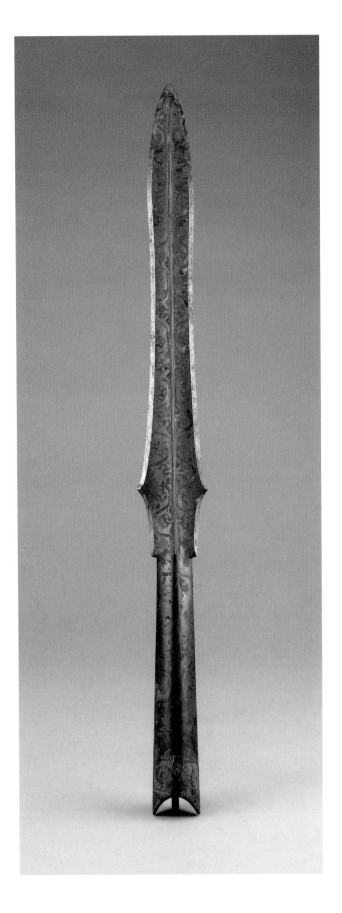

13

暗花紋銅矛 盱眙大雲山1號墓出土
西漢早期

Spearhead

Unearthed from Tomb 1, Dayun Mountain,
Xuyi, Jiangsu
Western Han period (206 BCE–9 CE),
2nd century BCE
Bronze
L: 45 cm, W: 5 cm
Nanjing Museum

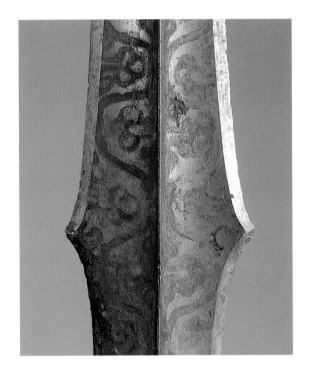

14

銅鈹 徐州獅子山楚王墓出土
西漢早期

Set of spears

Unearthed from the Tomb of the King of
Chu, Shizi Mountain, Xuzhou, Jiangsu
Western Han period (206 BCE–9 CE),
2nd century BCE
Bronze
L: 52.5 cm, W: 4 cm
L: 48 cm, W: 3.4 cm
Xuzhou Museum

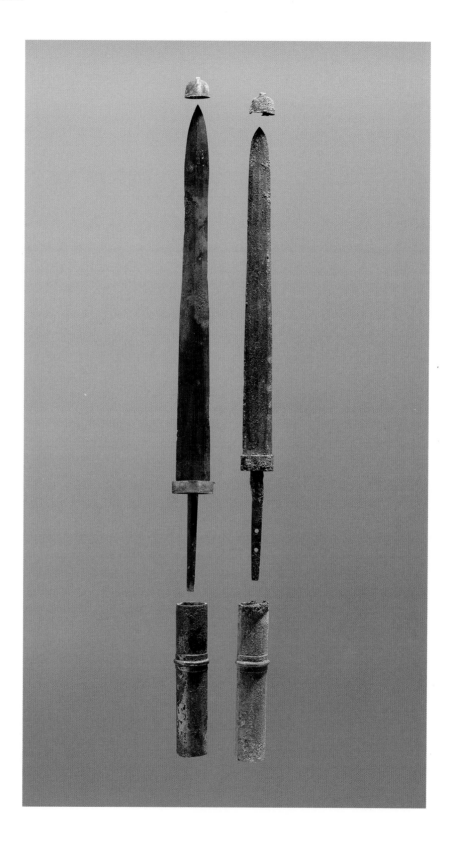

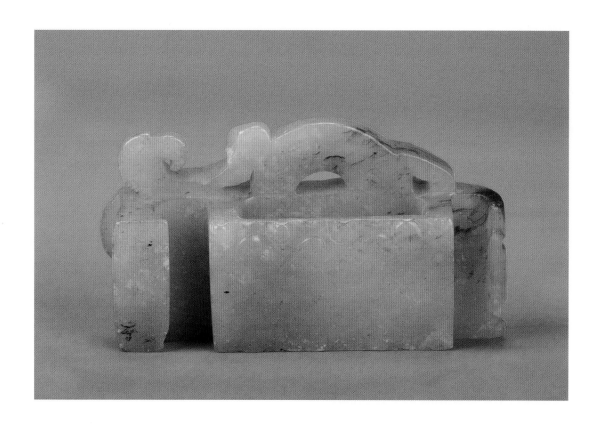

15

母子螭紋玉劍璏 儀征煙袋山出土
西漢

Scabbard mount with
dragon design

Unearthed from Yandai Mountain,
Yizheng, Jiangsu
Western Han period (206 BCE–9 CE)
Jade
L: 5.5 cm, W: 3.1 cm
Yizheng Museum

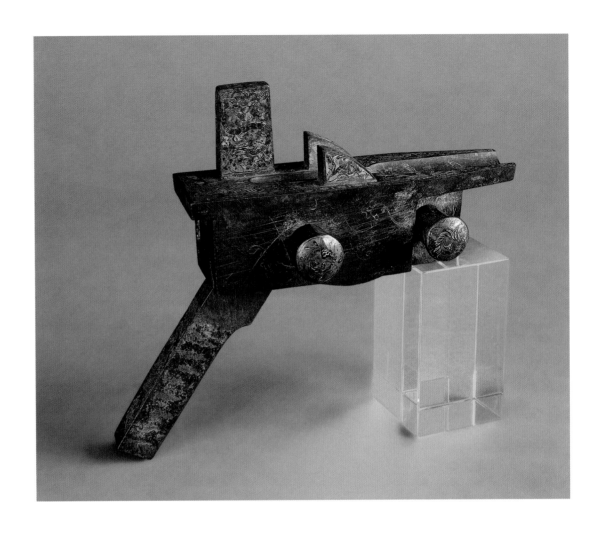

16

錯金銀弩機 泗陽大青墩出土
西漢中晚期

Crossbow trigger mechanism

Unearthed from Daqingdun site,
Siyang, Jiangsu
Western Han period (206 BCE–9 CE),
1st century BCE
Bronze with inlays of gold and silver
H: 5.5 cm, L: 14 cm, W: 11 cm
Nanjing Museum

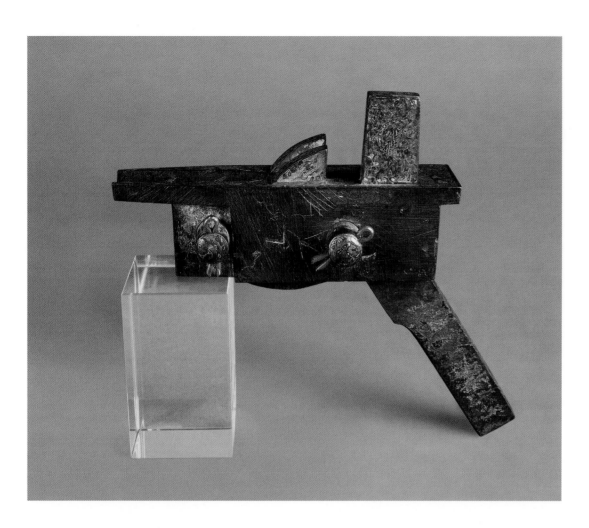

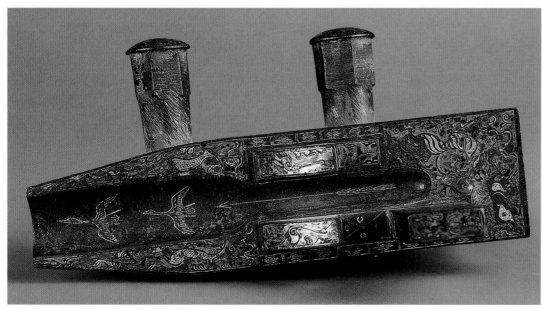

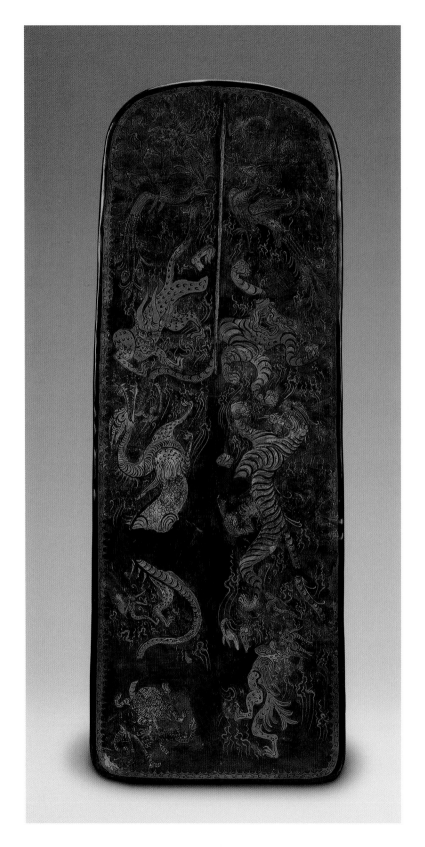

17

彩繪羽人四神紋漆翣 儀征陳集
楊莊村詹莊組出土 西漢晚期

Fan in the shape of a shield

Unearthed in Chenji, Yizheng, Jiangsu
Western Han period (206 BCE–9 CE),
1st century BCE
Lacquer
H: 73.5 cm, L: 0.9 cm, W: 27.5 cm
Yizheng Museum

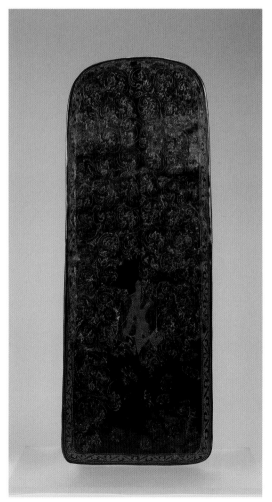

18

彩繪執兵陶俑　徐州北洞山
楚王墓出土 西漢

Set of soldier figurines

Unearthed from the Tomb of the King of
Chu, Beidong Mountain, Xuzhou, Jiangsu
Western Han period (206 BCE–9 CE),
2nd century BCE
Painted earthenware
H: 50 cm, L: 8.5 cm, W: 13.5 cm each
Xuzhou Museum

Three of these artworks are exhibited.

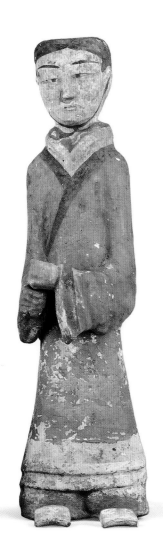
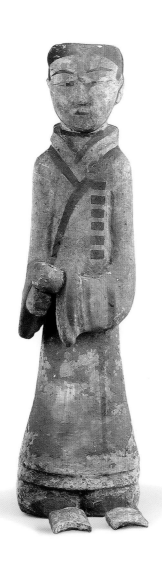
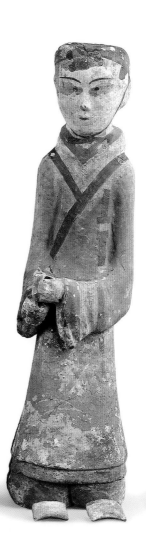
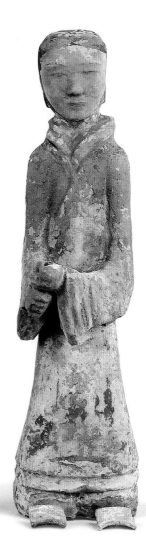

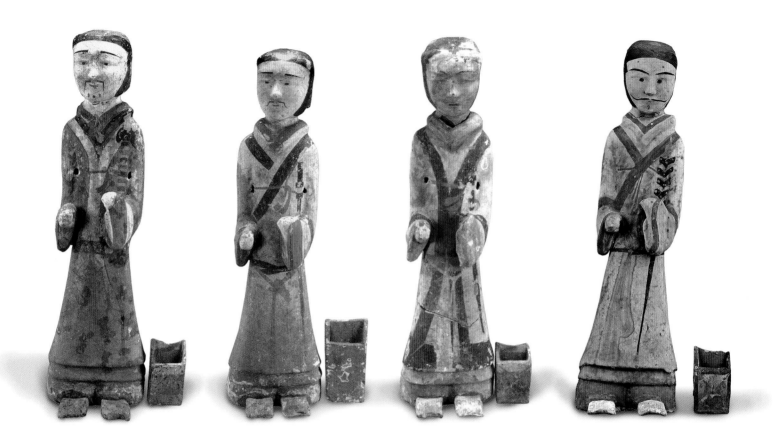

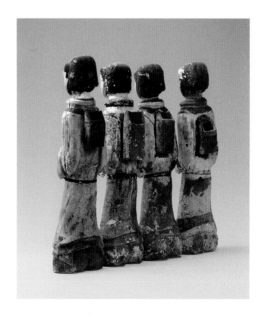

19

彩繪背箭箙陶俑 徐州北洞山
楚王墓出土 西漢早期

Set of archer figurines

Unearthed from the Tomb of the King of
Chu, Beidong Mountain, Xuzhou, Jiangsu
Western Han period (206 BCE–9 CE),
2nd century BCE
Painted earthenware
H: 49 cm, L: 8.5 cm, W: 15.5 cm each
Xuzhou Museum

Three of these artworks are exhibited.

20

跪坐甲冑陶俑 徐州獅子山
兵馬俑1號坑出土 西漢早期

Pair of kneeling warrior figurines

Unearthed from the Earthenware
Warrior Pit 1, Shizi Mountain, Xuzhou,
Jiangsu
Western Han period (206 BCE–9 CE),
2nd century BCE
Earthenware
H: 26.5 cm, L: 13 cm, W: 14 cm
H: 27 cm, L: 12.5 cm, W: 15 cm
Xuzhou Museum

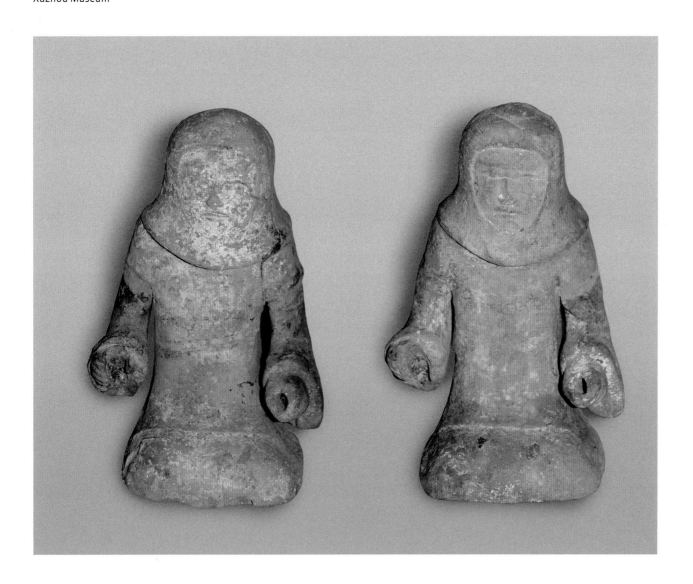

21

騎兵木俑 儀征煙袋山出土
西漢中晚期

Cavalry figurine

Unearthed from Yandai Mountain,
Yizheng, Jiangsu
Western Han period (206 BCE–9 CE),
1st century BCE
Wood
H: 75 cm, L: 80 cm, W: 32.5 cm
Yizheng Museum

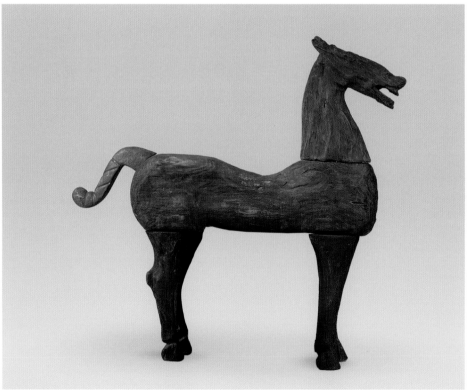

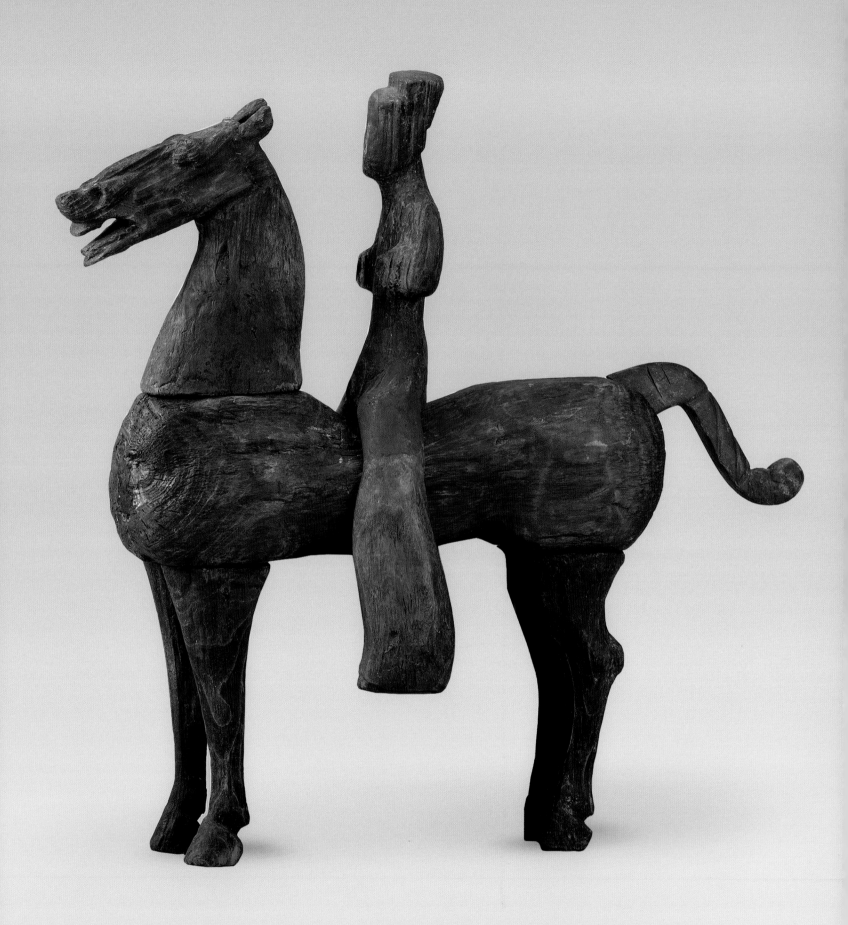

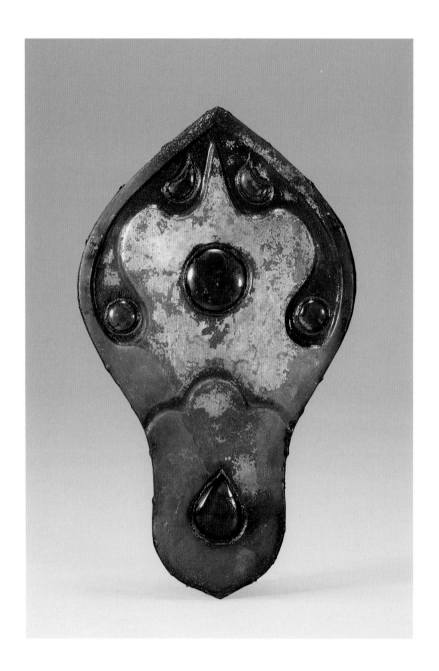

22

嵌宝石銀飾件 盱眙大雲山
2號坑出土 西漢早期

Horse fitting

Unearthed from Pit 2, Dayun Mountain,
Xuyi, Jiangsu
Western Han period (206 BCE–9 CE),
2nd century BCE
Silver with inlays of precious stones
H: 15 cm, L: 0.5 cm, W: 18.7 cm
Nanjing Museum

A pair of these objects is exhibited.

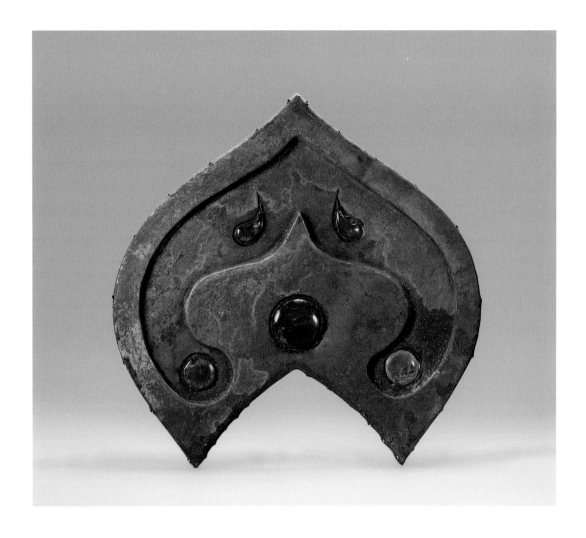

23

嵌宝石銀飾件 盱眙大雲山
2號坑出土 西漢早期

Horse fitting

Unearthed from Pit 2, Dayun Mountain,
Xuyi, Jiangsu
Western Han period (206 BCE–9 CE),
2nd century BCE
Silver with inlays of precious stones
H: 14.5 cm, L: 0.6 cm, W: 14.2 cm
Nanjing Museum

A pair of these objects is exhibited.

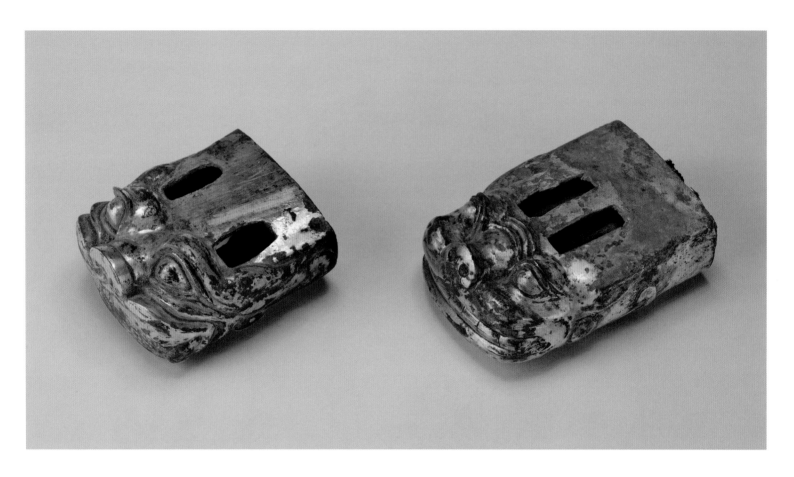

24

辕首飾 盱眙大雲山1號墓出土
西漢早期

Chariot pole fittings

Unearthed from Tomb 1,
Dayun Mountain, Xuyi, Jiangsu
Western Han period (206 BCE–9 CE),
2nd century BCE
Gilded bronze
H: 4 cm, L: 6.6 cm, W: 6 cm
Nanjing Museum

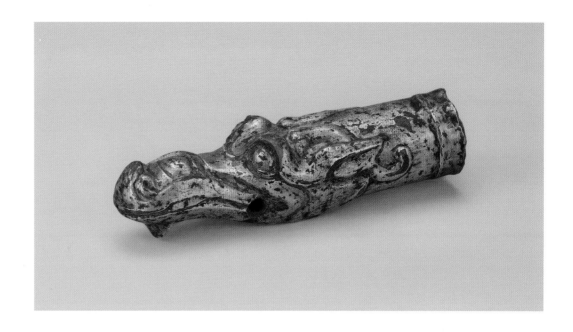

25
辕首飾 盱眙大雲山1號墓出土
西漢早期

Chariot pole fitting

Unearthed from Tomb 1,
Dayun Mountain, Xuyi, Jiangsu
Western Han period (206 BCE–9 CE),
2nd century BCE
Gilded bronze
L: 11 cm, W: 3 cm, D: 2.5 cm
Nanjing Museum

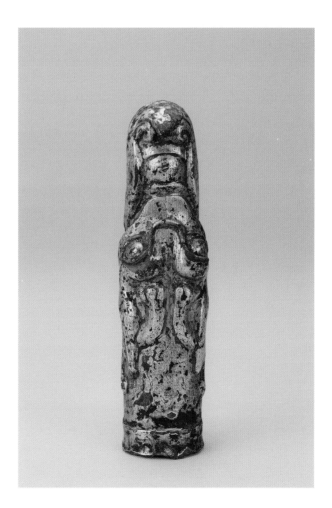

26

鑲寶石銀傘柄 盱眙大雲山
1號墓出土 西漢早期

Umbrella handle

Unearthed from Tomb 1,
Dayun Mountain, Xuyi, Jiangsu
Western Han period (206 BCE–9 CE),
2nd century BCE
Silver with inlays of agate
H: 29 cm, Diam: 2.7 cm
Nanjing Museum

27

銀飾件 盱眙大雲山2號坑出土
西漢早期

Chariot handle

Unearthed from Pit 2, Dayun Mountain,
Xuyi, Jiangsu
Western Han period (206 BCE–9 CE),
2nd century BCE
Silver
H: 4 cm, L: 11.5 cm
Nanjing Museum

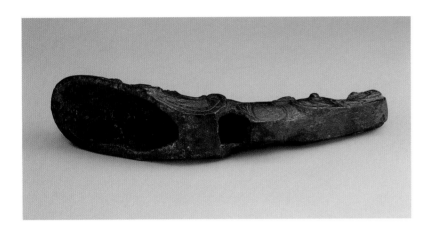

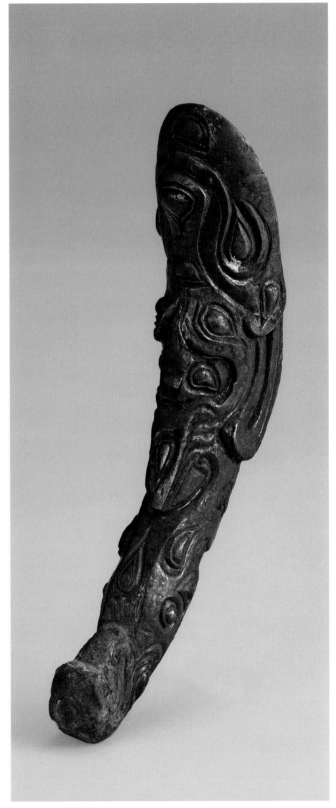

28

銅鼎 盱眙大雲山1號墓出土
西漢早期

Cauldron (*ding*)

Unearthed from Tomb 1,
Dayun Mountain, Xuyi, Jiangsu
Western Han period (206 BCE–9 CE),
2nd century BCE
Bronze
H: 43.5 cm, Diam: with handles 54 cm
Nanjing Museum

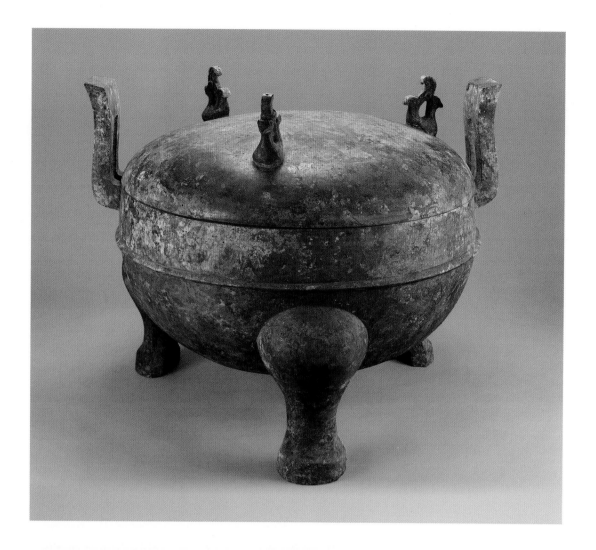

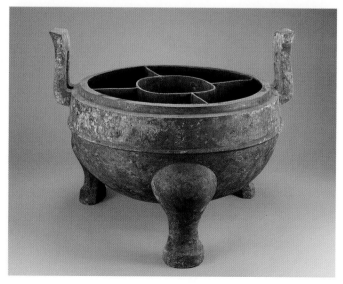

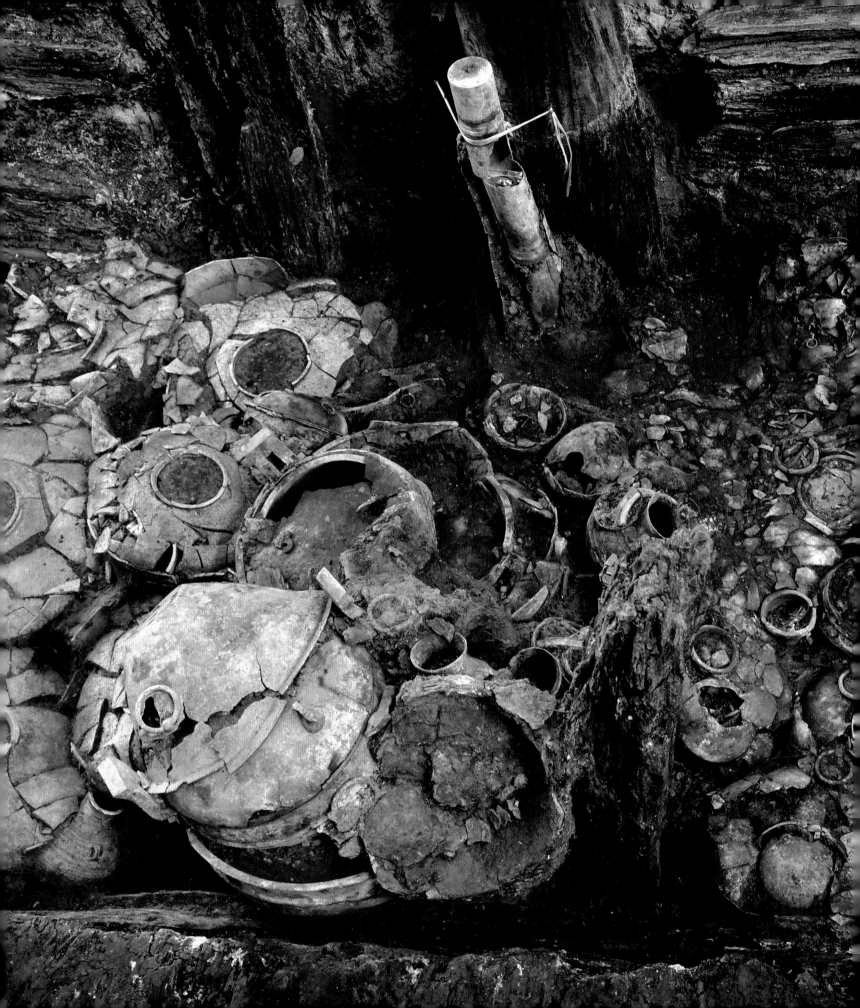

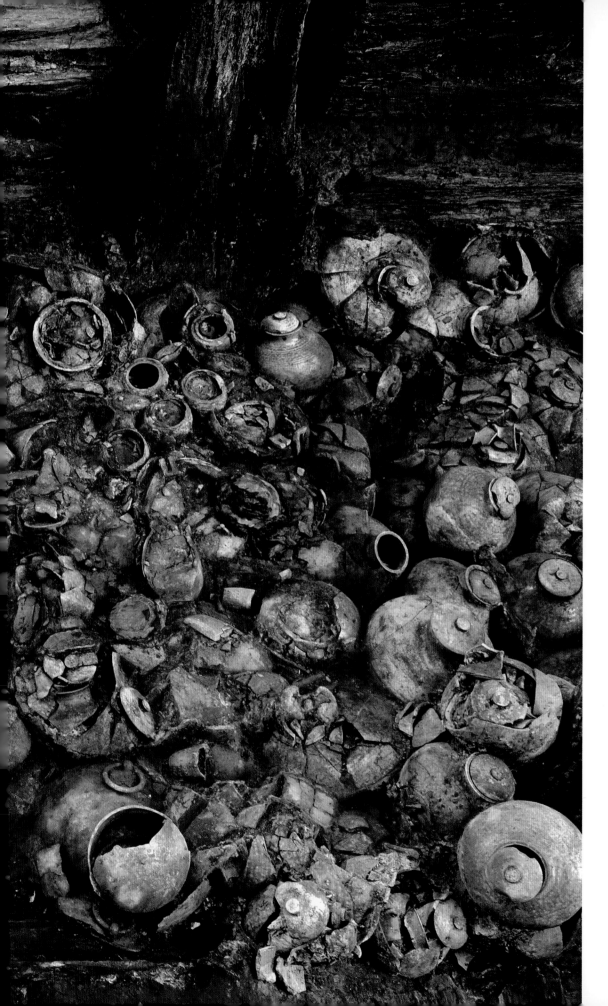

Excavation of Liu Fei's tomb at Dayun Mountain showing food and wine vessels.

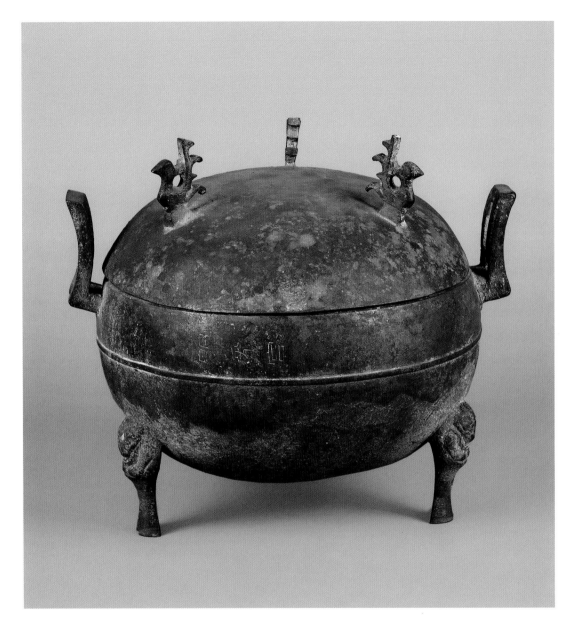

29 (LEFT)

"明光宮" 銅鼎 徐州東洞山
楚王后墓出土 西漢中期

"Mingguang Palace" cauldron (*ding*)

Unearthed from Tomb 2, Dongdong
Mountain, Xuzhou, Jiangsu
Western Han period (206 BCE–9 CE),
1st century BCE
Bronze
H: 21.5 cm, Diam: with handles 25 cm
Xuzhou Museum

30 (RIGHT)

銅鼎 盱眙大雲山1號墓出土
西漢早期

Cauldron (*ding*)

Unearthed from Tomb 1,
Dayun Mountain, Xuyi, Jiangsu
Western Han period (206 BCE–9 CE),
2nd century BCE
Bronze
H: 36.6 cm, Diam: with handles 46 cm
Nanjing Museum

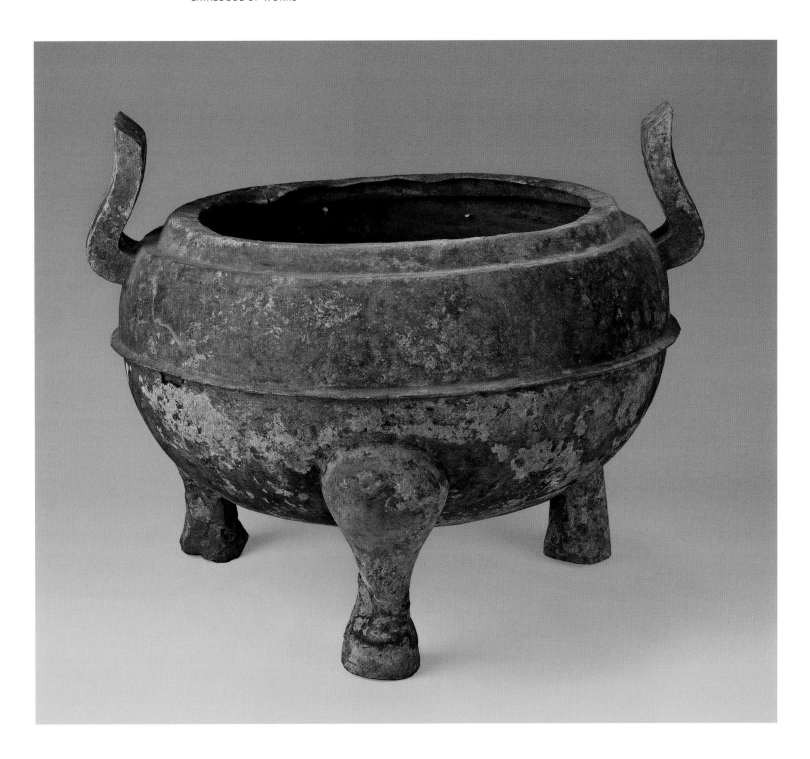

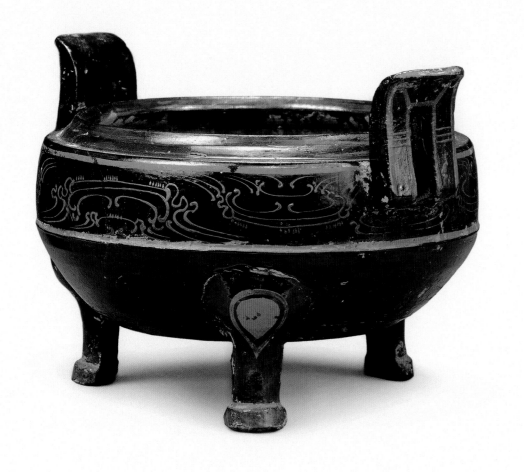

31 (LEFT)

陶胎漆繪三足鼎 徐州簸箕山
5號墓出土 西漢早期

Cauldron (*ding*)

Unearthed from Tomb 5, Boji Mountain,
Xuzhou, Jiangsu
Western Han period (206 BCE–9 CE),
2nd century BCE
Lacquered earthenware
H: 16 cm, L: 20 cm, W: 25 cm
Xuzhou Museum

32 (RIGHT)

銅染爐 盱眙大雲山1號墓出土
西漢早期

Hot pot

Unearthed from Tomb 1,
Dayun Mountain, Xuyi, Jiangsu
Western Han period (206 BCE–9 CE),
2nd century BCE
Bronze
H: 12.5 cm, L: 17.5 cm, W: 21 cm
Nanjing Museum

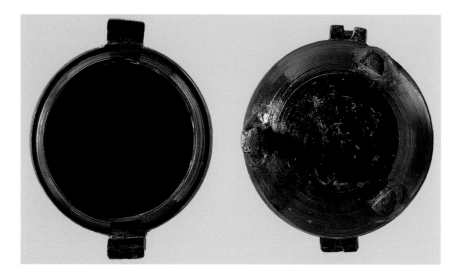

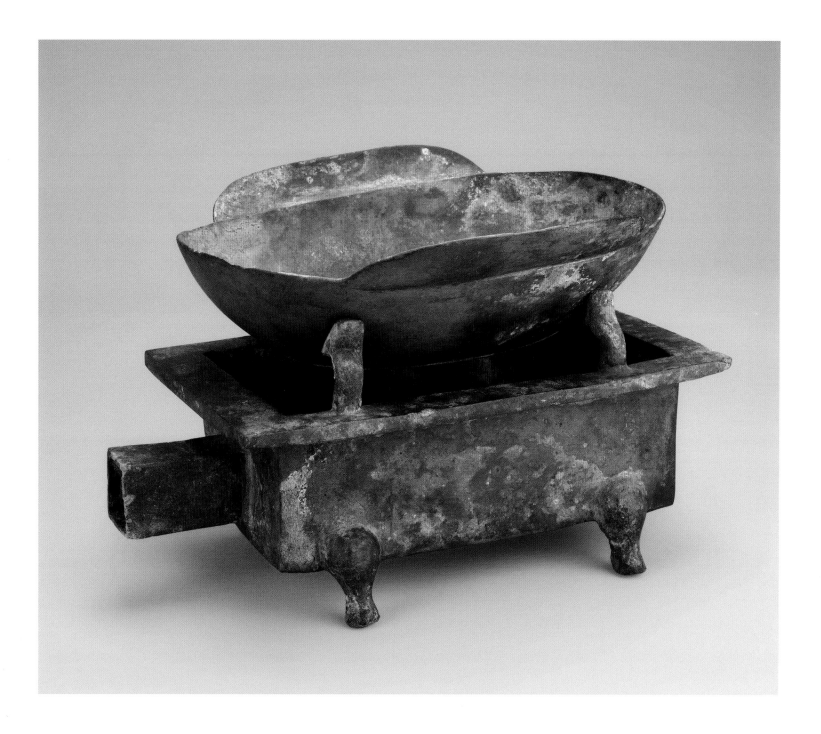

33

銅鋞 盱眙大雲山1號墓出土
西漢早期

**Cylindrical vessel for
carrying wine (*xing*)**

Unearthed from Tomb 1,
Dayun Mountain, Xuyi, Jiangsu
Western Han period (206 BCE–9 CE),
2nd century BCE
Bronze
H: 114.5 cm, Diam: 10 cm
Nanjing Museum

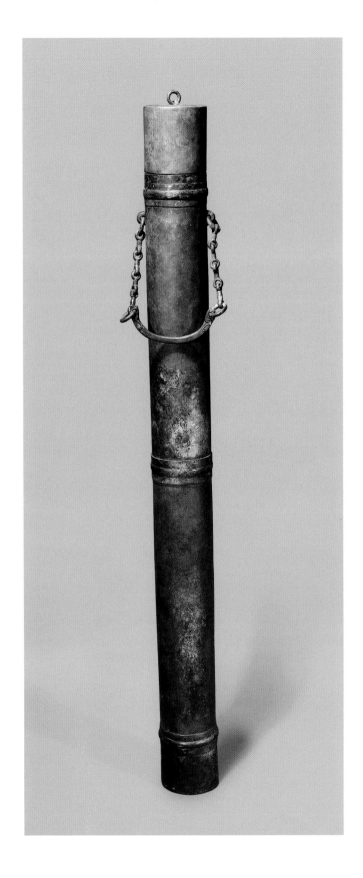

34

鎏金銅汲酒器 盱眙大雲山
1號墓出土 西漢早期

Wine vessel with siphoning tube

Unearthed from Tomb 1,
Dayun Mountain, Xuyi, Jiangsu
Western Han period (206 BCE–9 CE),
2nd century BCE
Gilded bronze
H: 57 cm, Diam: 10 cm
Nanjing Museum

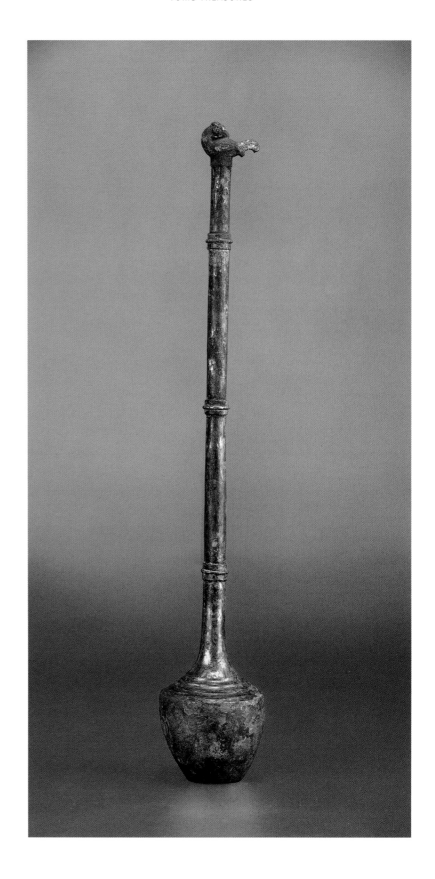

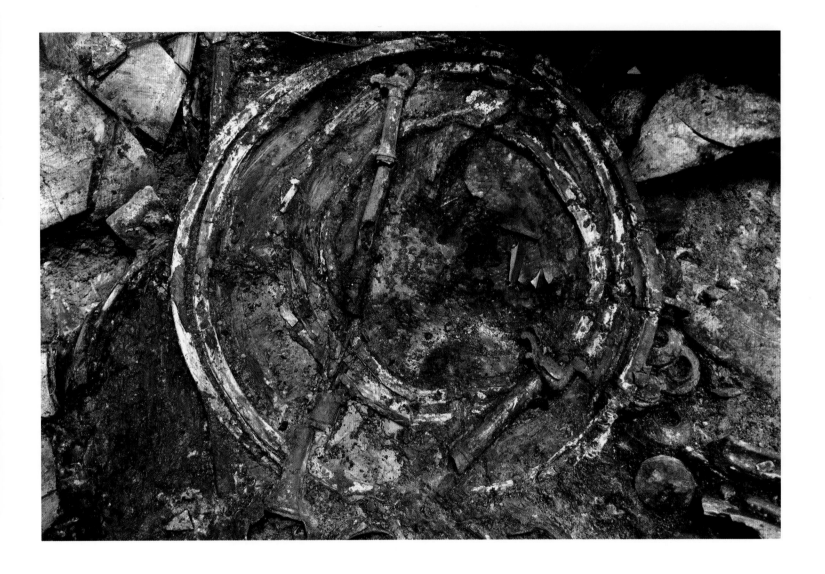

35

羊鈕虎足銅樽 儀征胡莊出土
西漢中晚期

Wine warmer (*zun*)

Unearthed in Huzhuang, Yizheng,
Jiangsu
Western Han period (206 BCE–9 CE),
1st century BCE
Bronze
H: 23 cm, Diam: 28 cm
Yizheng Museum

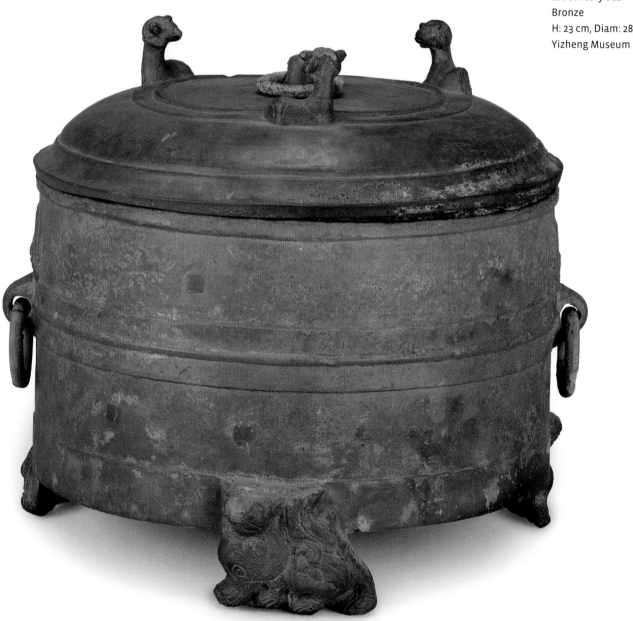

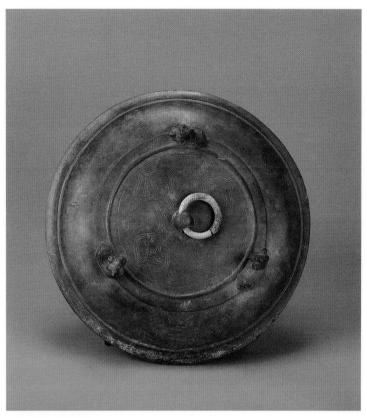

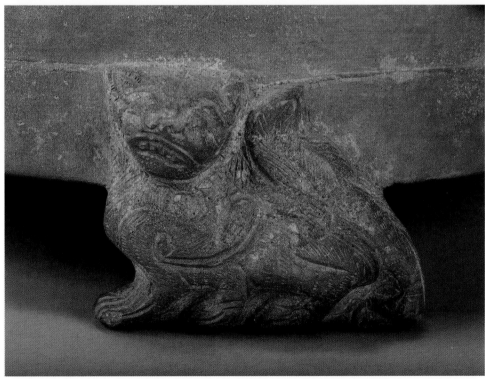

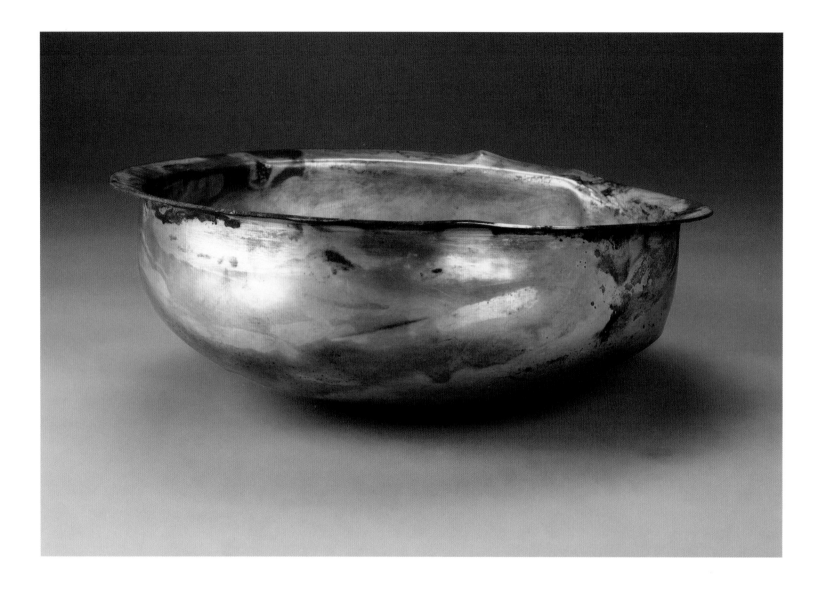

36

銀盆 盱眙大雲山1號墓出土
西漢早期

Basin

Unearthed from Tomb 1,
Dayun Mountain, Xuyi, Jiangsu
Western Han period (206 BCE–9 CE),
2nd century BCE
Silver
H: 7.5 cm, Diam: mouth 18.5 cm
Nanjing Museum

*Three basins of various sizes are
exhibited*

37

玉耳杯 盱眙大雲山1號墓出土
西漢早期

Ear cup

Unearthed from Tomb 1,
Dayun Mountain, Xuyi, Jiangsu
Western Han period (206 BCE–9 CE),
2nd century BCE
Jade
H: 12.2 cm, L: 10.2 cm, W: 5.2 cm
Nanjing Museum

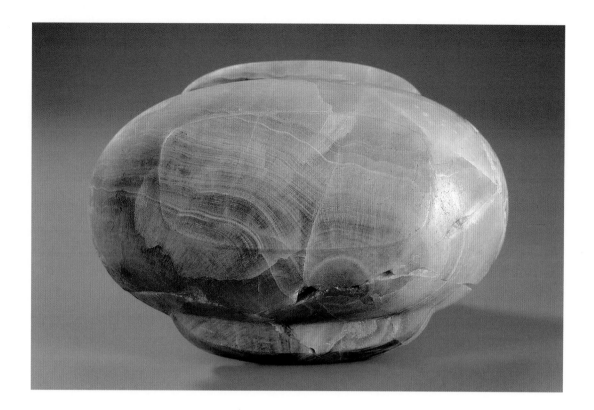

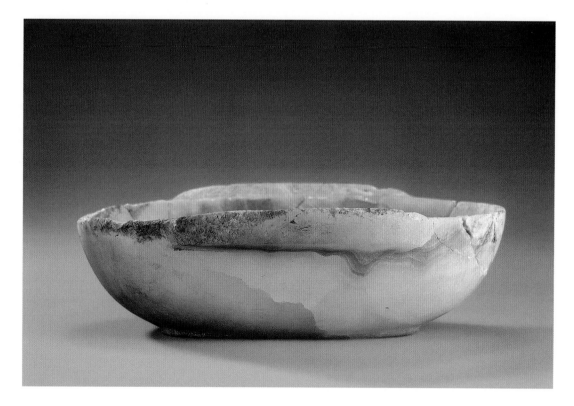

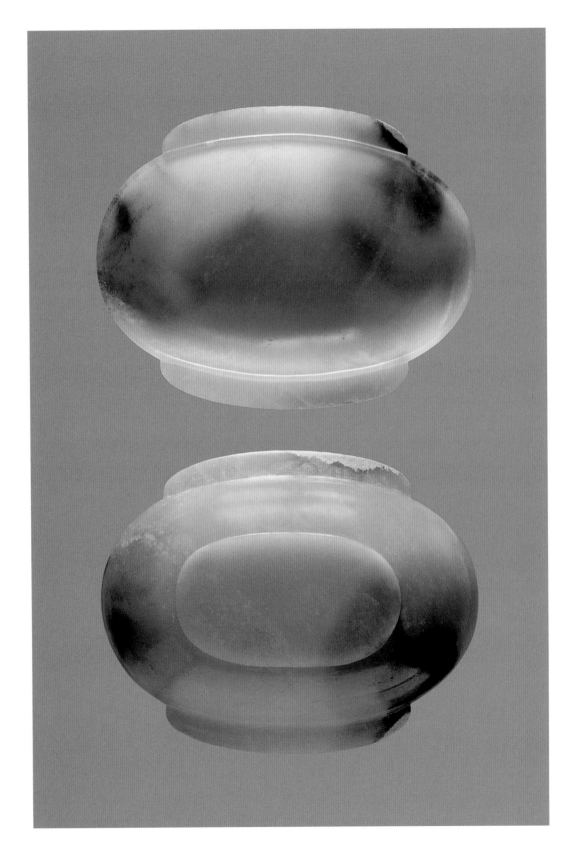

38

玉耳杯 徐州獅子山楚王墓出土
西漢早期

Ear cup

Unearthed from the Tomb of the King of
Chu, Shizi Mountain, Xuzhou, Jiangsu
Western Han period (206 BCE–9 CE),
2nd century BCE
Jade
H: 5 cm, L: 14.3 cm, W: 11.5 cm
Xuzhou Museum

39

玉高足杯 徐州獅子山楚王墓出土
西漢早期

High-stemmed cup

Unearthed from the Tomb of the King of
Chu, Shizi Mountain, Xuzhou, Jiangsu
Western Han period (206 BCE–9 CE),
2nd century BCE
Jade
H: 11.6 cm, Diam: mouth 6 cm
Nanjing Museum

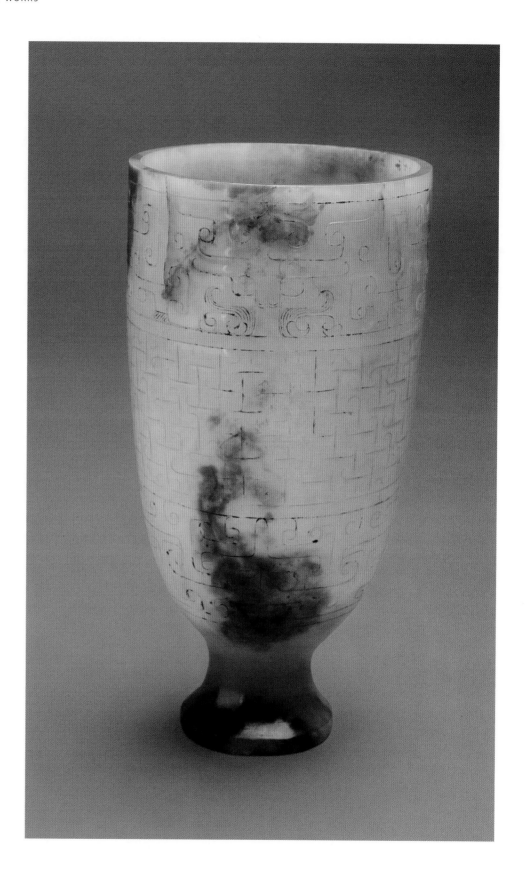

40

鳳鳥紋鋪首銜環青釉壺
儀征煙袋山出土 西漢中晚期

Vessel (*hu*) with design of birds amid clouds

Unearthed from Yandai Mountain,
Yizheng, Jiangsu
Western Han period (206 BCE–9 CE),
1st century BCE
Ceramic
H: 50 cm, Diam: 37 cm, mouth 15.8 cm
Yizheng Museum

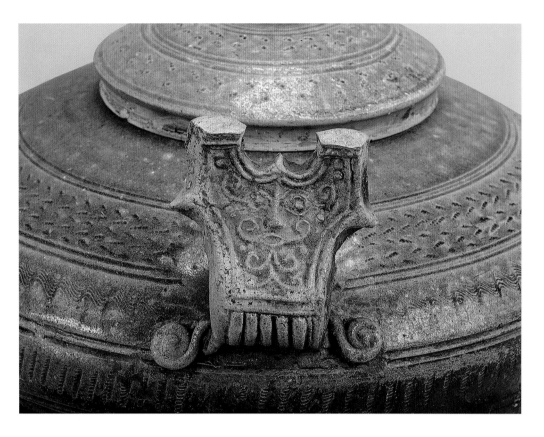

41

雙獸耳帶蓋青釉瓿 儀征聯營
1號墓出土 西漢早中期

**Container (*bu*) with animal-
shaped handles**

Unearthed from Tomb 1, Lianying site,
Yizheng, Jiangsu
Western Han period (206 BCE–9 CE),
2nd century BCE
Ceramic
H: 23.5 cm, L: 29 cm, W: 31 cm
Yizheng Museum

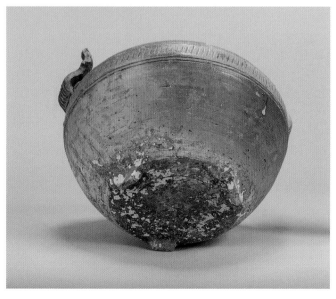

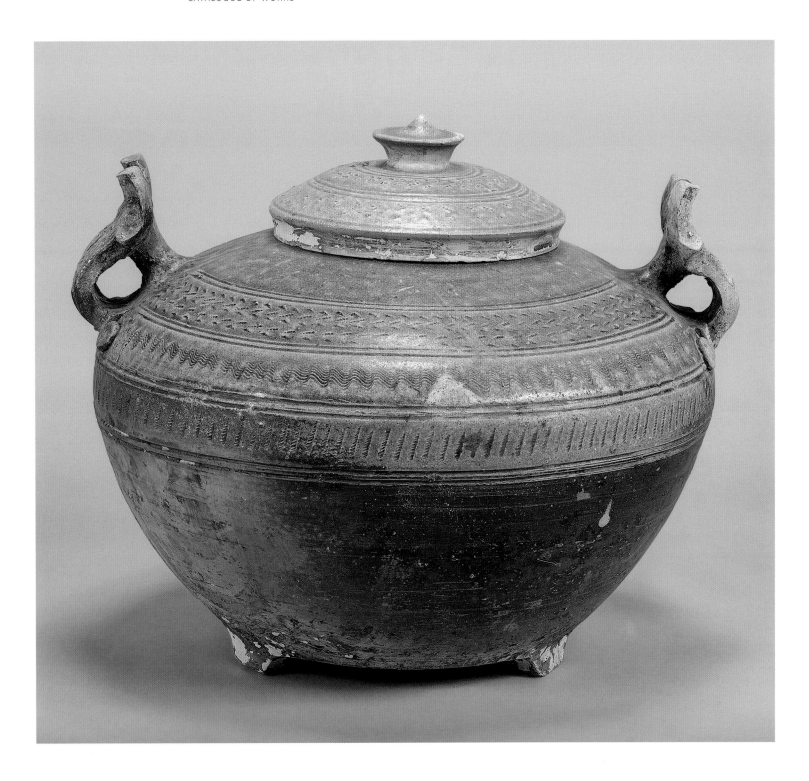

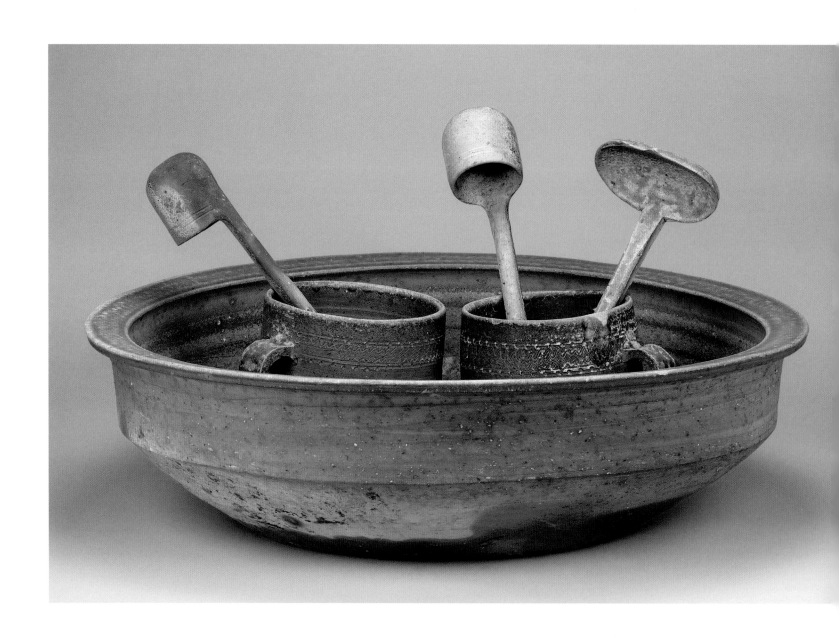

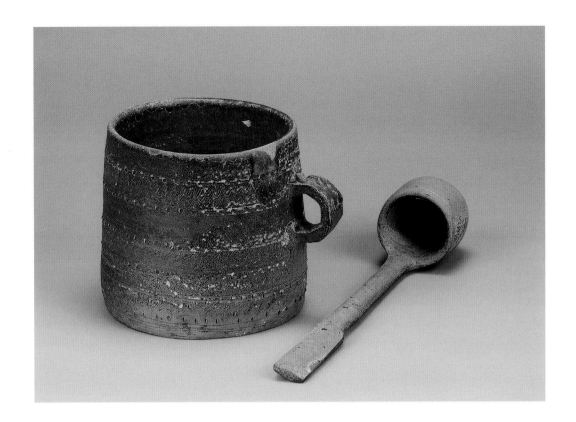

42

盆、杯、勺七件組合青釉器
盱眙大雲山9號墓出土 西漢早期

Set of drinking wares

Unearthed from Tomb 9,
Dayun Mountain, Xuyi, Jiangsu
Western Han period (206 BCE–9 CE),
2nd century BCE
Ceramic
Various dimensions
Nanjing Museum

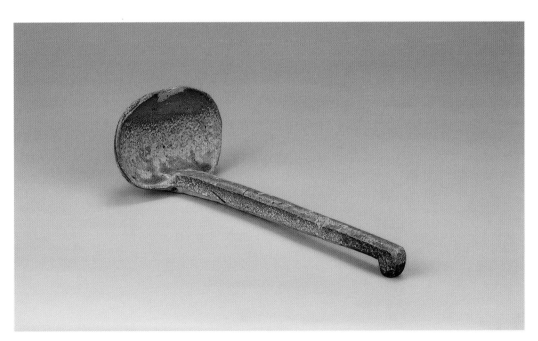

43
明器銅器组合 盱眙大雲山1號墓
1號坑出土 西漢早期

Set of funerary vessels

Unearthed from Tomb 1, Pit 1,
Dayun Mountain, Xuyi, Jiangsu
Western Han period (206 BCE–9 CE),
2nd century BCE
Bronze
Various dimensions
Nanjing Museum

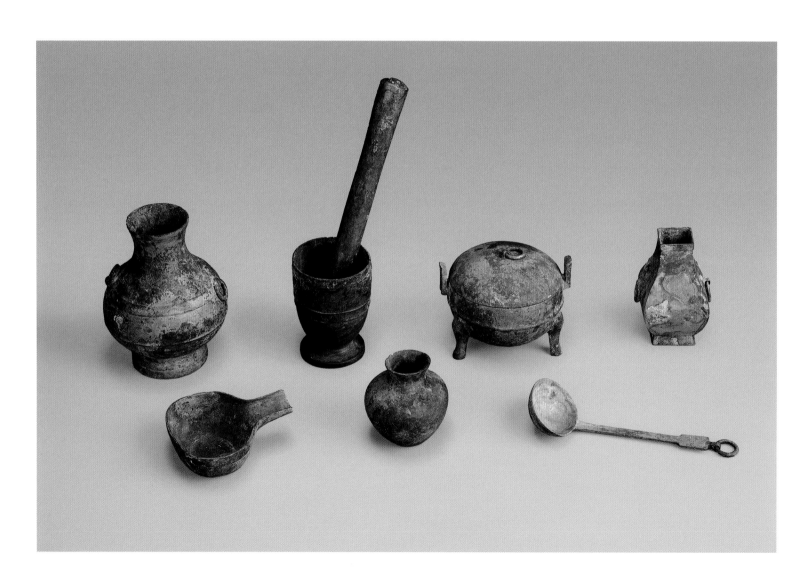

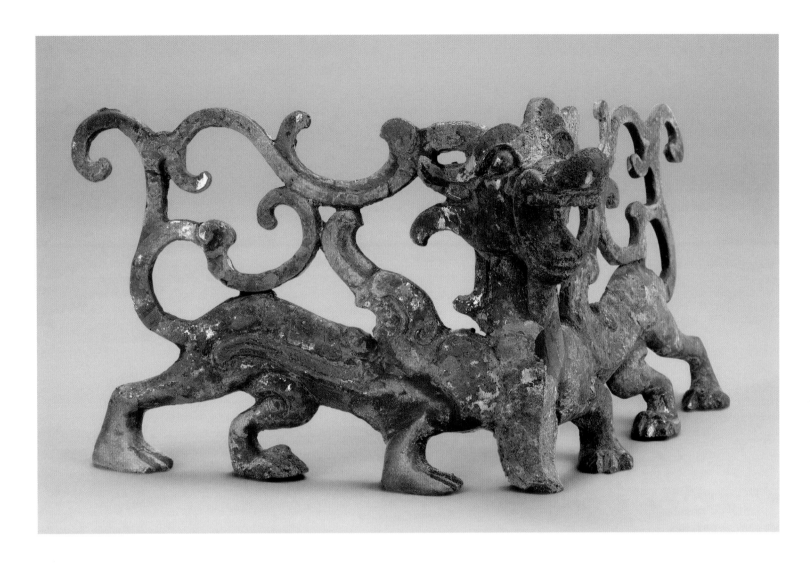

44

鎏金青銅案足飾 盱眙大雲山
1號墓1號坑出土 西漢早期

Ornaments for table feet

Unearthed from Tomb 1, Pit 1,
Dayun Mountain, Xuyi, Jiangsu
Western Han period (206 BCE–9 CE),
2nd century BCE
Gilt bronze
H: 9.5 cm, L: 11 cm, W: 16 cm
H: 13.3 cm, L: 9 cm, W: 16 cm
Nanjing Museum

Two of these artworks are exhibited.

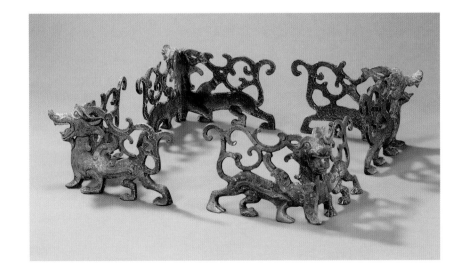

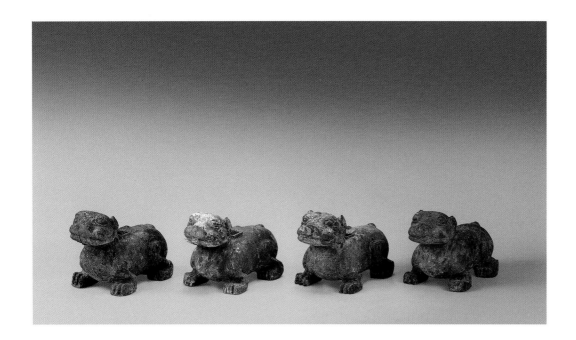

45

青銅虎座 盱眙大雲山1號墓出土
西漢早期

Set of four tent stands in the shape of tigers

Unearthed from Tomb 1,
Dayun Mountain, Xuyi, Jiangsu
Western Han period (206 BCE–9 CE),
2nd century BCE
Bronze
H: 12.8 cm, L: 21 cm, W: 12 cm each
Nanjing Museum

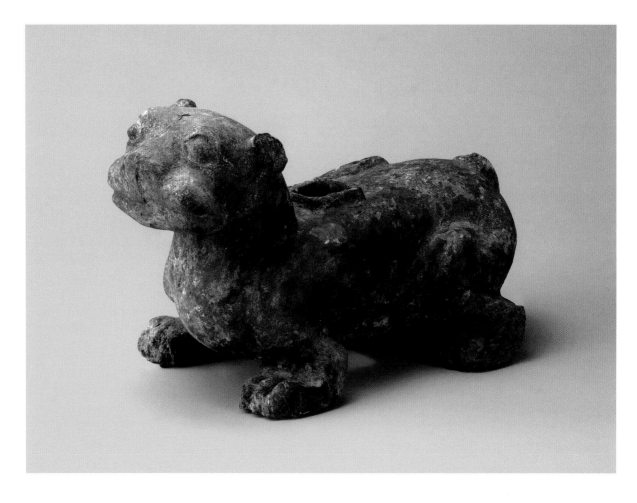

46

錯金銀銅虎鎮 盱眙大雲山1號墓
1號坑出土 西漢早期

**Mat weight in the shape of
a tiger**

Unearthed from Tomb 1, Pit 1,
Dayun Mountain, Xuyi, Jiangsu
Western Han period (206 BCE–9 CE),
2nd century BCE
Bronze with inlays of gold and silver
H: 5 cm, L: 9 cm, W: 7.5 cm
Nanjing Museum

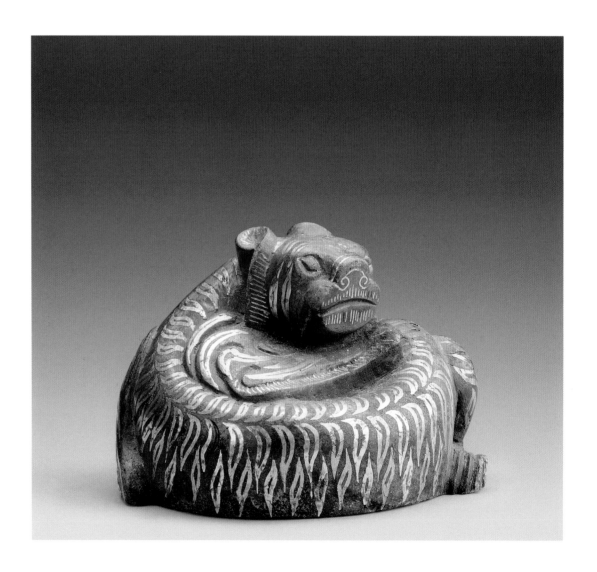

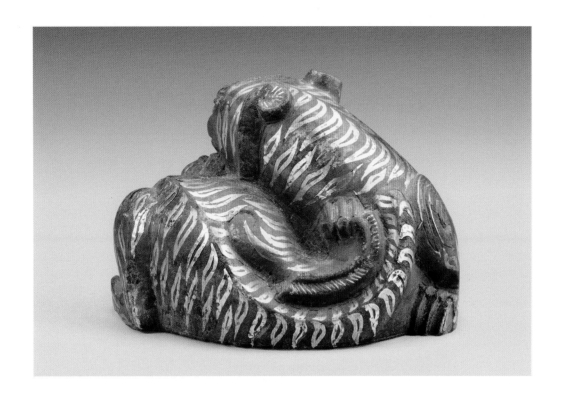

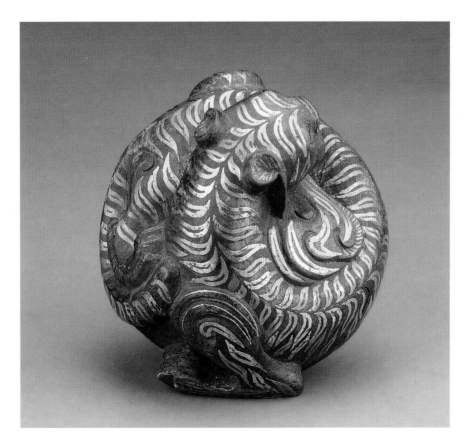

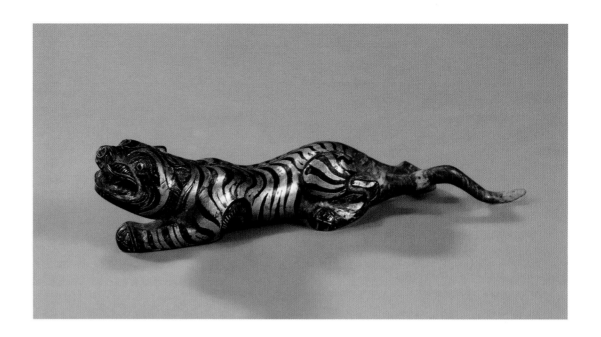

47

銅虎鎮 盱眙大雲山1號墓出土
西漢早期

Pair of mat weights in the shape of tigers

Unearthed from Tomb 1,
Dayun Mountain, Xuyi, Jiangsu
Western Han period (206 BCE–9 CE),
2nd century BCE
Bronze with inlays of gold and silver
H: 1.8 cm, L: 11.6 cm, W: 3 cm
H: 2.3 cm, L: 11.6 cm, W: 3 cm
Nanjing Museum

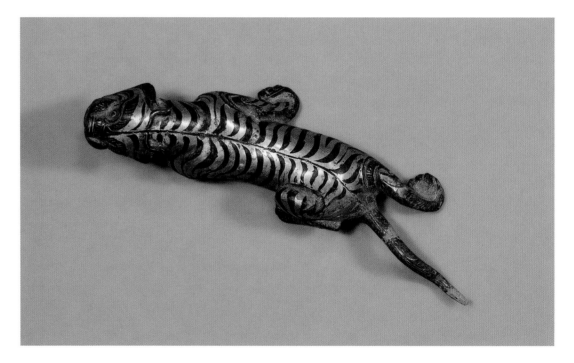

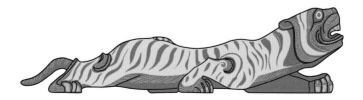

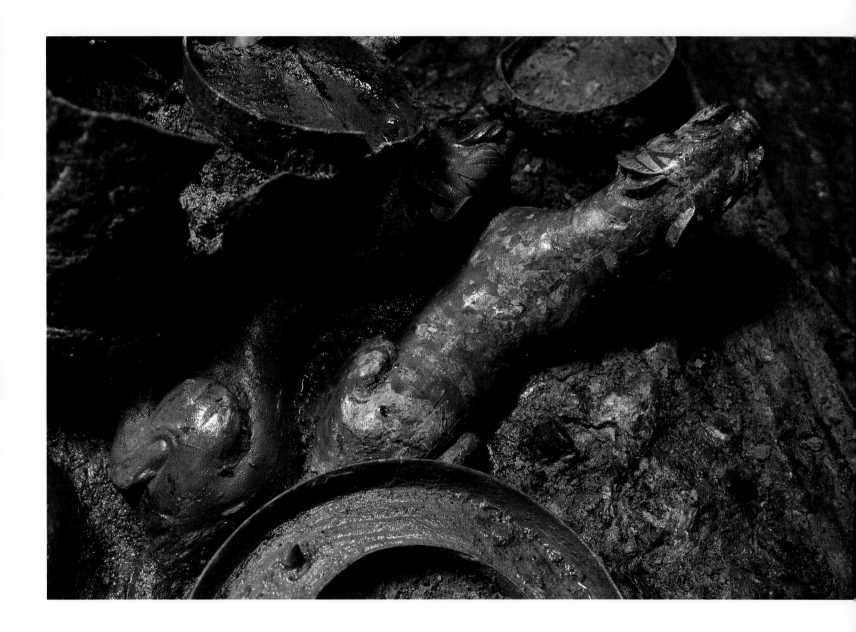

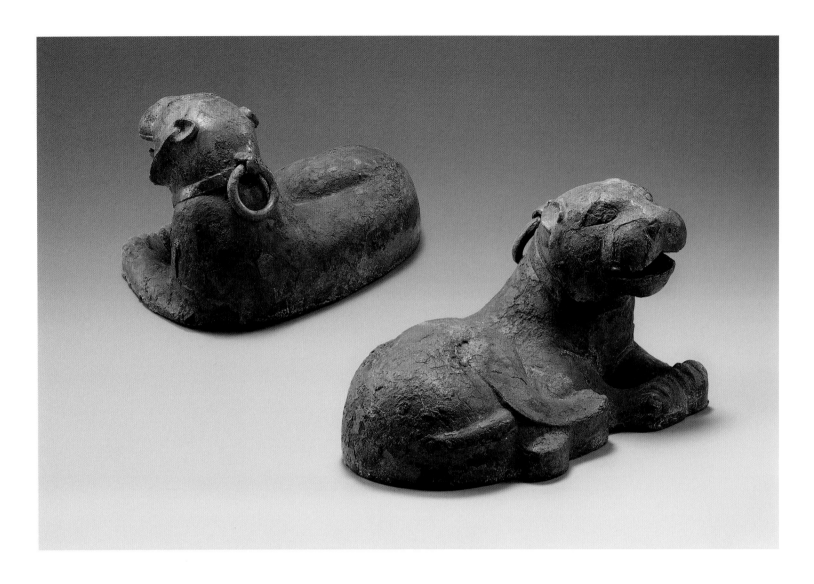

48

銅豹鎮 徐州獅子山楚王墓出土
西漢早期

**Mat weight in the shape of
a leopard**

Unearthed from the Tomb of the King of
Chu, Shizi Mountain, Xuzhou, Jiangsu
Western Han period (206 BCE–9 CE),
2nd century BCE
Bronze and lead
H: 12.5 cm, L: 20 cm, W: 12 cm
Xuzhou Museum

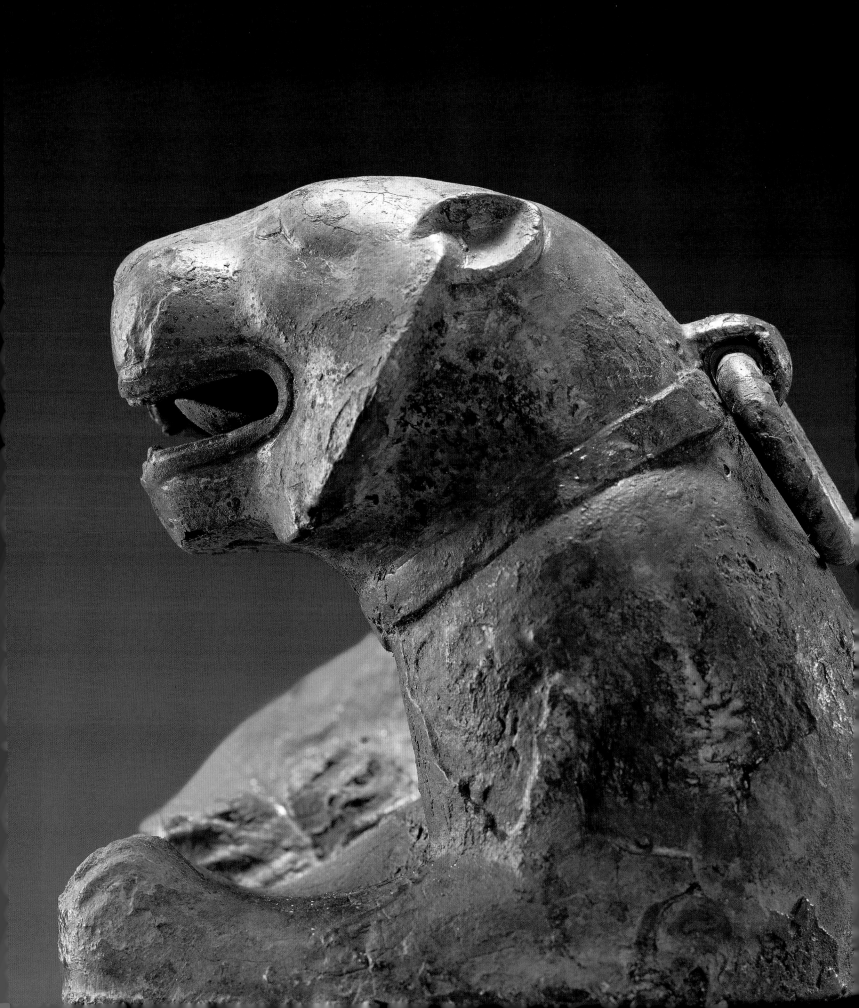

49

鎏金銅鹿燈 盱眙大雲山1號墓出土
西漢早期

Lamp in the shape of a deer (*ludeng*)

Unearthed from Tomb 1, Dayun Mountain,
Xuyi, Jiangsu
Western Han period (206 BCE–9 CE),
2nd century BCE
Gilded bronze
H: 43 cm, Diam: 22.2 cm
Nanjing Museum

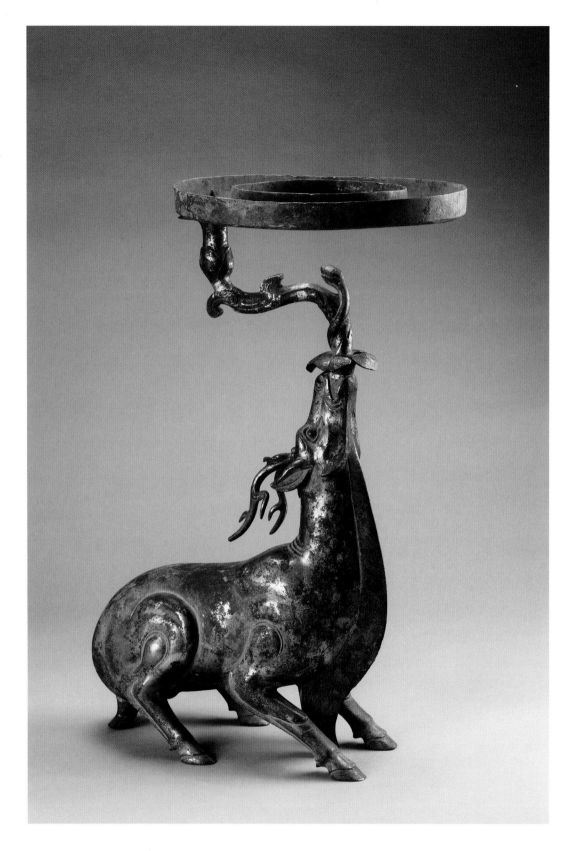

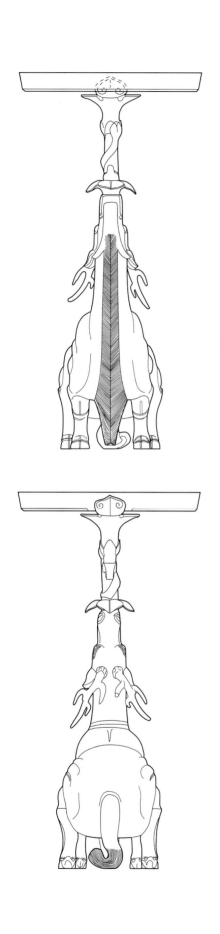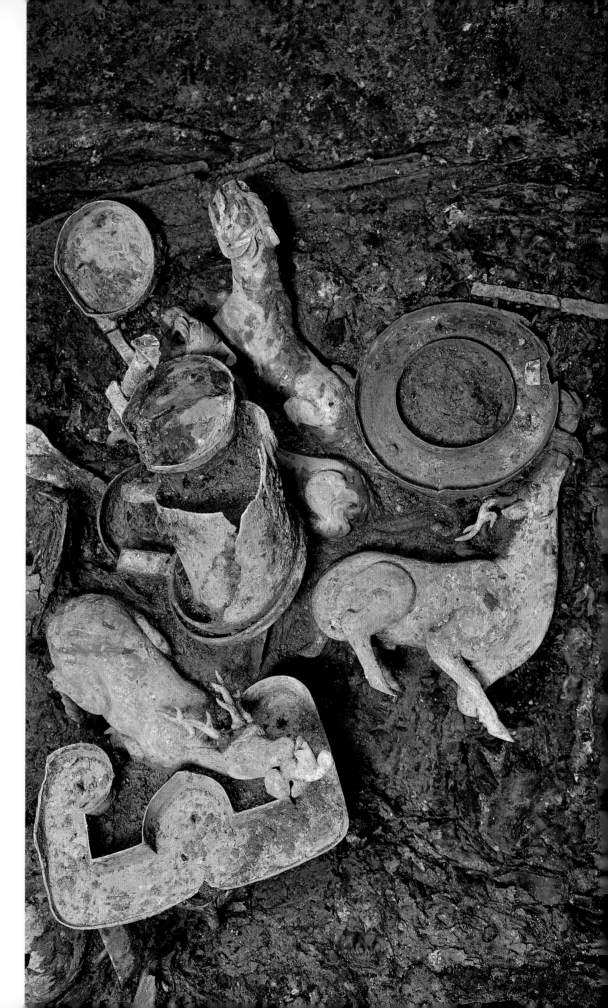

50
五枝銅燈 盱眙大雲山1號墓出土
西漢早期

Candelabra

Unearthed from Tomb 1,
Dayun Mountain, Xuyi, Jiangsu
Western Han period (206 BCE–9 CE),
2nd century BCE
Bronze
H: 62 cm, L: 18 cm, W: 99 cm
Nanjing Museum

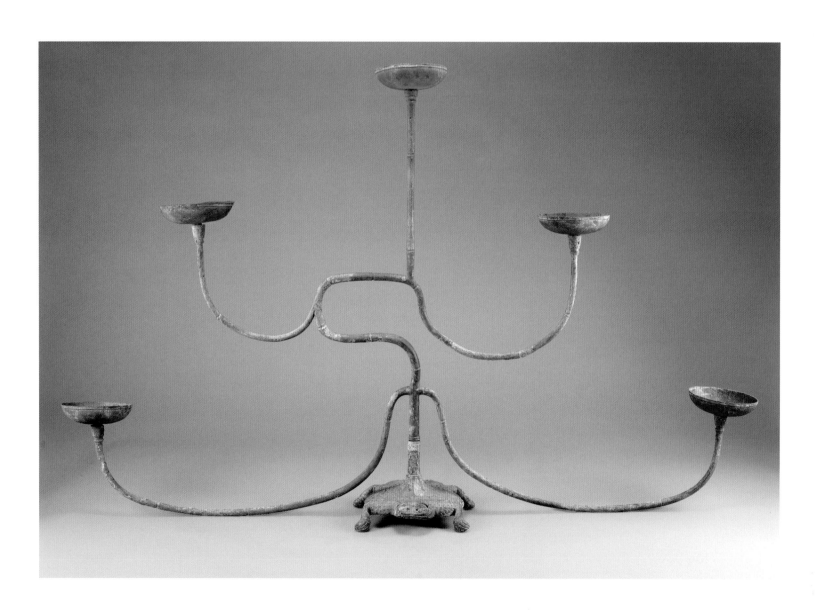

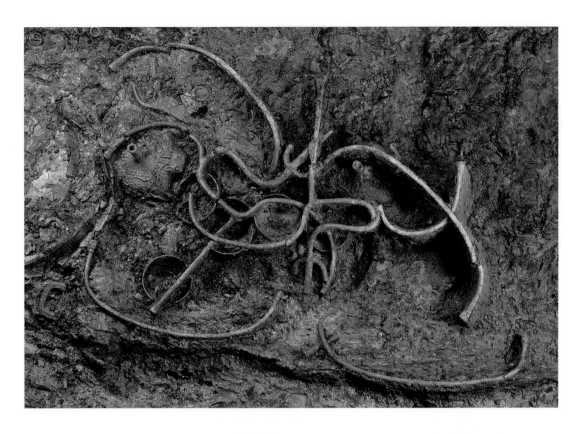

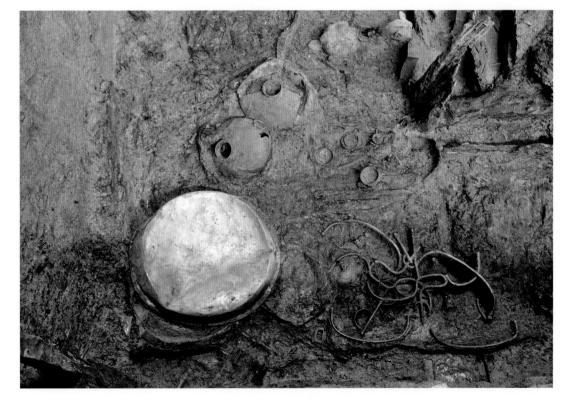

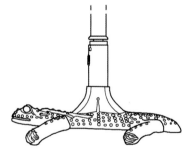

51

銅缸燈 盱眙大雲山1號墓出土
西漢早期

Lamp (*gangdeng*)

Unearthed from Tomb 1,
Dayun Mountain, Xuyi, Jiangsu
Western Han period (206 BCE–9 CE),
2nd century BCE
Bronze
H: 51 cm, L: 30 cm, W: 41 cm
Nanjing Museum

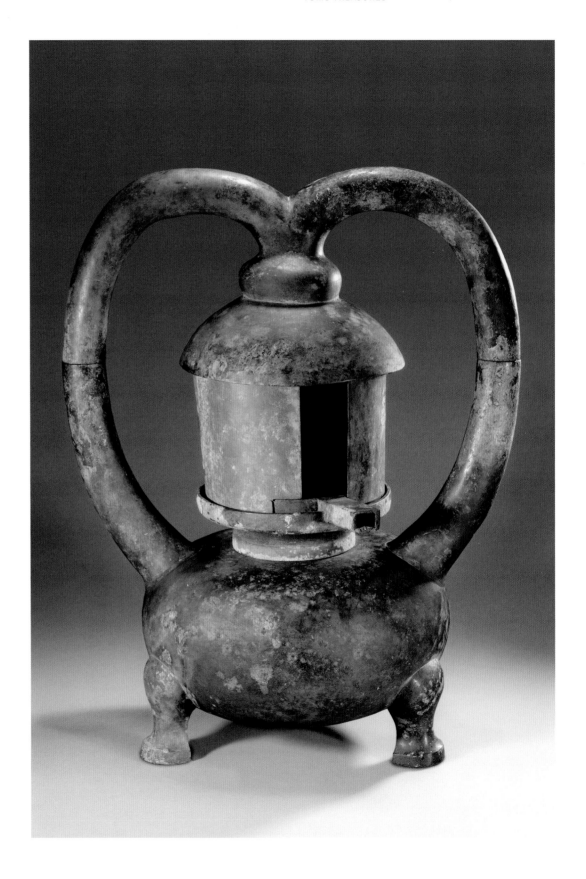

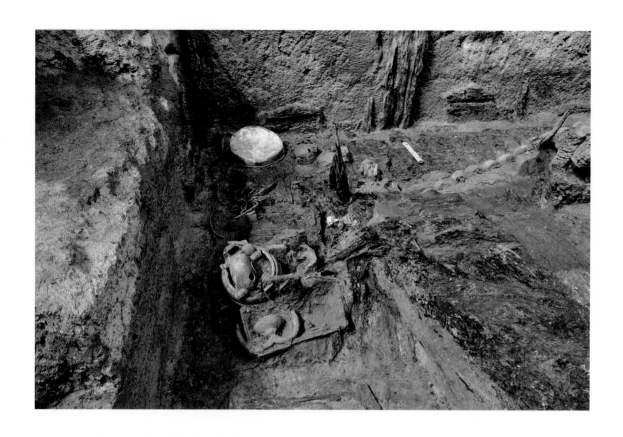

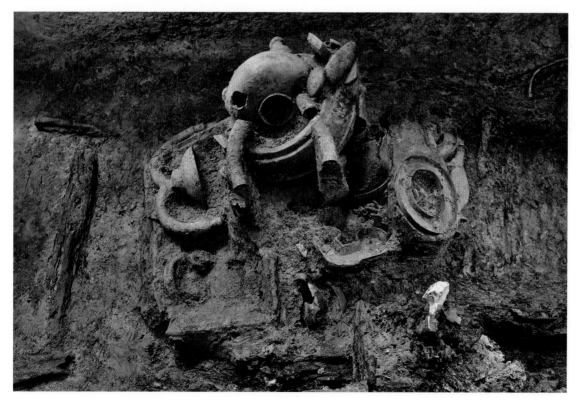

52
鏤空蟠龍紋鎏金銅熏爐
徐州小龜山楚王劉注墓出土
西漢早期

Incense burner with heavenly symbol design

Unearthed from the Tomb of the King of
Chu, Liu Zhu, Xiaogui Mountain, Xuzhou,
Jiangsu
Western Han period (206 BCE–9 CE)
2nd century BCE
Gilt bronze
H: 22 cm, Diam: 16 cm, mouth 11.7 cm
Nanjing Museum

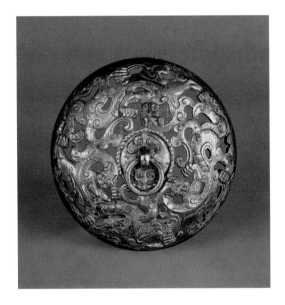

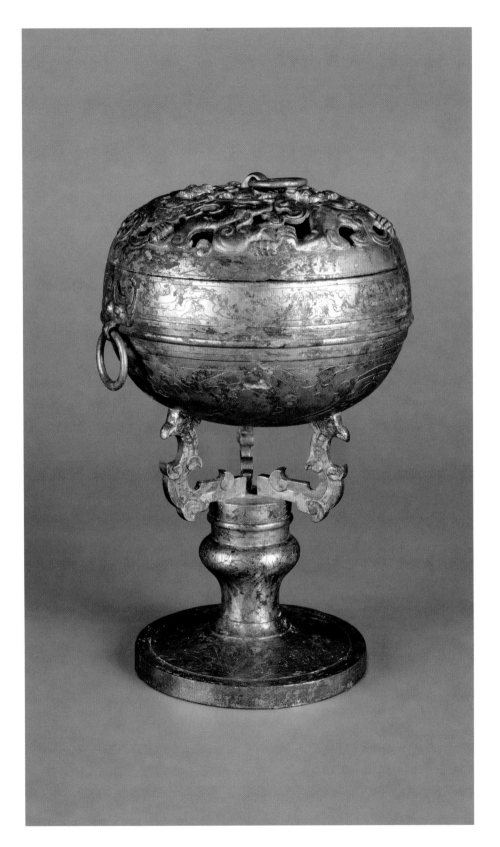

53

青釉立鳥陶熏 儀征聯營4號墓出土
西漢早中期

Incense burner

Unearthed from Tomb 4, Lianying site,
Yizheng, Jiangsu
Western Han period (206 BCE–9 CE),
2nd century BCE
Glazed earthenware
H: 17.1 cm, Diam: 13.5 cm
Yizheng Museum

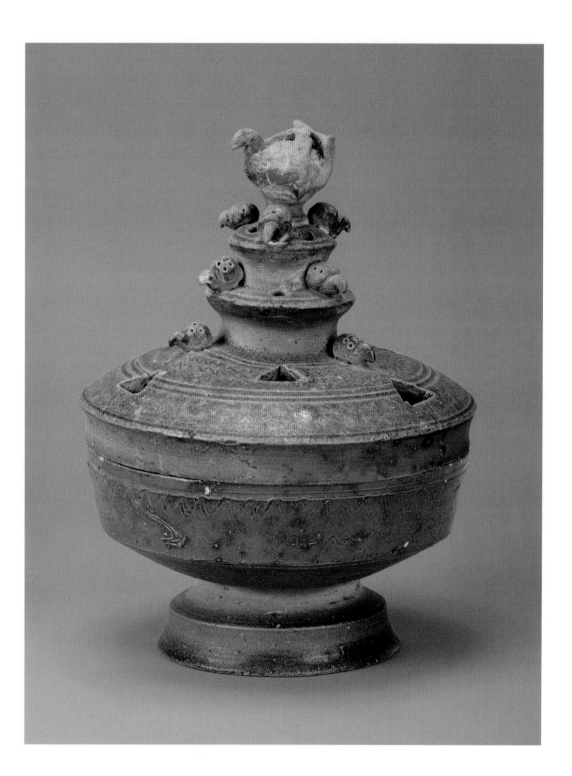

54

搓石 盱眙大雲山1號墓出土
西漢早期

Bath stone

Unearthed from Tomb 1,
Dayun Mountain, Xuyi, Jiangsu
Western Han period (206 BCE–9 CE),
2nd century BCE
Stone
H: 3.9 cm, L: 18.5 cm, W: 7 cm
Nanjing Museum

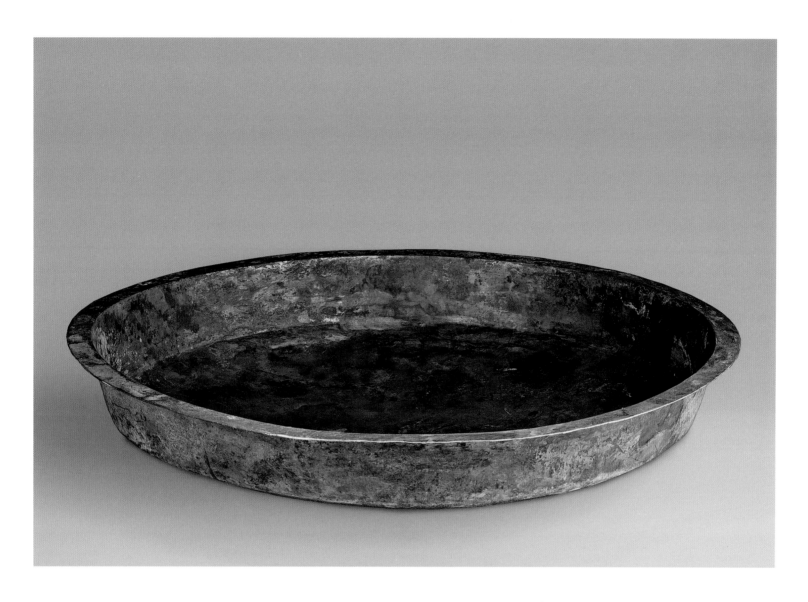

55

銀沐盆 盱眙大雲山1號墓出土
西漢早期

Bath basin

Unearthed from Tomb 1,
Dayun Mountain, Xuyi, Jiangsu
Western Han period (206 BCE–9 CE),
2nd century BCE
Silver
H: 14 cm, Diam: 73 cm
Nanjing Museum

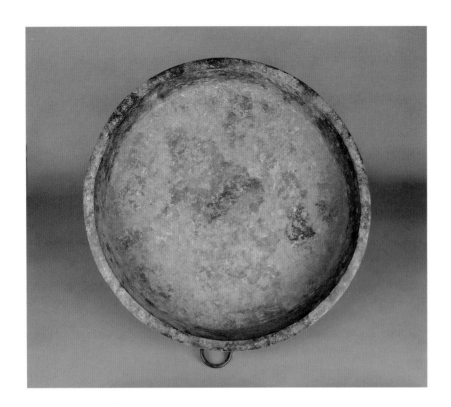

56

銅沐盤 泗陽大青墩出土
西漢中晚期

Bath basin

Unearthed from Daqingdun site,
Siyang county, Jiangsu
Western Han period (206 BCE–9 CE),
1st century BCE
Bronze
H: 15.5 cm, Diam: 70.5 cm
Nanjing Museum

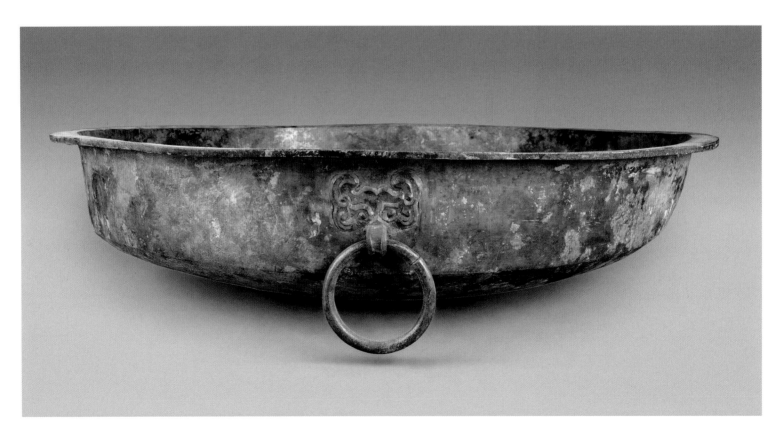

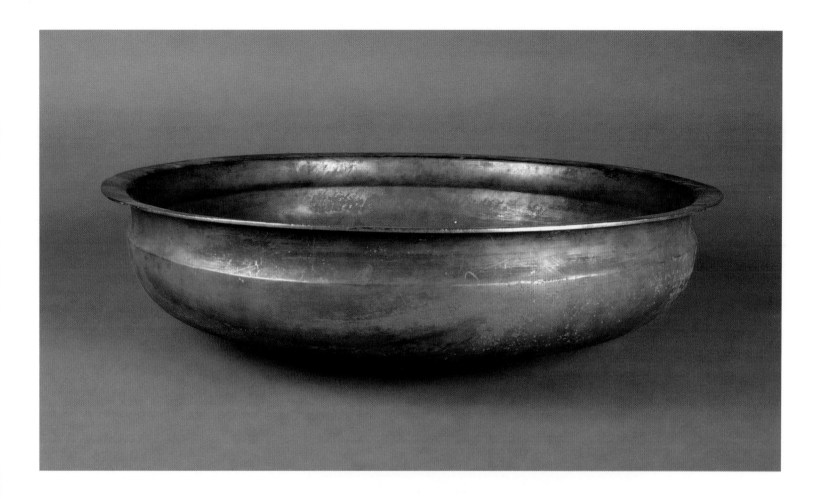

57

銀盆 徐州獅子山楚王墓出土
西漢早期

Basin

Unearthed from the Tomb of the King of
Chu, Shizi Mountain, Xuzhou, Jiangsu
Western Han period (206 BCE–9 CE),
2nd century BCE
Silver
H: 12 cm, Diam: 47 cm
Nanjing Museum

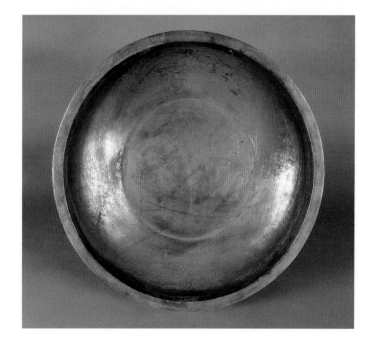

58

銀匜 盱眙大雲山1號墓出土
西漢早期

Pouring vessel (*yi*)

Unearthed from Tomb 1,
Dayun Mountain, Xuyi, Jiangsu
Western Han period (206 BCE–9 CE),
2nd century BCE
Silver
H: 12 cm, L: 35.8 cm, W: 29.5 cm
Nanjing Museum

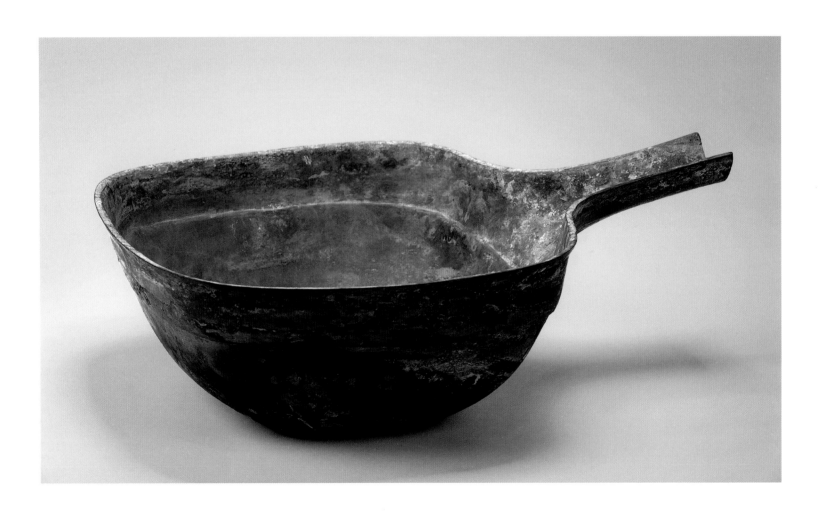

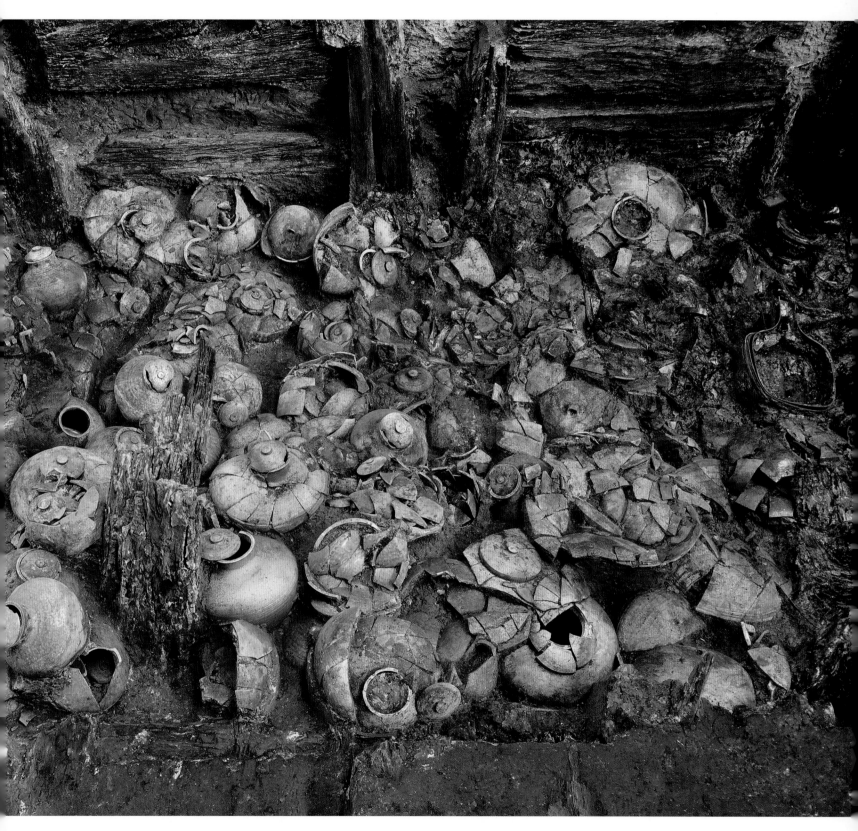

Excavation at Dayun Mountain with pouring vessel (*yi*) at far right.

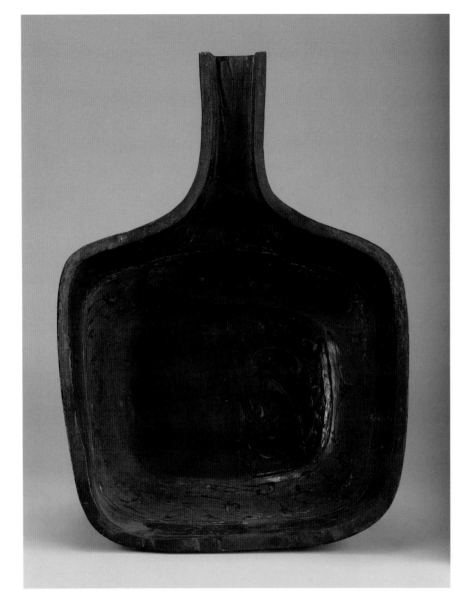

59

彩繪雲氣紋漆匜 儀征聯營
4號墓出土 西漢早中期

Pouring vessel (*yi*)

Unearthed from Tomb 4, Lianying site,
Yizheng, Jiangsu
Western Han period (206 BCE–9 CE),
2nd century BCE
Lacquer
H: 13.6 cm, L: 24 cm, W: 35 cm
Yizheng Museum

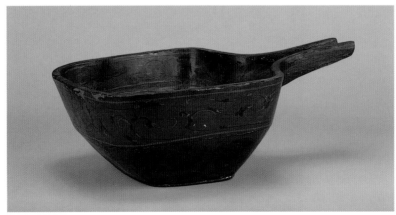

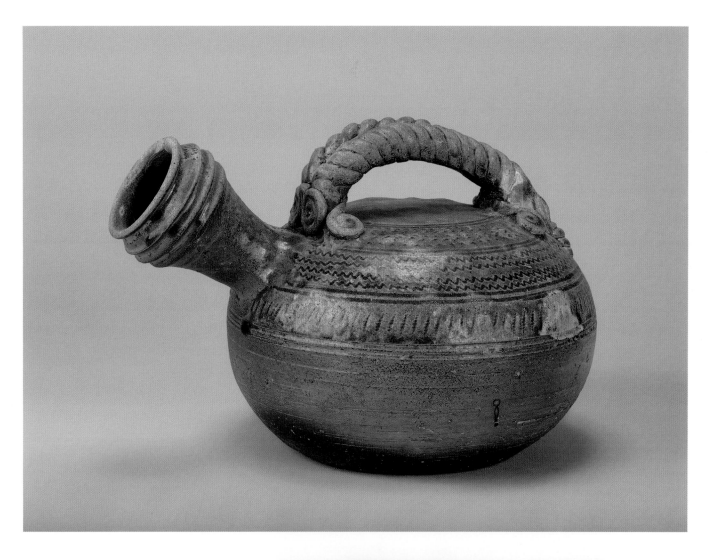

60

刻花紋青釉虎子 儀征聯營1號墓出土
西漢早中期

Urinal (*huzi*)

Unearthed from Tomb 1, Lianying site,
Yizheng, Jiangsu
Western Han period (206 BCE–9 CE),
2nd century BCE
Glazed ceramic
H: 18 cm, L: 25 cm, W: 22.7 cm
Yizheng Museum

61

銅祖 盱眙大雲山1號墓出土
西漢早期

Phallus

Unearthed from Tomb 1,
Dayun Mountain, Xuyi, Jiangsu
Western Han period (206 BCE–9 CE),
2nd century BCE
Bronze
H: 19 cm, Diam: base 10.9 cm
Nanjing Museum

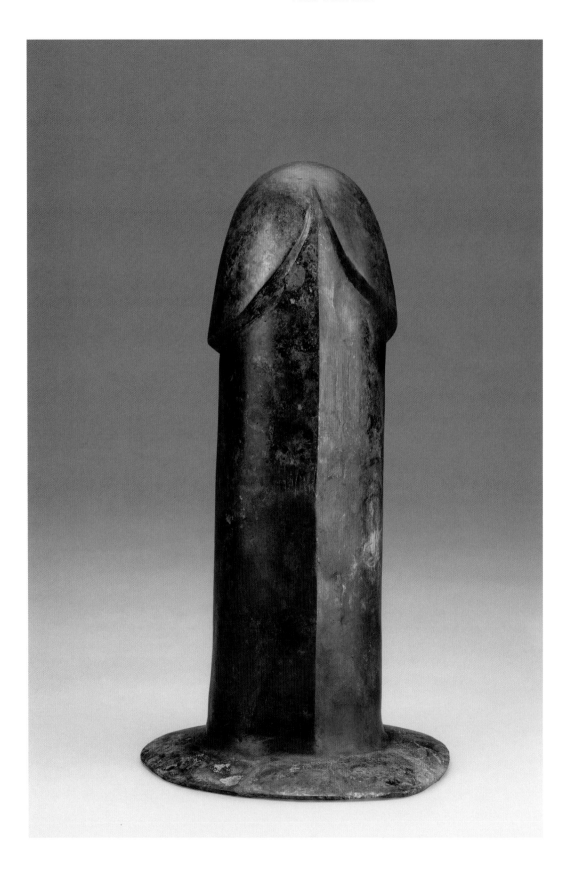

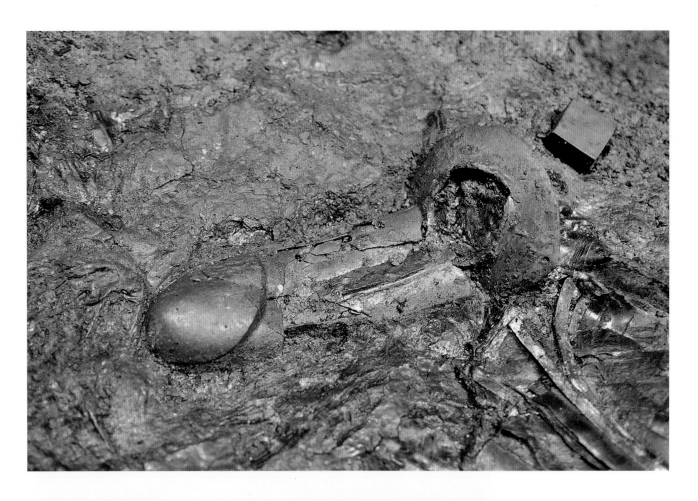

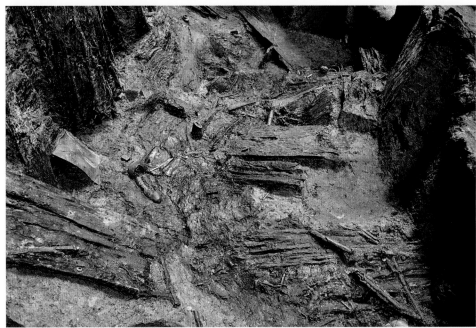

62

銅祖 儀征聯營11號墓出土
西漢早中期

Phallus

Unearthed from Tomb 11, Lianying site,
Yizheng, Jiangsu
Western Han period (206 BCE–9 CE),
2nd century BCE
Bronze
H: 3 cm, L: 15.5 cm, Diam: 3 cm, ring 6 cm
Yizheng Museum

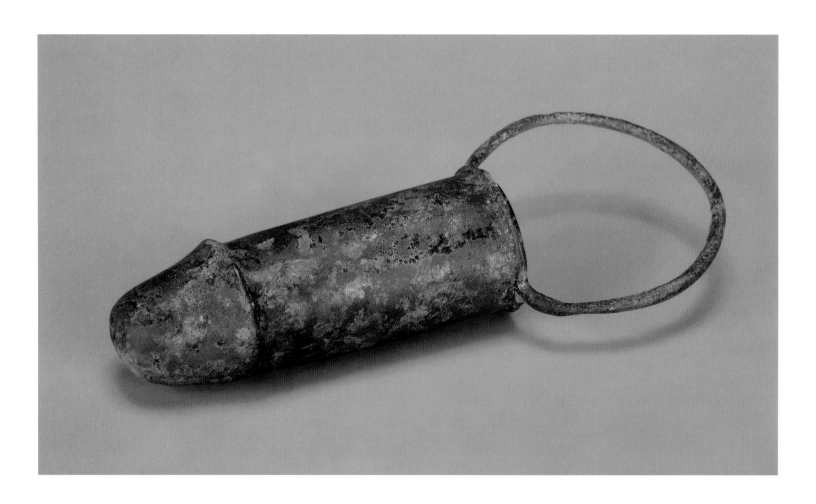

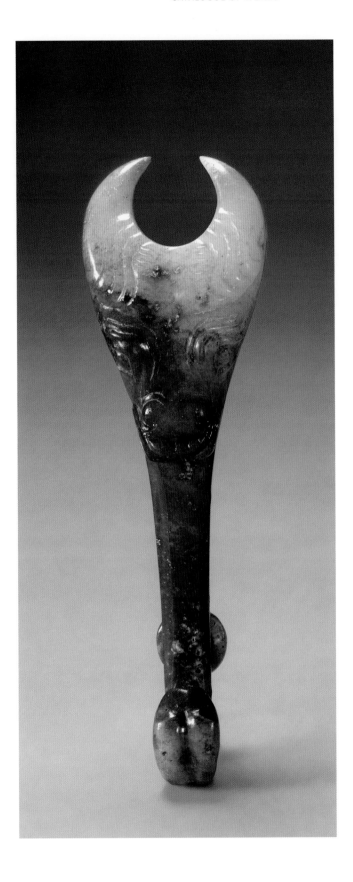

63

牛首形玉帶鉤 盱眙大雲山
1號墓出土 西漢早期

Belt hook in the shape of a bull's head

Unearthed from Tomb 1,
Dayun Mountain, Xuyi, Jiangsu
Western Han period (206 BCE–9 CE),
2nd century BCE
Jade
L: 7.3 cm, W: 2.2 cm
Nanjing Museum

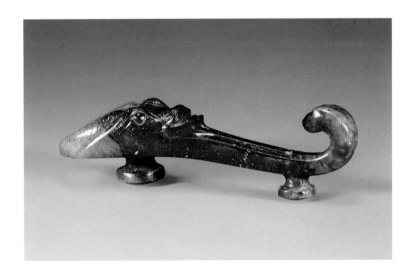

64

玉帶鉤 盱眙大雲山1號墓出土
西漢早期

Belt hook in the shape of a bull's head

Unearthed from Tomb 1,
Dayun Mountain, Xuyi, Jiangsu
Western Han period (206 BCE–9 CE),
2nd century BCE
Jade
L: 4.3 cm, W: 2.5 cm
Nanjing Museum

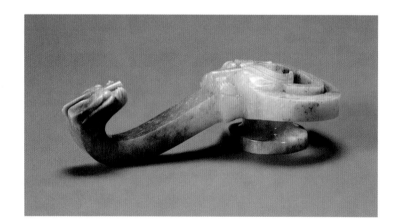

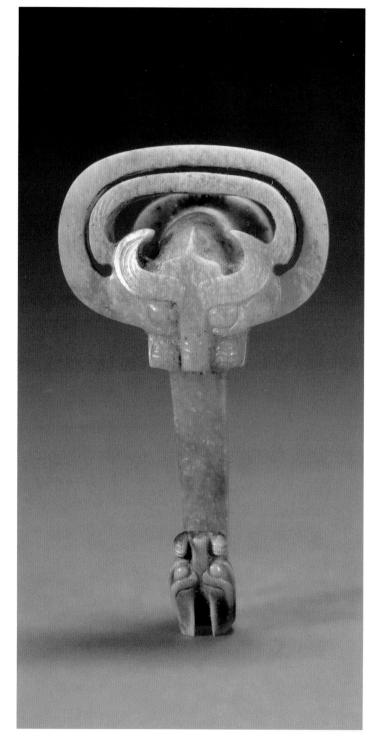

65

水晶帶鉤 盱眙大雲山1號墓出土
西漢早期

Belt hook

Unearthed from Tomb 1,
Dayun Mountain, Xuyi, Jiangsu
Western Han period (206 BCE–9 CE),
2nd century BCE
Crystal
L: 5.8 cm, W: 2.2 cm
Nanjing Museum

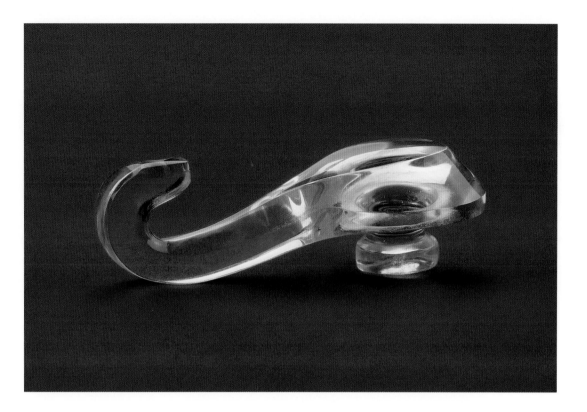

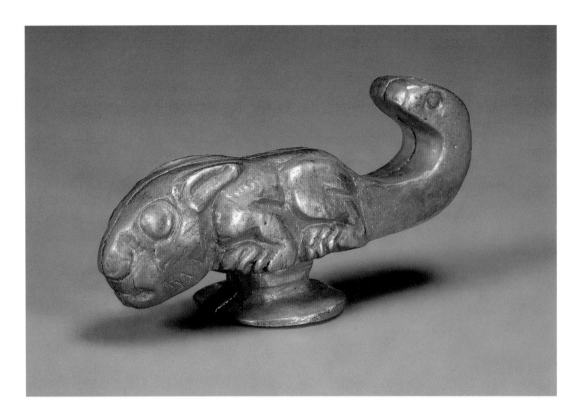

66

兔形金帶鉤 盱眙大雲山9號墓出土
西漢早期

**Belt hook in the shape of
a rabbit**

Unearthed from Tomb 9, Dayun Mountain,
Xuyi, Jiangsu
Western Han period (206 BCE–9 CE),
2nd century BCE
Gold
H: 2.2 cm, L: 3.8 cm, W: 1.3 cm
Nanjing Museum

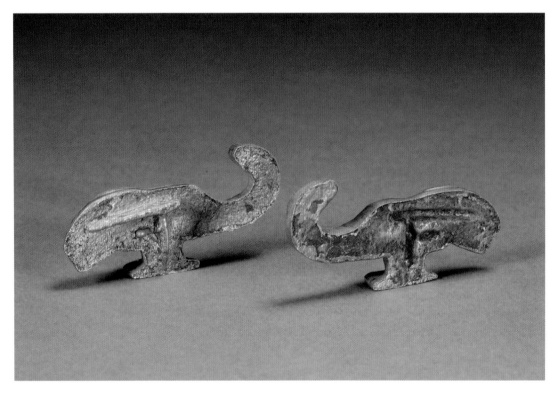

67

"長毋相忘" 銘銀帶鉤 盱眙大雲山
12號墓出土 西漢早期

Belt hook in the shape of a dragon

Unearthed from Tomb 12,
Dayun Mountain, Xuyi, Jiangsu
Western Han period (206 BCE–9 CE),
2nd century BCE
Silver
Together: L: 4 cm, W: 1.8 cm
Separate: H: 1.8 cm, L: 4 cm, W: 2 cm (each)
Nanjing Museum

Inscription: 長毋相忘 (*chang wu xiang wang*), "Enduring remembrance without fail" or "Forget me not"

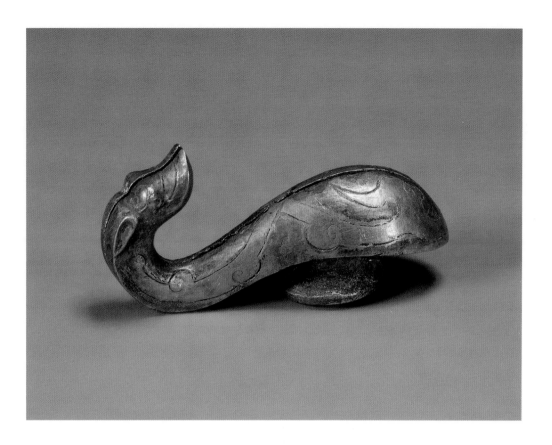

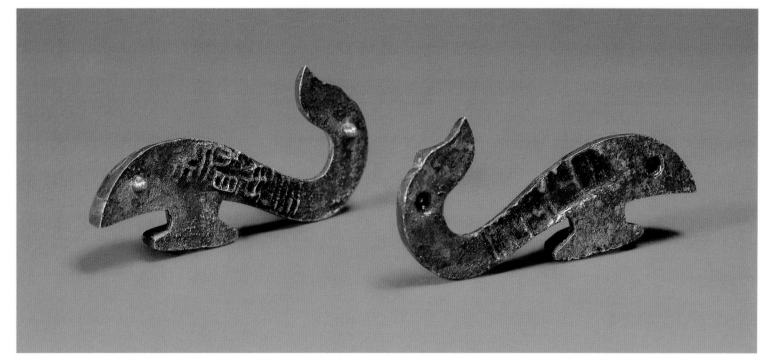

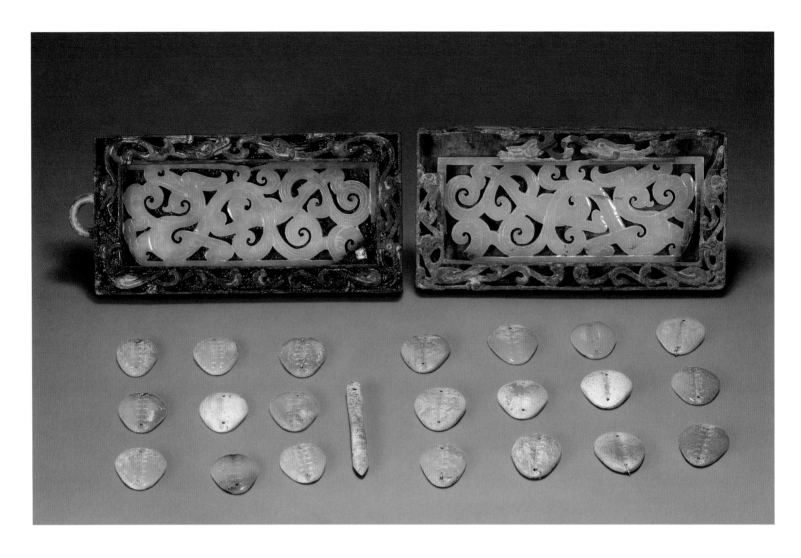

68

鑲玉鎏金銅帶頭綴玉貝腰帶
盱眙大雲山1號墓1號坑出土
西漢早期

Belt segments in the shape of cowrie shells and buckle

Unearthed from Tomb 1, Pit 1,
Dayun Mountain, Xuyi, Jiangsu
Western Han period (206 BCE–9 CE),
2nd century BCE
Jade with gilt bronze buckles
Various dimensions
Nanjing Museum

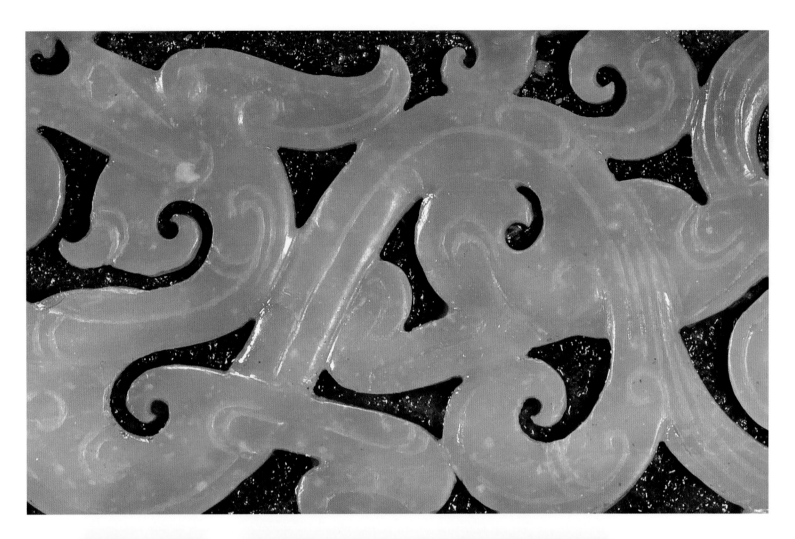

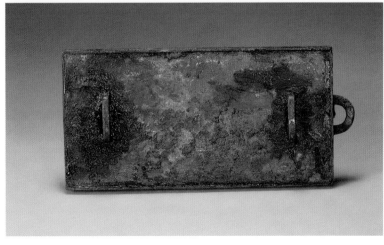

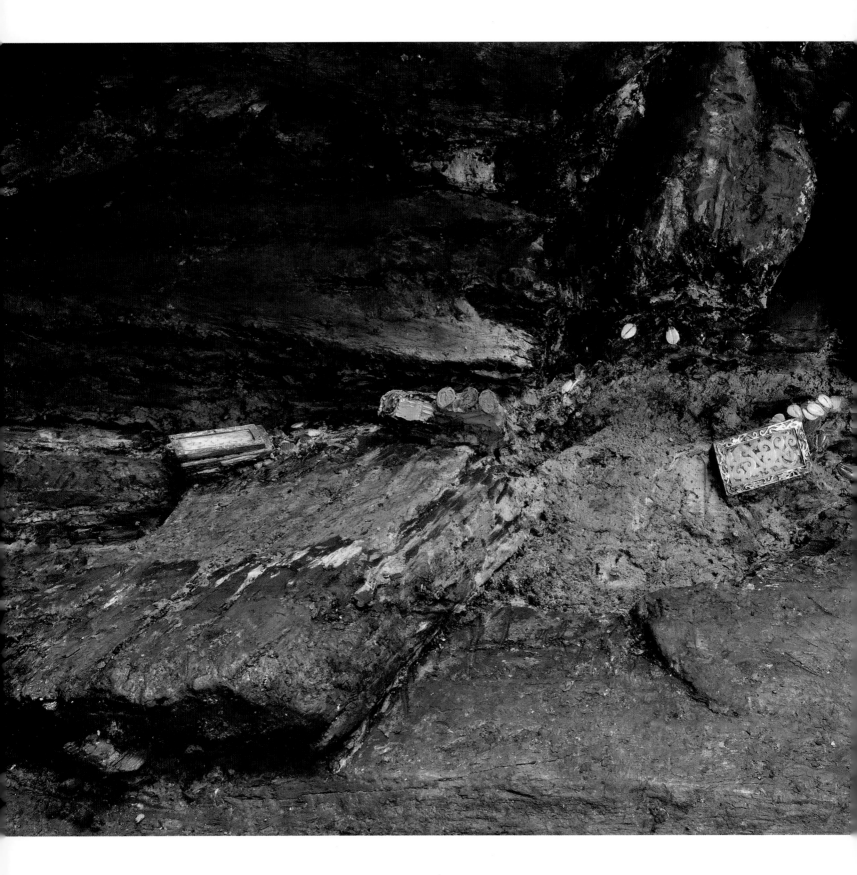

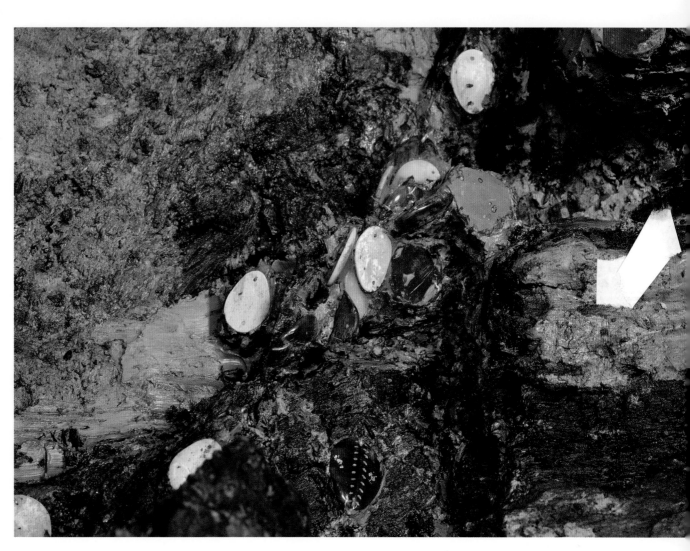

Excavation of Liu Fei's tomb at Dayun Mountain showing belt segments (CAT. 68)

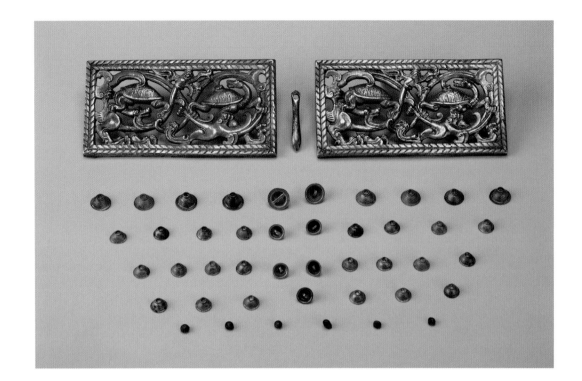

69

金帶扣 盱眙大雲山9號墓出土
西漢早期

Set of belt buckles

Unearthed from Tomb 9,
Dayun Mountain, Xuyi, Jiangsu
Western Han period (206 BCE–9 CE),
2nd century BCE
Gold and glass
H: 5.5 cm, L: 8.7 cm each buckle
Nanjing Museum

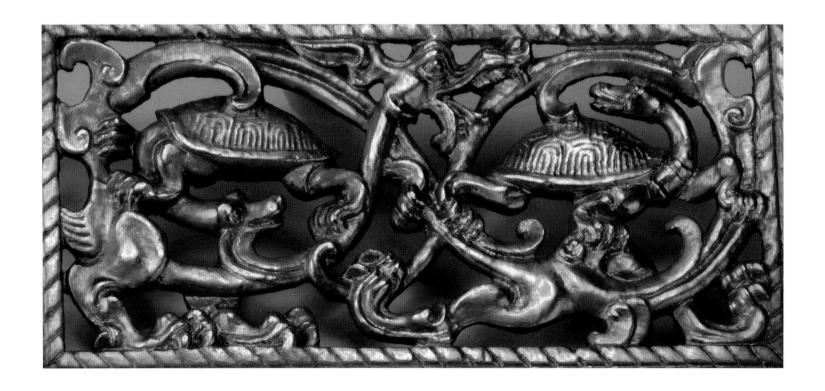

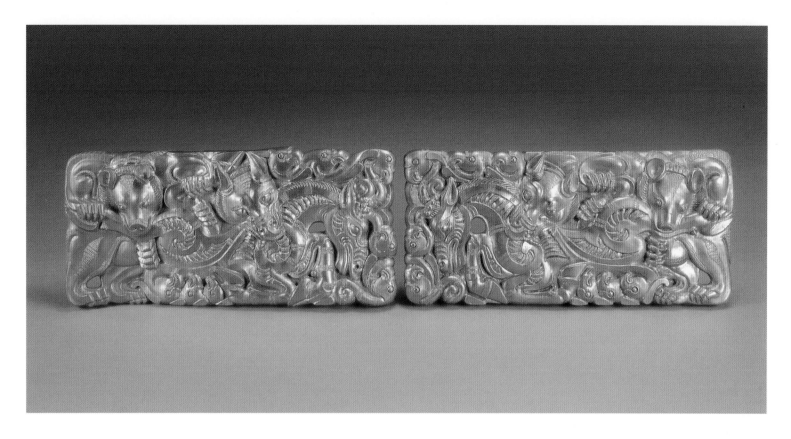

70

金帶扣 徐州天齊山漢墓出土
西漢早期

Set of belt buckles

Unearthed from a Han dynasty tomb,
Tianqi Mountain, Xuzhou, Jiangsu
Western Han period (206 BCE–9 CE),
2nd century BCE
Gold
H: 6.3 cm, L: 13.35 cm, W: 1 cm each
Xuzhou Museum

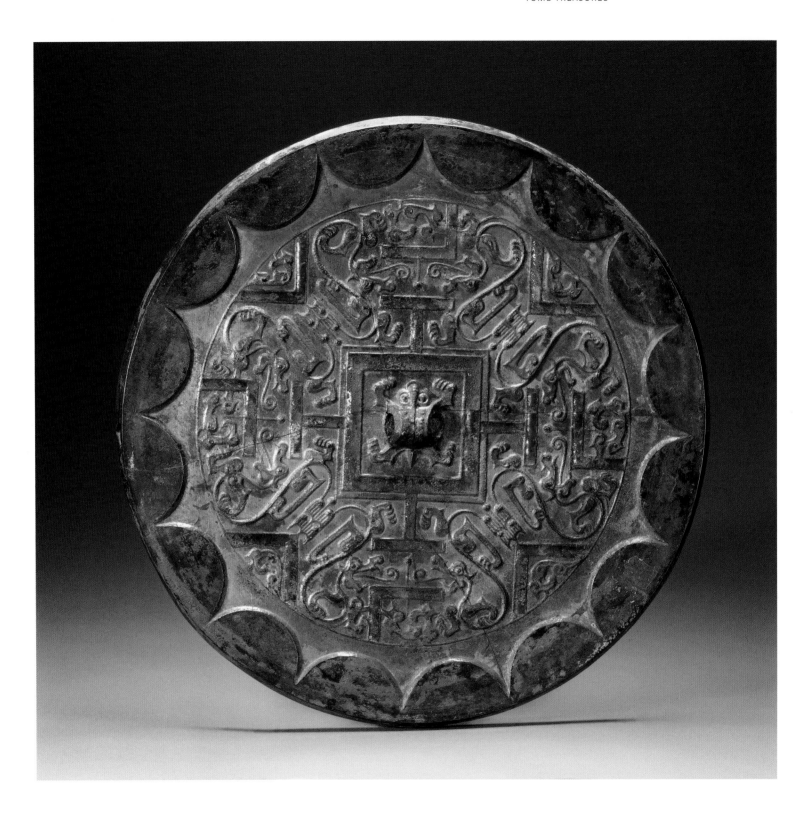

71 (LEFT)

龍紋規矩銅鏡 盱眙大雲山1號墓
1號坑出土 西漢早期

Mirror with dragon design

Unearthed from Tomb 1, Pit 1,
Dayun Mountain, Xuyi, Jiangsu
Western Han period (206 BCE–9 CE),
2nd century BCE
Bronze
Diam: 21 cm
Nanjing Museum

72 (RIGHT)

鳳紋銅鏡 盱眙大雲山6號墓出土
西漢早期

Mirror with phoenix design

Unearthed from Tomb 6,
Dayun Mountain, Xuyi, Jiangsu
Western Han period (206 BCE–9 CE),
2nd century BCE
Bronze
Diam: 21 cm
Nanjing Museum

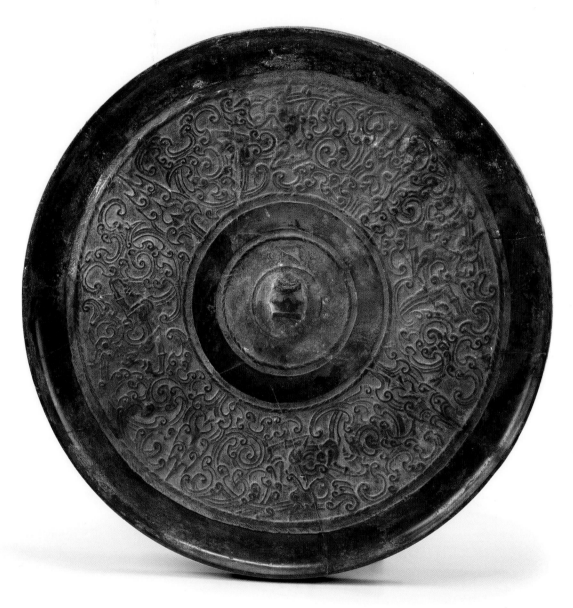

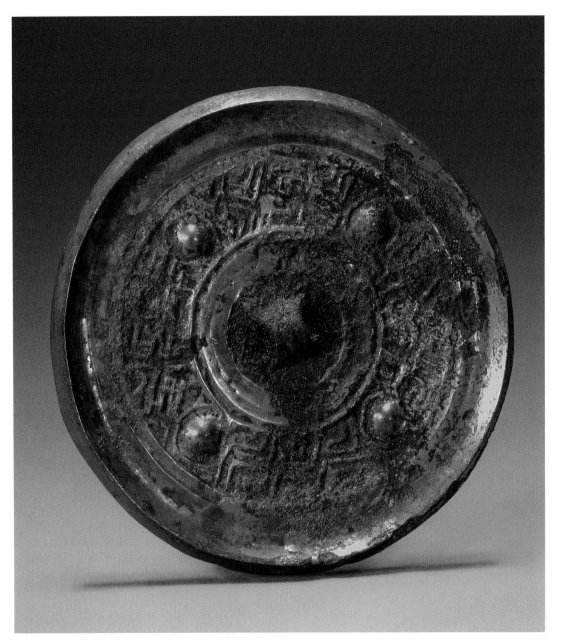

73 (LEFT)

小型雷文銅鏡（補妝鏡）
盱眙大雲山9號墓出土 西漢早期

Makeup mirror

Unearthed from Tomb 9, Dayun Mountain,
Xuyi, Jiangsu
Western Han period (206 BCE–9 CE),
2nd century BCE
Bronze
Diam: 4.5 cm
Nanjing Museum

74 (RIGHT)

金帽飾 盱眙大雲山1號墓1號坑出土
西漢早期

Hat ornaments

Unearthed from Tomb 1, Pit 1,
Dayun Mountain, Xuyi, Jiangsu
Western Han period (206 BCE–9 CE),
2nd century BCE
Gold
Various dimensions
Nanjing Museum

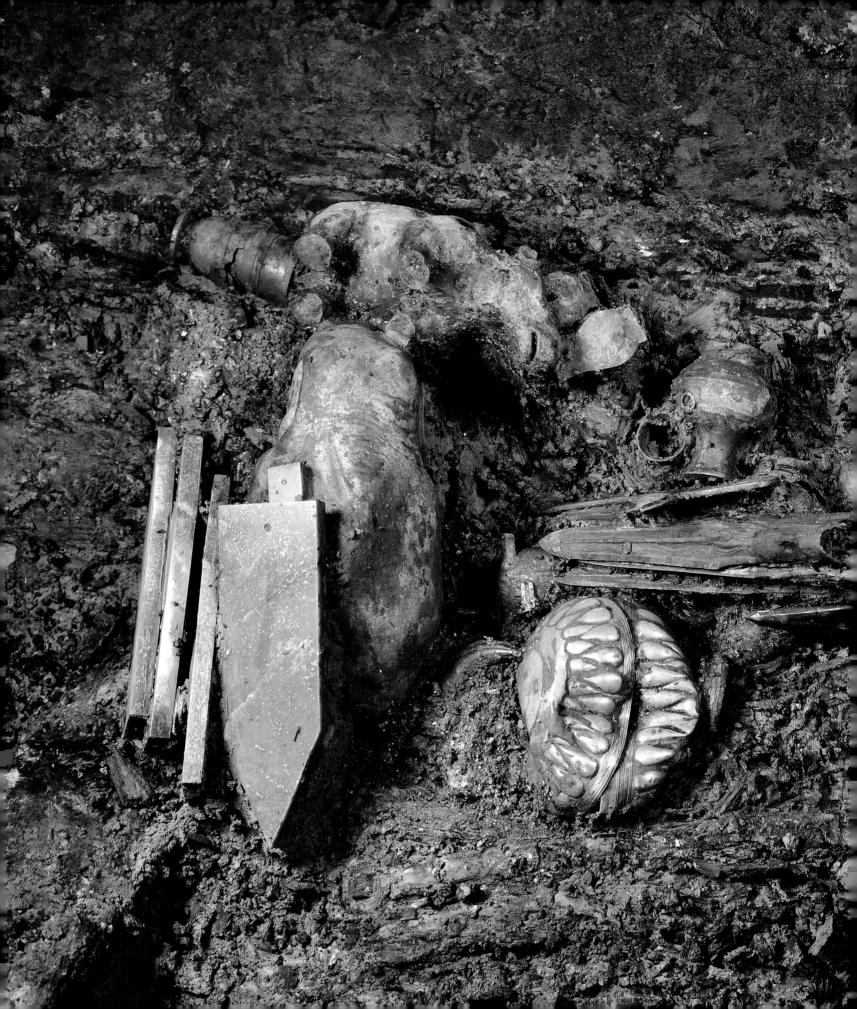

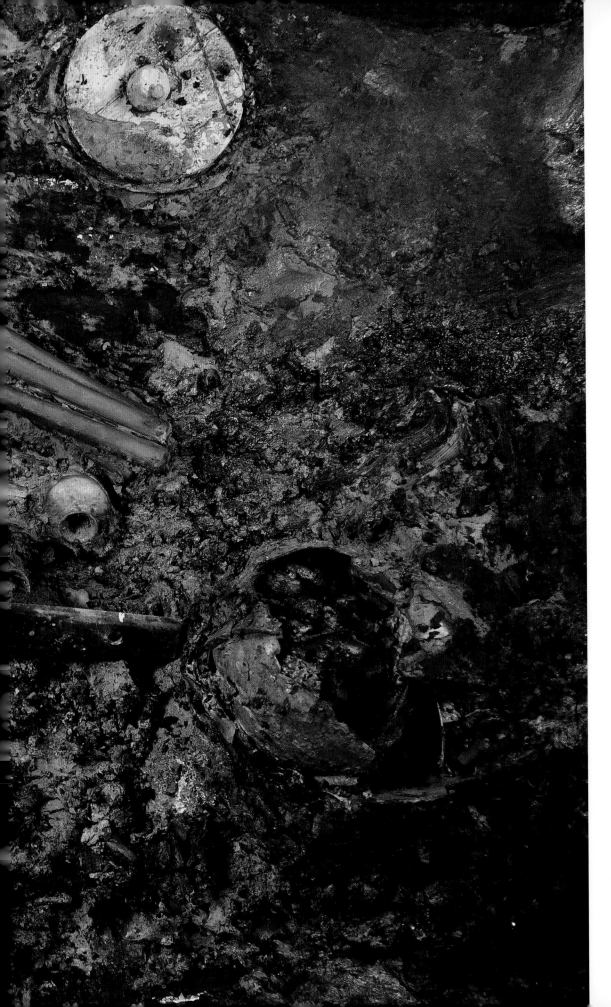

Excavation of Liu Fei's tomb at Dayun
Mountain showing CATS. 43, 75, 76, and 85

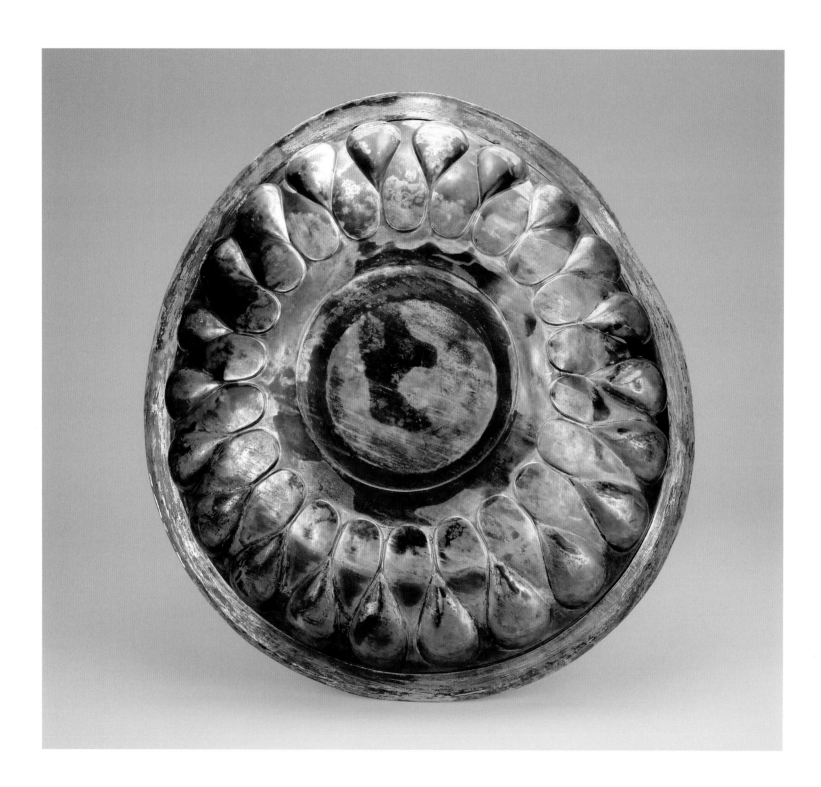

75 (LEFT)

銀盤 盱眙大雲山1號墓出土 秦朝

Basin

Unearthed from Tomb 1,
Dayun Mountain, Xuyi, Jiangsu
Qin dynasty (221–206 BCE)
Silver
H: 5 cm, Diam: mouth 37.5 cm
Nanjing Museum

76 (RIGHT)

直内玉戈 盱眙大雲山1號墓
1號坑出土 商朝

Dagger-axe (*ge*)

Unearthed from Tomb 1, Pit 1,
Dayun Mountain, Xuyi, Jiangsu
Shang dynasty (approx. 1600–1050 BCE)
Jasper
L: 23 cm, W: 4.2 cm
Nanjing Museum

77

龍形玉佩 徐州獅子山楚王墓出土
戰國時期

**Pendant in the shape of
a dragon**

Unearthed from the Tomb of the King of
Chu, Shizi Mountain, Xuzhou, Jiangsu
Zhou dynasty, Warring States period
(approx. 480–221 BCE)
Jade
H: 9.8 cm, L: 0.2 cm, W: 22 cm
Xuzhou Museum

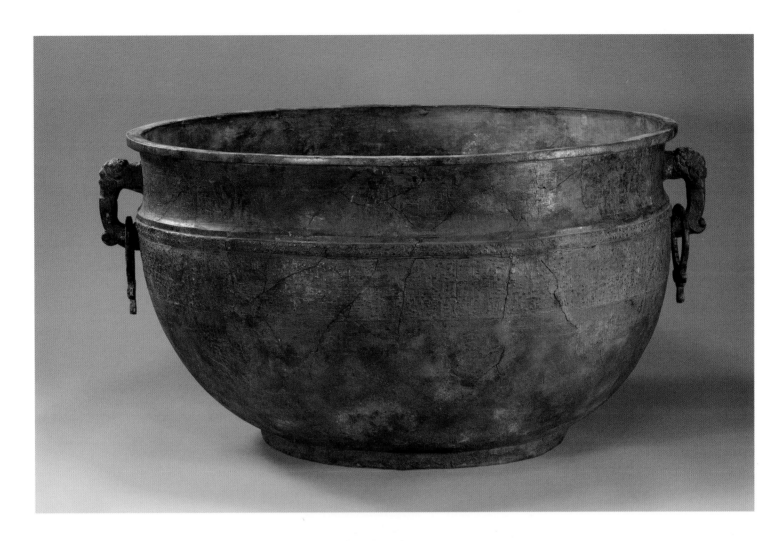

78

蟠螭紋青銅銷 盱眙大雲山
1號墓出土 春秋時期

Basin (*xuan*)

Unearthed from Tomb 1,
Dayun Mountain, Xuyi, Jiangsu
Zhou dynasty, Spring and Autumn
period (771–approx. 475 BCE)
Bronze
H: 34 cm, Diam: with handles 68 cm
Nanjing Museum

79

越國青銅錞于 盱眙大雲山1號墓
1號坑出土 戰國時期

Bell (*chunyu*)

Unearthed from Tomb 1, Pit 1,
Dayun Mountain, Xuyi, Jiangsu
Zhou dynasty, Warring States period
(approx. 480–221 BCE); Yue kingdom
Bronze
H: 67.5 cm, Diam: 40.5 cm, mouth 30.6 cm
Nanjing Museum

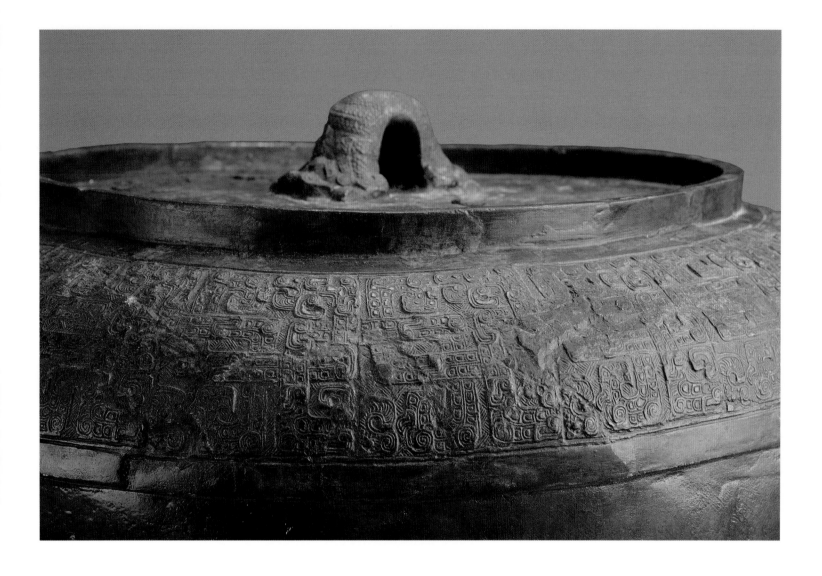

80

銅虎鎮 盱眙大雲山1號墓出土
西漢早期

Pair of weights in the shape of tigers

Unearthed from Tomb 1,
Dayun Mountain, Xuyi, Jiangsu
Western Han period (206 BCE–9 CE),
2nd century BCE
Bronze with inlays of gold and silver
H: 21.5 cm, L: 43 cm, W: 12.5 cm each
Nanjing Museum

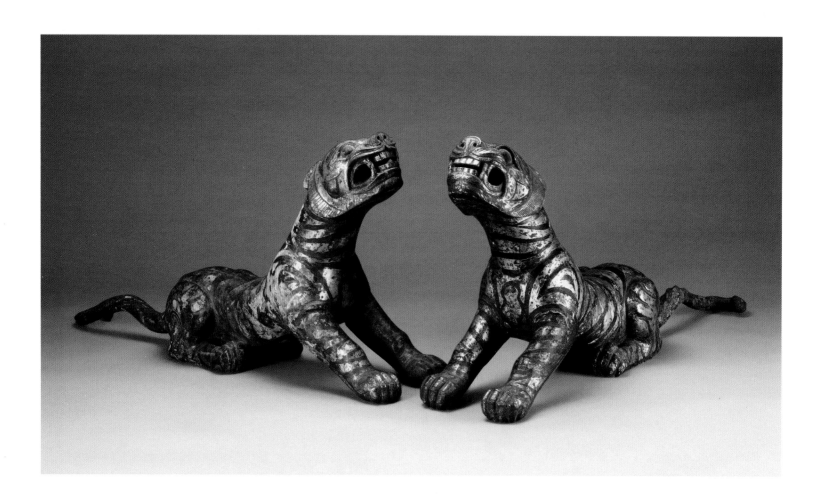

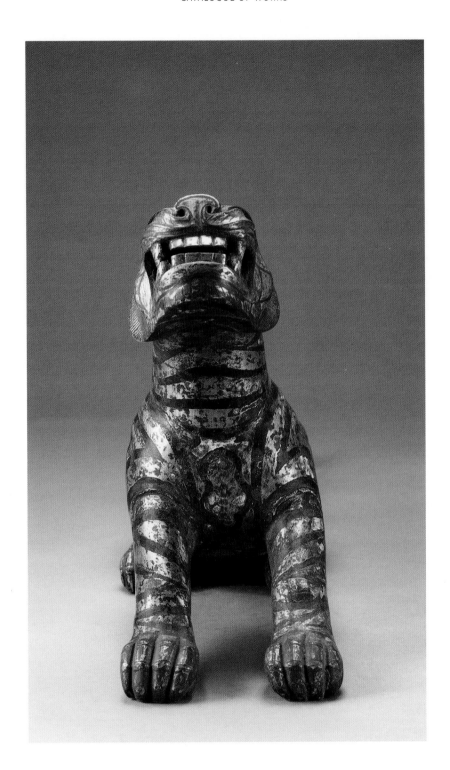

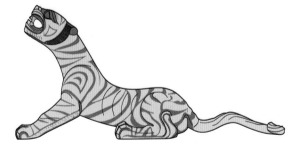

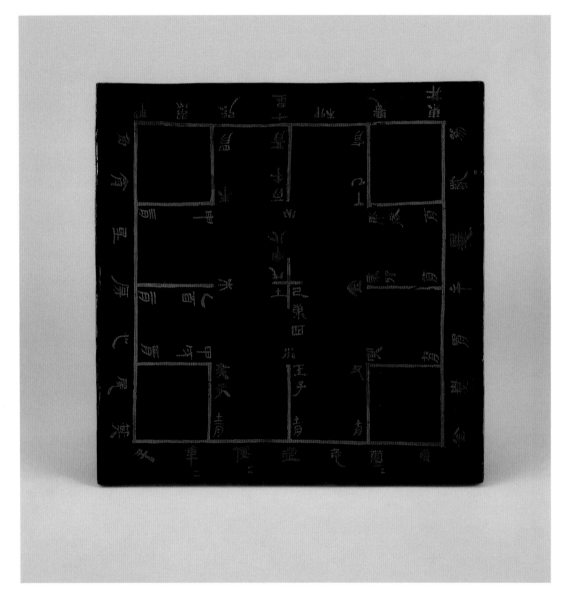

81

漆占卜盤（地盤） 儀征聯營
10號墓出土 西漢早期

Divination board

Unearthed from Tomb 10, Lianying site,
Yizheng, Jiangsu
Western Han period (206 BCE–9 CE),
2nd century BCE
Lacquer
H: 21 cm, L: 1 cm, W: 21 cm
Yizheng Museum

82

金縷玉衣 盱眙大雲山
楚王后墓出土 西漢早期

Jade suit

Unearthed from Tomb 2,
Dayun Mountain, Xuyi, Jiangsu
Western Han period (206 BCE–9 CE),
2nd century BCE
Jade and gold
H: 28 cm, L: 175 cm, W: 76 cm
Nanjing Museum

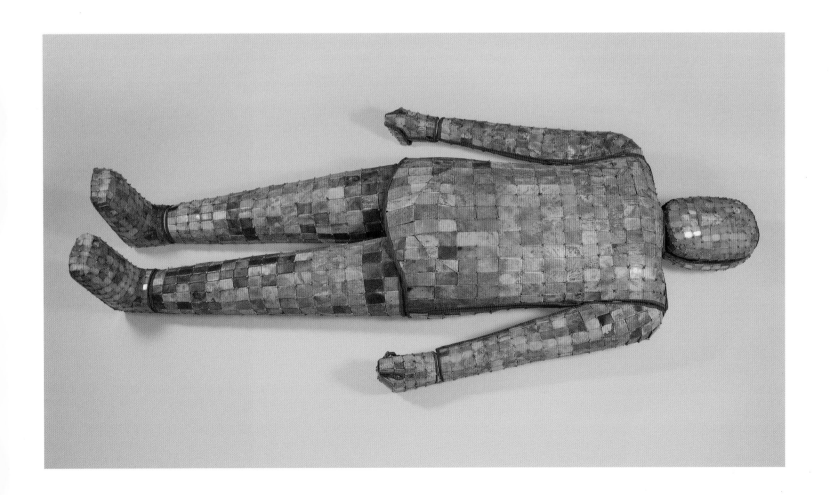

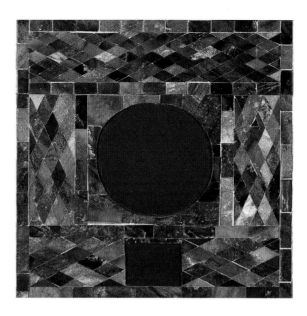

83

玉棺 徐州獅子山楚王墓出土
西漢早期

Coffin

Unearthed from the Tomb of the King of
Chu, Shizi Mountain, Xuzhou, Jiangsu
Western Han period (206 BCE–9 CE),
2nd century BCE
Jade, lacquer, and wood
H: 108 cm, L: 280.5 cm, W: 110.5 cm
Xuzhou Museum

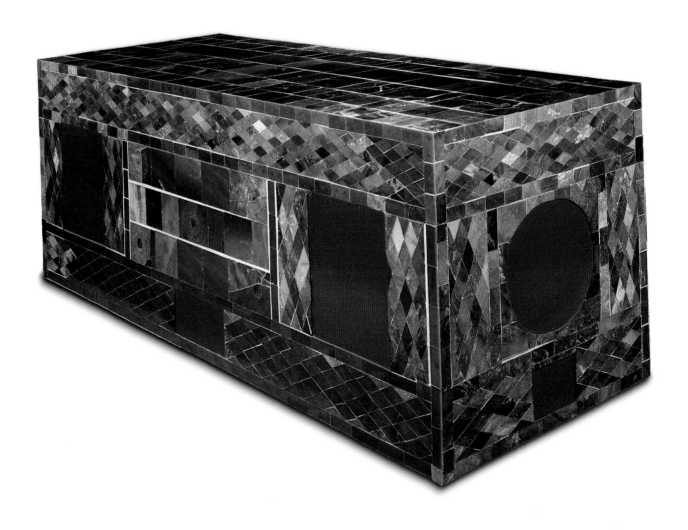

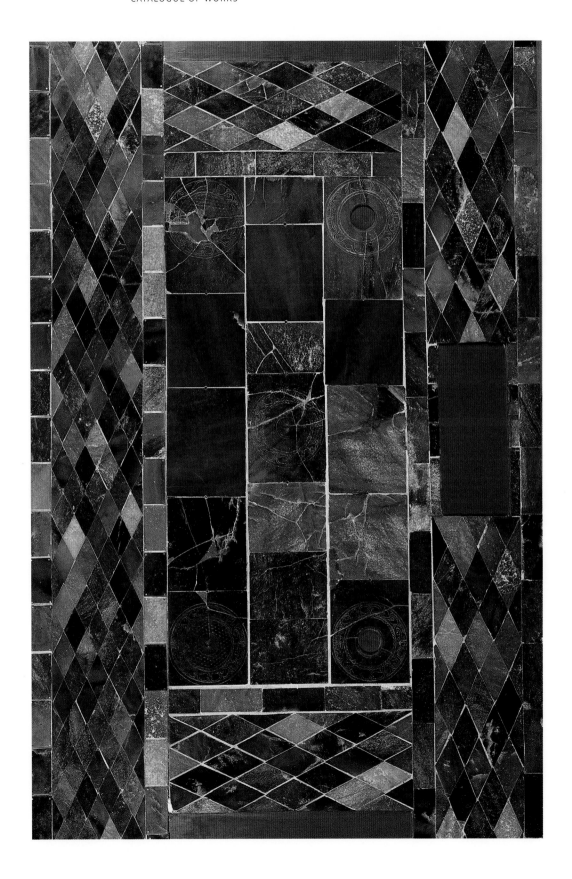

84

龍紋鑲玉漆枕 徐州後樓山
5號墓出土 西漢早期

Pillow with dragon design

Unearthed from Tomb 5, Houlou
Mountain, Xuzhou, Jiangsu
Western Han period (206 BCE–9 CE),
2nd century BCE
Lacquer inlaid with jade
H: 9 cm, L: 9 cm, W: 18.2 cm
Xuzhou Museum

85

玉圭 盱眙大雲山1號墓1號坑出土
西漢早期

Tablets (*gui*)

Unearthed from Tomb 1, Pit 1,
Dayun Mountain, Xuyi, Jiangsu
Western Han period (206 BCE–9 CE),
2nd century BCE
Jade
H: 28.85 cm, L: 1.7 cm, W: 9.6 each
Nanjing Museum

Two of these artworks are exhibited.

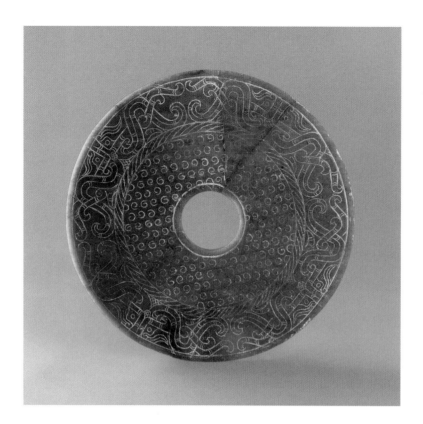

86

玉璧 徐州獅子山楚王墓出土
西漢早期

Disk (*bi*)

Unearthed from the Tomb of the King of
Chu, Shizi Mountain, Xuzhou, Jiangsu
Western Han period (206 BCE–9 CE),
2nd century BCE
Jade
Diam: 23 cm
Nanjing Museum

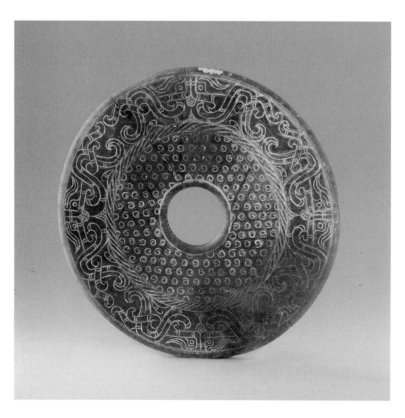

87

玉璧 徐州獅子山楚王墓出土
西漢早期

Disk (*bi*)

Unearthed from the Tomb of the King of
Chu, Shizi Mountain, Xuzhou, Jiangsu
Western Han period (206 BCE–9 CE),
2nd century BCE
Jade
Diam: 14 cm
Xuzhou Museum

88

玉環 盱眙大雲山1號墓出土
西漢早期

Ring (*huan*)

Unearthed from Tomb 1,
Dayun Mountain, Xuyi, Jiangsu
Western Han period (206 BCE–9 CE),
2nd century BCE
Jade
Diam: 11 cm
Nanjing Museum

89

龍首玉璜 盱眙大雲山10號墓出土
西漢早期

Ornament (*huang*) with dragon design

Unearthed from Tomb 10, Dayun Mountain,
Xuyi, Jiangsu
Western Han period (206 BCE–9 CE),
2nd century BCE
Jade
H: 2.4 cm, L: 9.4 cm
Nanjing Museum

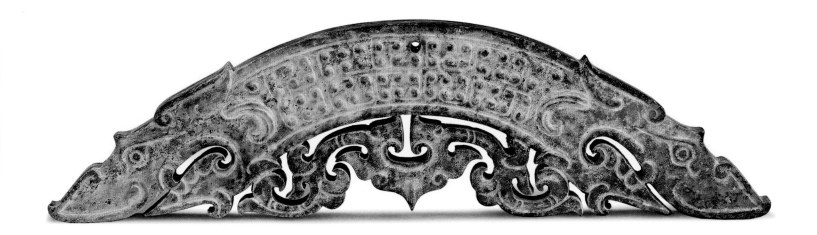

90

玉璜 徐州獅子山楚王墓出土
西漢早期

Ornament (*huang*)

Unearthed from the Tomb of the King of
Chu, Shizi Mountain, Xuzhou, Jiangsu
Western Han period (206 BCE–9 CE),
2nd century BCE
Jade
H: 9 cm, L: 20 cm
Nanjing Museum

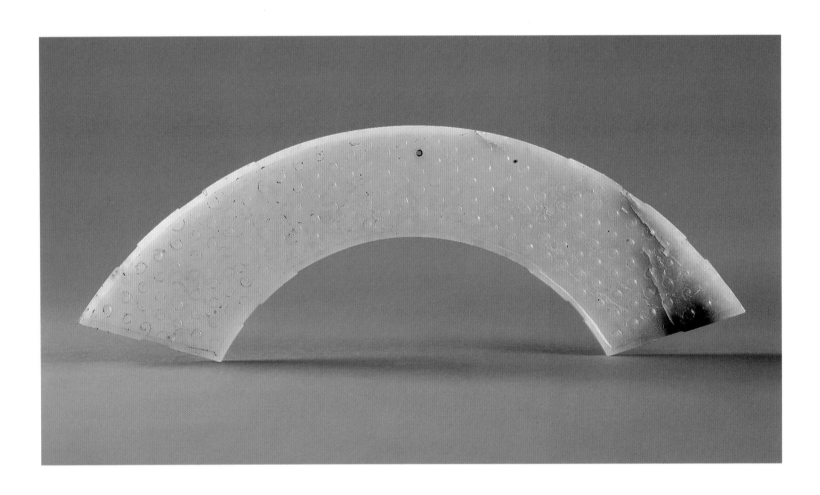

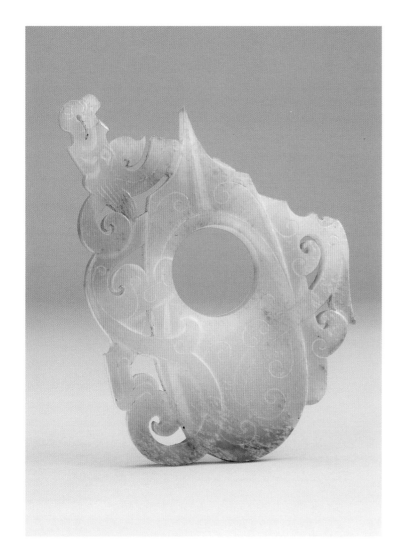
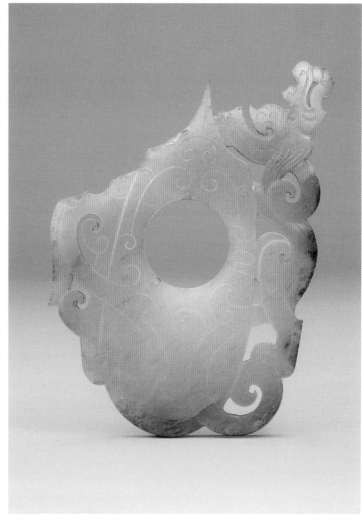

91

韘形玉佩 盱眙大雲山1號墓
1號坑出土 西漢早期

Pendant in the shape of a thumb ring (*she*)

Unearthed from Tomb 1, Pit 1,
Dayun Mountain, Xuyi, Jiangsu
Western Han period (206 BCE–9 CE),
2nd century BCE
Jade
H: 6.3 cm, L: 9.5 cm
Nanjing Museum

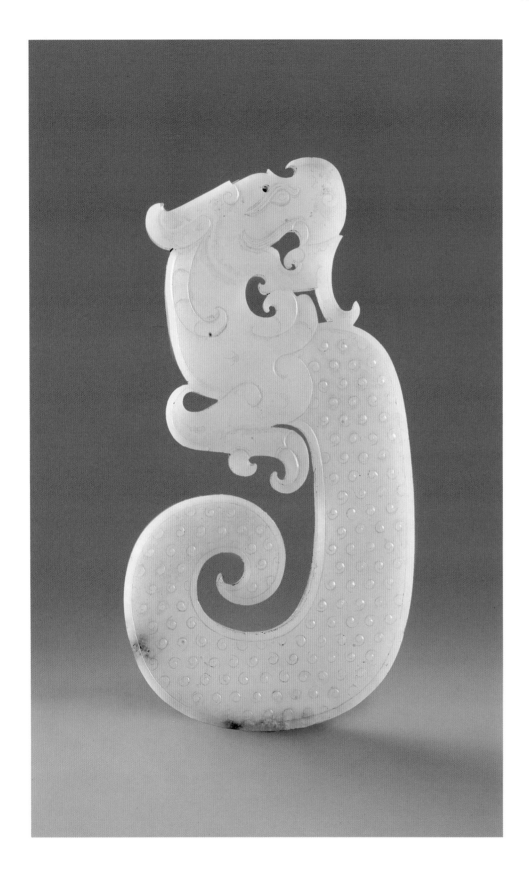

92

龍形玉佩 徐州獅子山楚王墓出土
西漢早期

**Pendant in the shape of
a dragon**

Unearthed from the Tomb of the King of
Chu, Shizi Mountain, Xuzhou, Jiangsu
Western Han period (206 BCE–9 CE),
2nd century BCE
Jade
H: 14.6 cm, L: 8 cm
Nanjing Museum

93

龍形玉飾 徐州獅子山楚王墓出土
西漢早期

Pendant in the shape of a dragon

Unearthed from the Tomb of the King of
Chu, Shizi Mountain, Xuzhou, Jiangsu
Western Han period (206 BCE–9 CE),
2nd century BCE
Jade
H: 17.5 cm, L: 0.5 cm, W: 11 cm
Xuzhou Museum

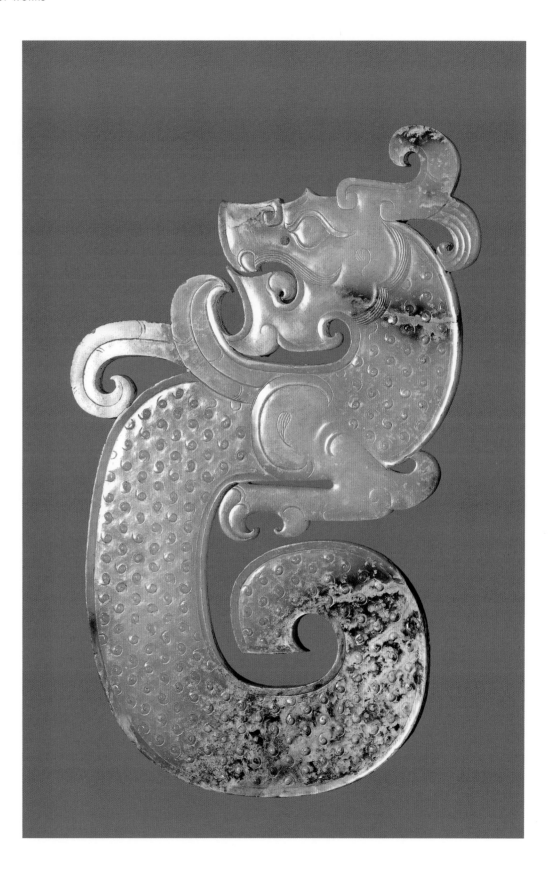

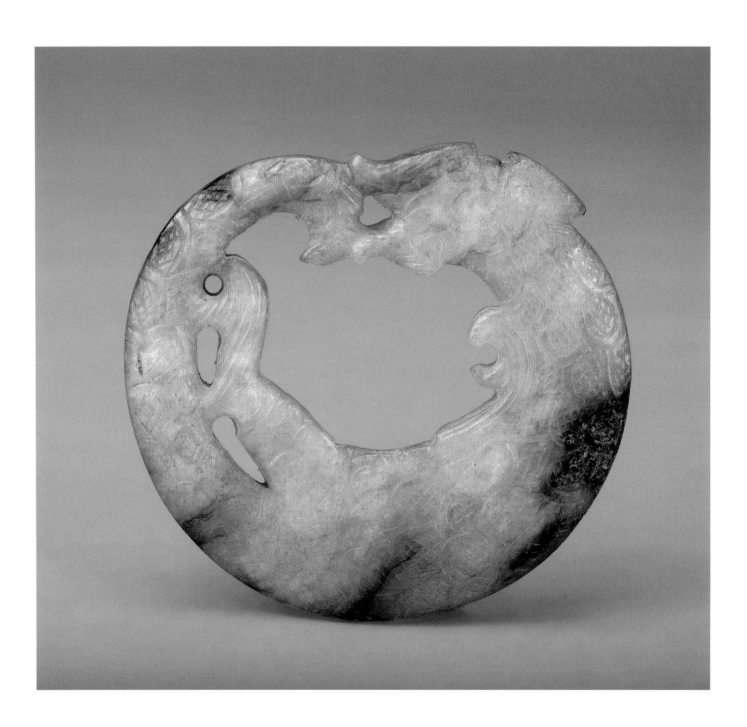

94 (LEFT)

龍形玉佩 儀征聯營4號墓出土
西漢早中期

Pendant in the shape of
a dragon

Unearthed from Tomb 4, Lianying site,
Yizheng, Jiangsu
Western Han period (206 BCE–9 CE),
2nd century BCE
Jade
Diam: 3.5 cm
Yizheng Museum

95 (RIGHT)

蟬形玉佩 徐州獅子山楚王墓出土
西漢早期

Pendant in the shape of
a cicada

Unearthed from the Tomb of the King of
Chu, Shizi Mountain, Xuzhou, Jiangsu
Western Han period (206 BCE–9 CE),
2nd century BCE
Jade
H: 4.5 cm, L: 1 cm, W: 2.1 cm
Xuzhou Museum

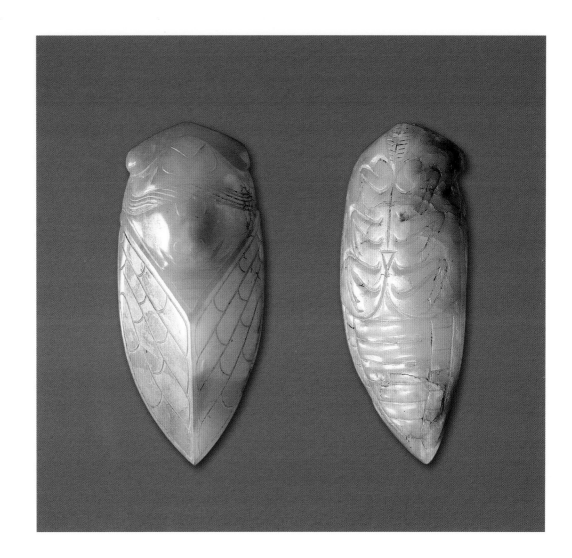

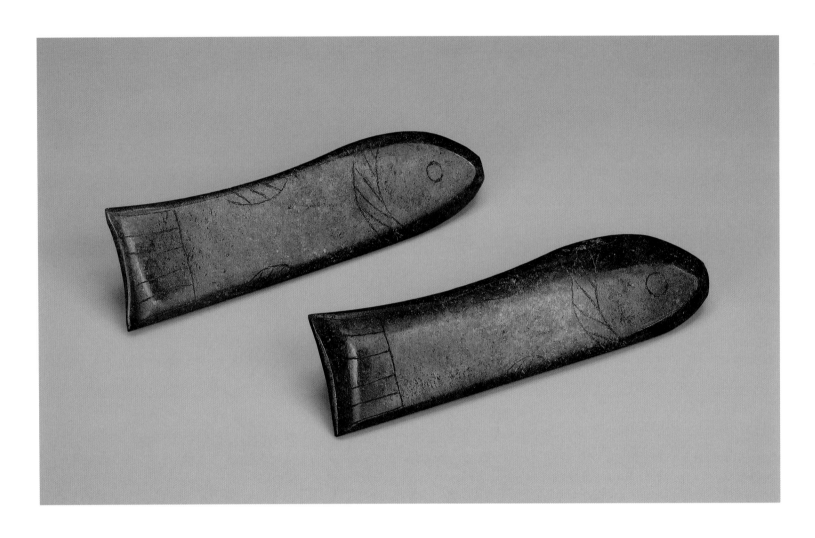

96

玉鱼 儀征團山5號墓出土
西漢早期

Fish-shaped plaques

Unearthed from Tomb 5, Tuan Mountain,
Yizheng, Jiangsu
Western Han period (206 BCE–9 CE),
2nd century BCE
Jade
H: 0.9 cm, L: 13.3 cm, W: 3.7 cm
H: 0.9 cm, L: 13.3 cm, W: 3.9 cm
Yizheng Museum

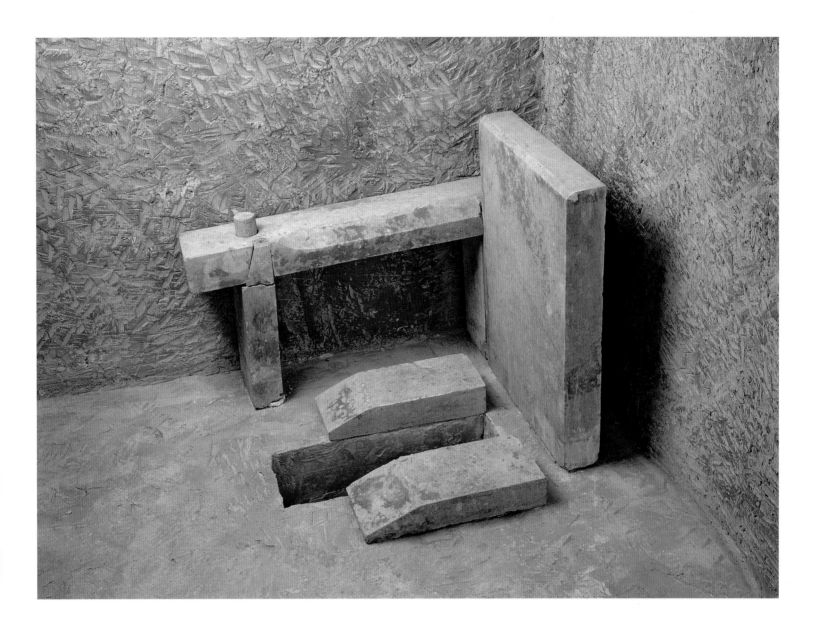

97

石廁 徐州駄藍山楚王后墓出土
西漢早期

Toilet

Unearthed from Tomb 2, Tuolan
Mountain, Xuzhou, Jiangsu
Western Han period (206 BCE–9 CE),
2nd century BCE
Stone
H: 73 cm, L: 108 cm, W: 86 cm
Xuzhou Museum

98

七子漆奩盒 盱眙東陽廟塘漢墓出土
西漢中晚期

Cosmetics box set

Unearthed from Dongyang Miaotang site,
Xuyi, Jiangsu
Western Han period (206 BCE–9 CE),
1st century BCE
Lacquer
H: 12.5 cm, Diam: lid 20.7 cm
Nanjing Museum

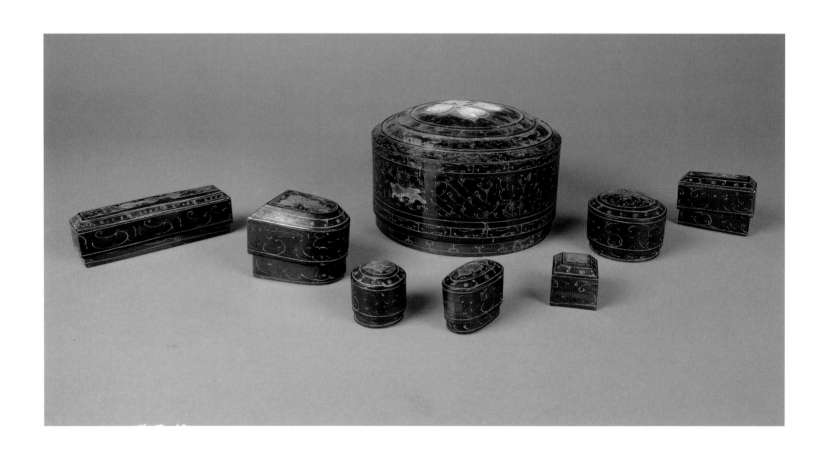

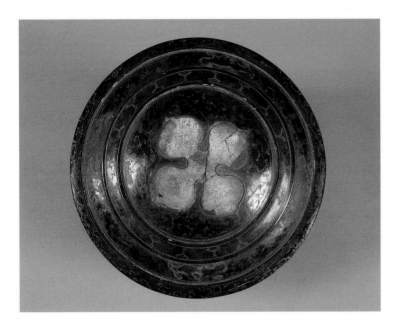

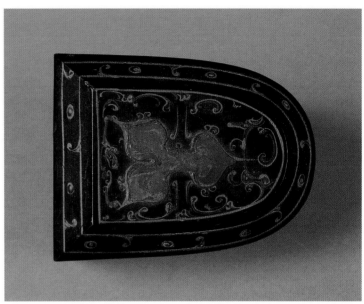

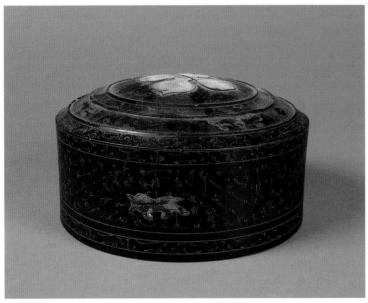

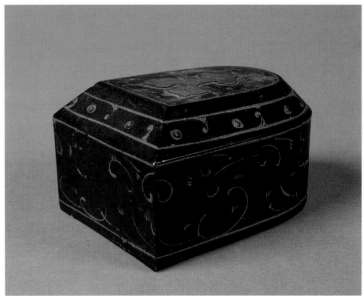

99

"長樂未央" 陶瓦當
館藏 西漢

Roof tile

Western Han period (206 BCE–9 CE)
Earthenware
H: 2 cm, Diam: 17.5 cm
Xuzhou Museum

Inscription:
長樂未央 (*Chang le wei yang*),
"Everlasting happiness without end"

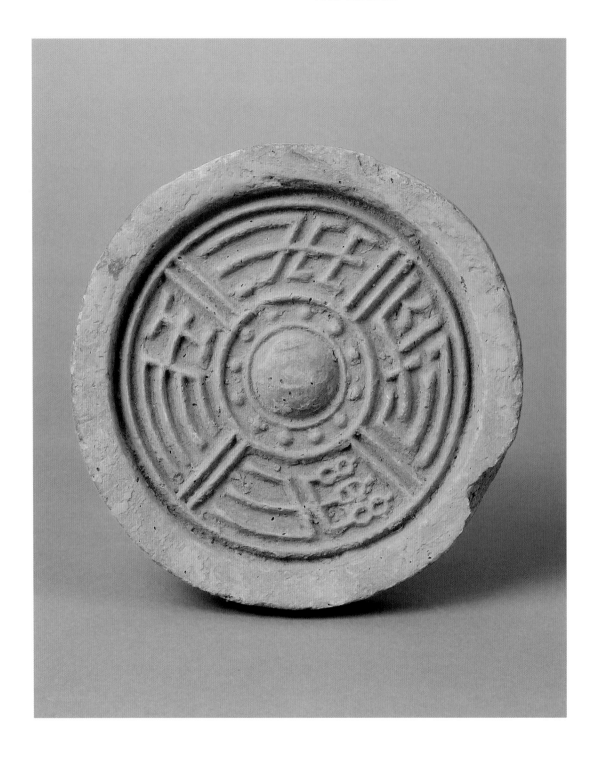

100

"長生無極" 陶瓦當
館藏 西漢

Roof tile

Western Han period (206 BCE–9 CE)
Earthenware
H: 2.2 cm, Diam: 16.5 cm
Xuzhou Museum

Inscription:
長生無極 (*Chang sheng wu ji*), "Eternal
life without limit"

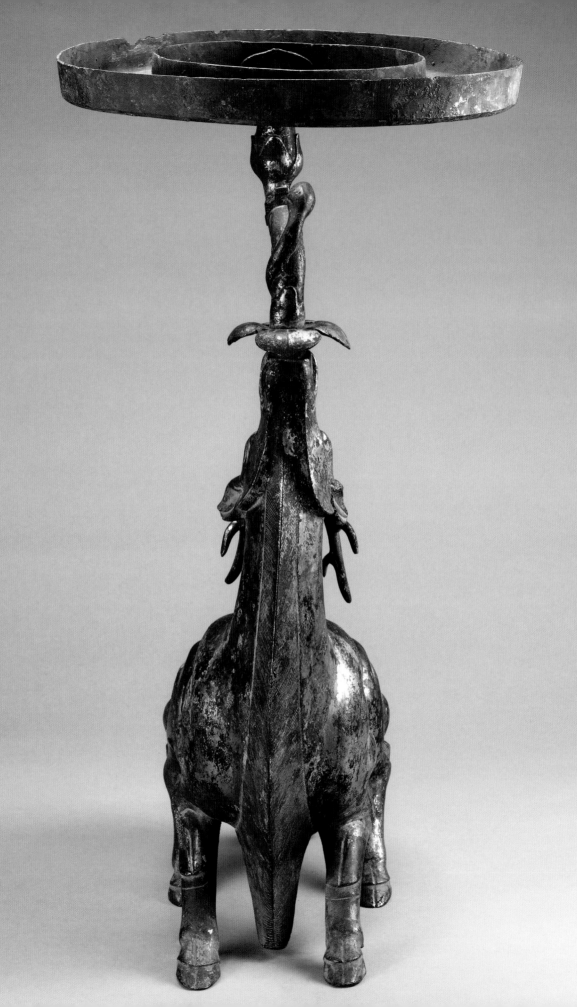

BIBLIOGRAPHY

Ban Gu (32–92). 1962. "Chuyuanwang zhuan" (Biography of King Yuan of Chu). In *Han shu* (History of the Former Han dynasty). Beijing: Zhonghua shuju.
(漢) 班固, 1962: 漢書·楚元王傳。北京: 中華書局.

———. 1974. *Courtier and Commoner in Ancient China: Selections from the* History of the Former Han. Translated by Burton Watson. New York: Columbia University Press.

———. 1983. *Huo Guang Jin Midi zhuan* (Biographies of Huo Guang and Jin Midi). In *Han shu* (History of the Former Han dynasty). Beijing: Zhonghua shuju.
(漢) 班固, 1983: 漢書·霍光金日磾轉。北京: 中華書局.

Chen Hai. 2004. "G dian yu xihan nüyong xing wanju kao" (Research on the G-spot and female sexual toys of the Western Han dynasty). *Kaogu yu wenwu* 3: 62–67.
陳海, 2004: G點與西漢女用性玩具考。收入 考古與文物, 3: 62–67.

Dongnan wenhua (Southeast culture; journal). Beijing: Wenwu chubanshe.
東南文化。北京: 文物出版社.

Excavation Team of the Chu Royal Tomb at Shizi Mountain, eds. 1998. "Xuzhou Shizishan Xihan Chu wang ling fajue jianbao" (A short report on the discovery of a Chu royal tomb of the Western Han at Lion Mountain in Xuzhou). *Wenwu* 8: 4–33.
獅子山楚王陵考古隊, 1998: 徐州獅子山西漢楚王陵發掘簡報。收入文物, 8: 4–33.

Fu Yi (approx. 35–90). 1996. "Rhapsody on Dance." In *Wen Xuan, or Selections of Refined Literature*. Vol. 3, *Rhapsodies on Natural Phenomena, Birds and Animals,*

Aspirations and Feelings, Sorrowful Laments, Literature, Music, and Passions, by Xiao Tong (501–531), translated with annotations by David R. Knechtges, 251. Princeton, NJ: Princeton University Press.

Ge Hong, ed. 2009. *Xijing zaji* (Miscellaneous records of the Western capital). Beijing: Beijing ai ru sheng shu zi hua ji shu yanjiu zhongxin.
葛洪, 2009: 西京雜記。北京: 北京愛如生數字化技術研究中心.

Geng Jianjun, and Liu Chao. 2013. "Xuzhou shi Quanshan qu Xiwoniushan Han mu fajue" (The discovery of a Han tomb in the western Crouching Ox Mountain in the Quanshan district of Xuzhou city). In *Jiangsu kaogu, 2010–2011* (Jiangsu archaeology, 2010–2011), 87–91. Nanjing: Nanjing chubanshe.
耿建軍、劉超, 2013: 徐州市泉山區西臥牛山漢墓發掘。收入江蘇省文物局主編, 江蘇考古(2010–2011)。南京出版社, 87–91.

Gunter, Ann C., and Paul Jett. 1992. *Ancient Iranian Metalwork in the Arthur M. Sackler Gallery and the Freer Gallery of Art*. Washington, DC: Arthur M. Sackler Gallery; Freer Gallery of Art; Smithsonian Institution.

Hansen, Valerie. 2012. *The Silk Road: A New History*. Oxford: Oxford University Press.

Henan Province Shangqiu City Cultural Relics Management Committee, Henan Provincial Institute of Cultural Relics and Archaeology, and Henan Province Yongcheng City Cultural Relics Management Committee. 2001. *Mangdangshan Xihan Liangwang mudi* (Western Han royal tombs from the state of Liang at Mangdang Mountain). Beijing: Wenwu chubanshe.

河南省商丘市文物管理委員會、河南省文物考古研究所、河南省永城市文物管理委員會, 2001: 芒碭山西漢梁王墓地。北京: 文物出版社.

Henan Provincial Institute of Cultural Relics and Archaeology. 1996. *Yongcheng Xihan Liangguo wangling yu qinyuan* (Excavations in the Liang State mausoleum precinct of the Western Han dynasty in Yongcheng). Zhengzhou: Zhongzhou Ancient Books Publishing House.
河南省文物考古研究所, 1996: 永城西漢梁國王陵與寢園。中州古籍出版社.

Huang Ruxuan. 2015. *Shitu yu shipan* (Cord-and-hook diagram and the cosmic board). *Kaogu* 1: 92–102.
黃儒宣, 2015: 式圖與式盤。考古, 1: 92–102.

Institute of Archaeology at the Chinese Academy of Social Sciences and Henan Provincial Cultural Relic Management Office. 1980. *Mancheng Hanmu fajue baogao* (Report on the discovery of Han tombs at Mancheng). Beijing: Wenwu chubanshe.
中国社会科学院考古研究所、河北省文物管理處, 1980: 滿城漢墓發掘報告。北京: 文物出版社.

Kaogu (Archaeology; journal). Beijing: Wenwu chubanshe.
考古。北京: 文物出版社.

Kaogu xuebao (Acta Archaeological Sinica; journal). Beijing: Wenwu chubanshe.
考古學報。北京: 文物出版社.

Kaogu yu wenwu (Archaeology and cultural relics; journal). Beijing: Wenwu chubanshe.
考古與文物。北京: 文物出版社.

Knoblock, John, and Jeffrey Riegel. 2000. *The Annals of Lü Buwei: A Complete Translation and Study*. Stanford, CA: Stanford University Press.

Legge, James. (1893) 2000. *Chinese Classics: With a Translation, Critical and Exegetical Notes, Prolegomena, and Copius Indexes*. Vol. 5, *The Ch'un Ts'ew with the Tso Chuen*. Taipei: SMC Publishing.

Lewis, Mark Edward. 2007. *The Early Chinese Empires: Qin and Han*. Cambridge, MA: Belknap Press of Harvard University Press.

Li Huibing. 1978. "Lue tan ciqi de qiyuan ji tao yu ci de guanxi" (A study of the relationship between the origin of porcelain and pottery). *Wenwu* 3: 75–79.
李輝柄, 1978: 略談瓷器的起源及陶與瓷的關係。收入文物, 3: 75–79.

Li Yinde. 2013. "Jiangsu xihan zhuhou wang lingmu kaogu de xin jinzhan" (New archaeological research on the kings' mausoleums in Jiangsu). *Dongnan wenhua* 1: 87–95.
李銀德, 2013: 江蘇西漢諸侯王陵墓考古的新進展。收入東南文化, 1: 87–95.

Li Zebin. 2002. "Jian lun Yangzhou Handai qiqi yishu tese" (A study of the artistic character of the lacquers of the Han dynasty in Yangzhou). In *Nanjing daxue lishi xi kaogu zhuanye chengli sanshi zhounian jinian wenji* (Papers for the thirtieth anniversary of the archaeology major in the history department of Nanjing University), edited by Jiang Zanchu, 432–35. Tianjin: Tianjin renmin chubanshe.
李則斌, 2002: 簡論揚州漢代漆器藝術特色。收入蔣贊初主編: 南京大學歷史系考古專業成立三十週年紀念文集。天津人民出版社 432–35.

Liu Dunzhen. (1980) 2008. *Zhongguo gudai jianzhu shi* (A history of ancient Chinese architecture). Beijing: Zhongguo jianzhu gongye chubanshe.
劉敦楨, (1980) 2008: 中國古代建築史。北京: 中國建築工業出版社.

Liu Qin. 2007. "Jiangsu Yizheng Liuji Lianying Xihan mu chutu zhanbu qipan" (A study of the lacquer cosmic board from the Western Han tomb at Lianying, Liuji township, Yizheng county, Jiangsu province). *Dongnan wenhua* 6: 19–22.
劉勤, 2007: 江蘇儀征劉集聯營西漢墓出土占卜漆盤。收入東南文化, 6: 19–22.

Loewe, Michael, and Edward L. Shaughnessy, eds. 1999. *The Cambridge History of Ancient China, From the Origins of Civilization to 221 BC*. Cambridge: Cambridge University Press.

Lu Jianfang et al. 2003. "Siyang Daqingdun Sishui wang ling" (The king's mausoleum of the Sishui kingdom at Daqingdun, Siyang). *Dongnan wenhua* 4: 26–29.
陸建方 等, 2003: 泗陽大青墩泗水王陵。收入東南文化, 4: 26–29.

Mencius (approx. 372–289 BCE). 1983. *Mengzi—Wan Zhang I* (Mencius: Discussion with Wan Zhang I). In *Huang Kan shou pi bai wen shisan jing* (The thirteen classics annotated by Huang Kan). Shanghai: Shanghai guji chubanshe.
(春秋) 孟軻, 1983: 孟子·萬章上。收入黃侃手批白文十三經。上海: 上海古籍出版社.

Mutschler, Fritz-Heiner, and Achim Mittag, eds. 2008. *Conceiving the Empire: China and Rome Compared*. Oxford and New York: Oxford University Press.

Nanjing Museum. 1985. "'Tongshan Guishan erhao Xihan yandong mu' yi wen de zhongyao buchong" (Important additions to the article "The Western Han cave-tunnel tomb at Tongshan Gui Mountain number two"). *Kaogu xuebao* 3: 352.
南京博物院, 1985: "銅山龜山二號西漢崖洞墓 "一文的重要補充。收入考古學報, 3: 352.

———. 1987. "Jiangsu yizheng yandaishan han mu" (The Western Han tomb at Yandai Mountain, Yizheng county, Jiangsu province). *Kaogu xuebao* 4: 471–501.
南京博物院, 1987: 江蘇儀征煙袋山漢墓。收入考古學報, 4: 471–501.

———. 1990. "Jin shi nian lai Jiangsu kaogu de xin chengguo" (New archaeological accomplishment in Jiangsu province over the past decade). In *Wenwu kaogu gongzuo shinian* (A decade of Archaeology and antiquity studies), edited by the *Wenwu* editorial committee, 101–15. Beijing: Wenwu chubanshe.
南京博物院, 1990: 近十年來江蘇考古的新成果。收入文物編輯委員會 編: 文物考古工作十年。北京文物出版社, 101–15.

———. 2013. *Changwu xiangwang: du Xuyi Dayunshan Jiangdu wangling* (Forget me not: Reading the mausoleum of the king of Jiangdu at Xuyi, Dayun Mountain). Nanjing: Yilin chubanshe.
南京博物館, 2013: 长毋相忘: 讀盱眙大云山江都王陵。南京, 譯林出版社.

Nanjing Museum and the Cultural Bureau of Tongshan County. 1985. "Tongshan Guishan erhao Xihan yandong mu" (The number two Western Han cave-tunnel tomb at Tongshan Gui Mountain). *Kaogu xuebao* 1: 119–33.
南京博物院、銅山縣文化館, 1985: 銅山龜山二號西漢崖洞墓。收入考古學報, 1: 119–33.

Nanjing Museum and the Xuyi Culture Radio and TV News Publication Bureau. 2013. "Jiangsu Xuyi xian Dayunshan Xihan Jiangdu yihao mu" (Royal Jiangdu tomb number one of the Western Han dynasty at Dayun Mountain in Xuyi county, Jiangsu). *Kaogu* 10: 3–68.
南京博物院、盱眙縣文廣新局, 2013: 江蘇盱眙縣大雲山西漢江都王陵一號墓。收入考古, 10: 3–68.

———. 2013. "Jiangsu Xuyi xian Dayunshan Jiangdu wang mu M9, M10 faxian jianbao" (Short report on the discovery of M9 and M10 in the royal Jiangdu tomb in Xuyi county, Jiangsu). *Dongnan wenhua* 1: 52–69.
南京博物院、盱眙縣文廣新局, 2013: 江蘇盱眙縣大雲山江都王陵M9、M10發掘簡報。收入東南文化, 1: 52–69.

Nanjing Museum and the Yizheng Museum Preparation Office. 1992. *Yizheng Zhangji Tuanshan Han mu* (The Western Han tomb at Tuan Mountain, Zhangji township, Yizheng county). *Kaogu xuebao* 4: 477–509.
南京博物院、儀征博物館籌備辦公室, 1992: 儀征張集團山漢墓。收入考古學報, 4: 477–509.

National Museum of China and the Xuzhou Museum. 2005. *Da Han Chu wang—Xuzhou Xihan Chuwang lingmu wenwu jicui* (Kings of Chu of the great Han—selected masterpieces from mausoleums of the kings of Chu of the Western Han in Xuzhou). Beijing: Zhongguo Shehuikexue chubanshe.
中國國家博物館、徐州博物館, 2005: 大漢楚王一徐州西漢楚王陵墓文物輯萃。中國社會科學出版社.

Nylan, Michael, and Michael Loewe, eds. 2010. *China's Early Empires: A Re-appraisal.* Cambridge: Cambridge University Press.

Qiu Yongsheng, and Xu Xu. 1992. *Xuzhou Tuolanshan Xihanmu* (Western Han tombs of Tuolan Mountain in Xuzhou). In *Zhongguo kaoguxue nianjian (1991)* (The 1991 almanac of Chinese archaeological studies), by the China Archaeological Society, 173–74. Beijing: Wenwu chubanshe.
邱永生、徐旭, 1992: 徐州馱藍山西漢墓。收入中國考古學會編, 中國考古學年鑑 (1991)。北京: 文物出版社, 173–74.

Qu Yuan (approx. 340–278 BCE). 2002. "The Nine Songs," translated by David Hawkes. In *Classical Chinese Literature.* Vol. 1, *From Antiquity to the Tang Dynasty,* edited by John Minford and Joseph S. M. Lau, 256. New York: Columbia University Press; Hong Kong: Chinese University Press.

Shandong Museum. 1972. "Qufu Jiulongshan Hanmu fajue jianbao" (A short report on the discovery of a Han grave at Jiulong Mountain in Qufu), *Kaogu* 5: 39–44.
山東省博物館, 1972: 曲阜九龍山漢墓發掘簡報。收入文物, 5: 39–44.

Sima Biao (d. 306). 1980. *Xu Han shu—Liyi zhi* (Continuation of the history of the Han dynasty: Etiquette). Beijing: Zhonghua shuju.
(漢) 司馬彪, 1980: 續漢書·禮儀志。北京: 中華書局.

Sima Qian (approx. 145–90 BCE). 1959. *Shiji—Chuyuanwang shijia* (Records of the grand historian: Hereditary houses of King Yuan of Chu). Beijing: Zhonghua shuju.
(漢) 司馬遷, 1959: 史記·楚元王世家。北京: 中華書局.

———. [Ssu-Ma Ch'ien]. 1961. "The Basic Annals of Emperor Kao-tsu." In *Records of the Grand Historian of China,* trans. Burton Watson, 77–119. New York: Columbia University Press.

Smith, Thomas E. 1992. "Ritual and the Shaping of Narrative: The Legend of the Han Emperor Wu." PhD diss., University of Michigan.

Sun Xingyan (1753–1818) et al. 1990. *Hanguan liu zhong* (Six Han official records). Beijing: Zhonghua shuju.
(清) 孫星衍, 1990: 漢官六種。北京: 中華書局.

Twitchet, Denis, and John K. Fairbank, eds. 1986. *The Ch'in and Han Empires, 221 BC–AD 220.* Vol. 1 of *The Cambridge History of China.* Cambridge: Cambridge University Press.

Wenwu (Cultural relics; journal). Beijing: Wenwu chubanshe.
文物。北京: 文物出版社.

Xuzhou Museum. 1984. "Xuzhou shiqiao Han mu qingli baogao" (Report on the conservation of the stone bridge of the Han tomb at Xuzhou). *Wenwu* 11: 22–40.
徐州博物館, 1984: 徐州石橋漢墓清理報告。收入文物, 11: 22–40.

———. 1997. "Jiangsu Tongshan xian Guishan erhao Xihan yandong mu cailiao de zai buchong" (Further additions to the materials from the Gui Mountain number two Western Han cave-tunnel tomb in Tongshan county of Jiangsu). *Kaogu* 2: 36–45.
徐州博物館, 1997: 江蘇銅山縣龜山二號西漢崖洞墓材料的再補充。收入考古, 2: 36–45.

Xuzhou Museum and Nanjing University, Department of History, Archaeology major. 2003. *Xuzhou Beidongshan Xihan Chuwangmu* (The tombs of Chu kings from the Western Han dynasty in Beidong Mountain of Xuzhou). Beijing: Wenwu chubanshe.
徐州博物館、南京大學歷史系考古專業 編, 2003: 徐州北洞山西漢楚王墓。北京: 文物出版社.

Yang Tianyu. 2004a. *Liyi yizhu: yanli* (Annotated commentary on the book of rites: Yanli). Shanghai: Shanghai Ancient Books Publishing House.
楊天宇 撰, 2004: 禮儀譯註·燕禮。上海古籍出版社.

———. 2004b. *Zhouli yizhu: jiuzheng* (Annotated commentary on the rites of Zhou: Jiuzheng), Shanghai: Shanghai Ancient Books Publishing House.
楊天宇 撰, 2004: 周禮譯註·酒正。上海古籍出版社.

Yangzhou Museum. 2004. *Han Guangling guo qiqi* (Lacquerware from the state of Guangling during the Han dynasty), p. 118, pl. 89. Beijing: Wenwu chubanshe.
揚州博物館, 2004: 漢廣陵國漆器。北京: 文物出版社, p. 118、圖版89.

Zhang Min et al. 1992. "Yizheng Zhangji Tuanshan Hanmu" (The Han tombs at Tuanshan, Zhangji, Yizheng). *Kaogu xuebao* 4: 477–509.
張敏 等, 1992: 儀征張集團山漢墓。收入考古學報, 4: 477–509.

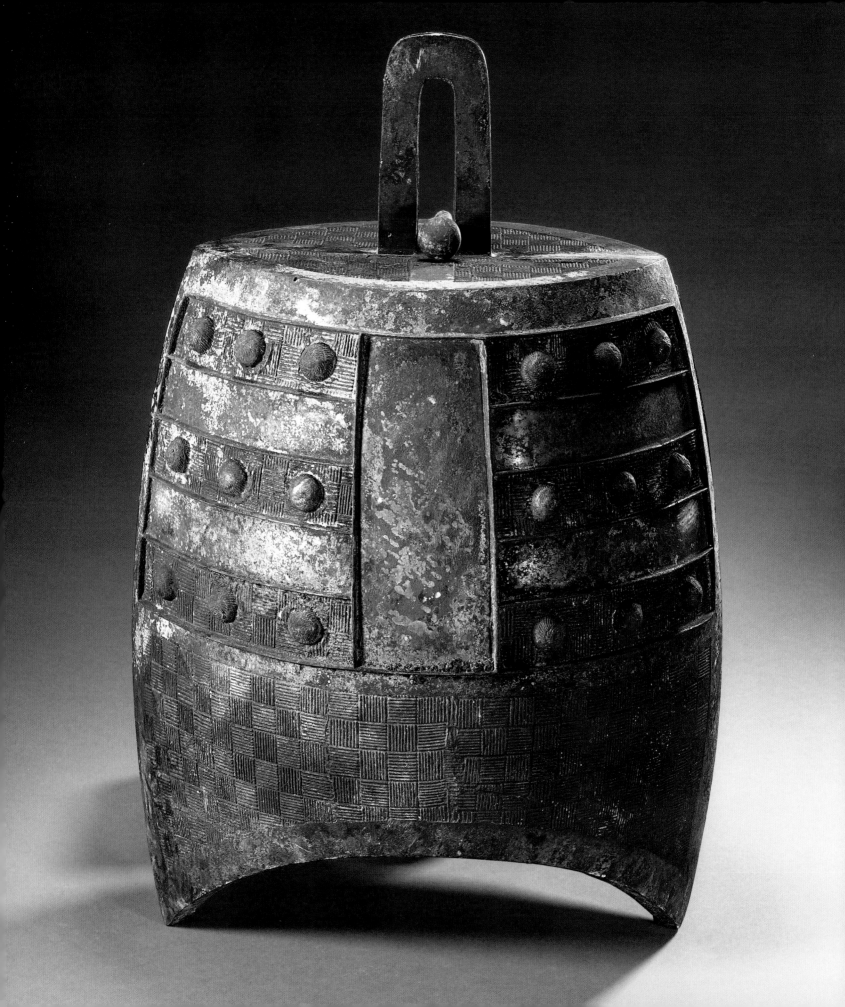

CONTRIBUTORS

Jay Xu—editor, cocurator, and essayist—is director of the Asian Art Museum of San Francisco. He is a member of the American Academy of Arts and Sciences and the Association of Art Museum Directors. Xu obtained his MA and PhD in early Chinese art and archaeology from Princeton University and previously held positions at the Shanghai Museum, the Metropolitan Museum of Art, the Seattle Art Museum, and the Art Institute of Chicago. He is coeditor of *Emperors' Treasures: Chinese Art from the National Palace Museum, Taipei* (2016).

Fan Jeremy Zhang, cocurator, is senior associate curator of Chinese art at the Asian Art Museum of San Francisco. He obtained his PhD from Brown University and previously held curatorial positions at the Metropolitan Museum of Art, the Smith College Museum of Art, and the John and Mable Ringling Museum of Art. His recent exhibition catalogs include *Collecting Art of Asia* (2013) and *Royal Taste: The Art of Princely Courts in Fifteen-Century China* (2015).

Jamie Chu, coordinating editor, is curatorial assistant at the Asian Art Museum of San Francisco, where she worked on the *Emperors' Treasures* exhibition and catalogue. She obtained her BA from UCLA and MA from the University of Pennsylvania, and she did postgraduate studies at Tsinghua University.

Claire Yi Yang, coordinating editor, is curatorial associate at the Asian Art Museum of San Francisco. She is a PhD candidate at UC Berkeley, and she holds degrees from UC Berkeley, Leiden University, and Fudan University. She previously held a curatorial position at the Shanghai Museum.

Li Zebin, essayist, is deputy director of the Institute of Archaeology at the Nanjing Museum. He graduated from the history department at Nanjing University and previously held positions at the Yangzhou Museum and the Yangzhou City Institute of Cultural Relics and Archaeology.

Li Yinde, essayist, is director emeritus and researcher at the Xuzhou Museum. He has published many articles and is the author or editor of seven books, including *Xuzhou wenwu kaogu wenji* (Archaeological collection of Xuzhou; 2011) and *Zhongguo yuqi tongshi: Qin Han juan* (A general history of Chinese jade: Qin and Han dynasties, 2014).

Tianlong Jiao, essayist, is the Joseph de Heer Curator of Asian Art at the Denver Art Museum. He obtained his PhD from Harvard University, and he previously held positions at the Asian Art Museum, the Hong Kong Maritime Museum, and the Bishop Museum. Jiao is the author of *The Neolithic of Southeast China: Cultural Transformation and Regional Interaction on the Coast* (2007).

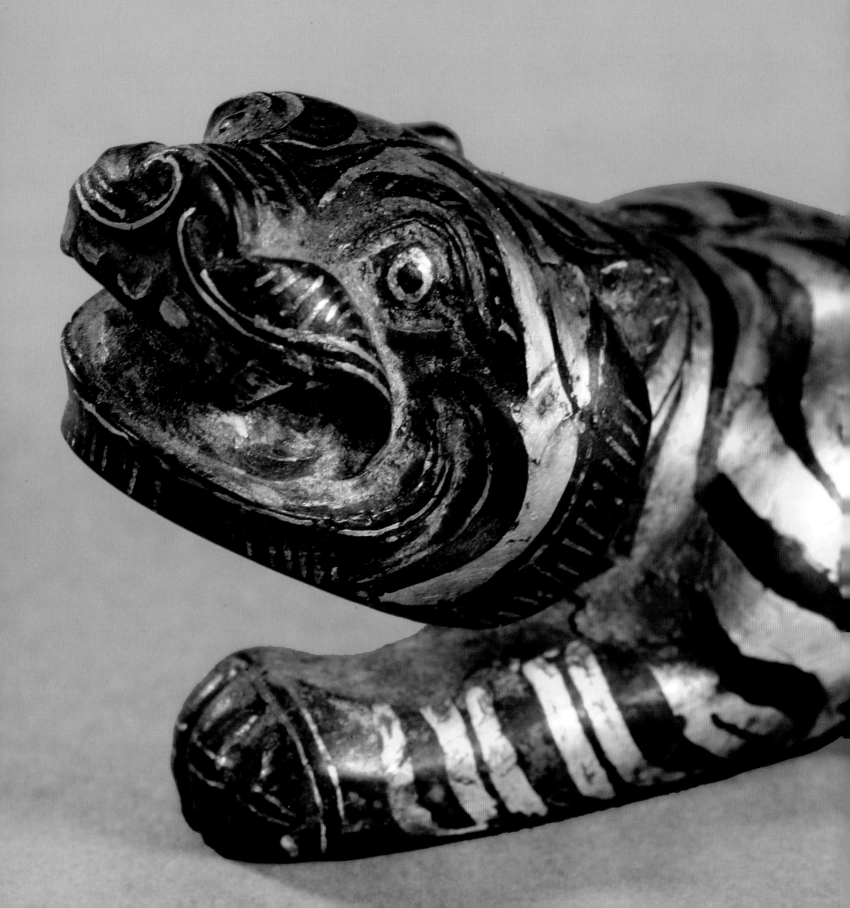

INDEX